LANDSCAPE PAINTING IN OIL

LANDSCAPE PAINTING IN OIL

BY WENDON BLAKE

Paintings by George Cherepov

WATSON-GUPTILL PUBLICATIONS, NEW YORK

PITMAN PUBLISHING, LONDON

For Mack and Pooh and Piglet

Copyright © 1976 by Watson-Guptill Publications

First published 1976 in the United States and Canada by Watson-Guptill Publications,
a division of Billboard Publications, Inc.
1515 Broadway, New York, N.Y. 10036

Published in Great Britain by Pitman Publishing Ltd.,
39 Parker Street, London WC2B 5PB
ISBN 0-273-00122-1

Library of Congress Cataloging in Publication Data
Blake, Wendon.
 Landscape painting in oil.
 Bibliography:p.
 Includes index.
 I. Landscape painting—Technique I. Cherepov,
 George, 1909- II. Title.
ND1342.B55 1976 751.4′5 75-34024
ISBN 0-8230-2609-4

Manufactured in U.S.A.

First Printing, 1976
Second Printing, 1976
Third Printing, 1977
Fourth Printing, 1978
Fifth Printing, 1979

CONTENTS

INTRODUCTION

This book is an introduction to landscape painting for the reader who's already done some oil painting, who likes the outdoors, and who wants to get out there and paint.

The first five chapters explain how to get started. *Materials and Equipment* tells you what brushes, knives, painting surfaces, and other things you've got to buy if you don't own them already. *Colors, Mediums, and Varnishes* gives you a basic list of tube colors and tells you how they behave. *Observing Nature* shows you how to analyze things like light and shadow, color, perspective, and the distinctive shapes of the landscape. *Planning the Picture* tells you how to pick your subject; how to plan your composition; how to paint on location; and how to work from sketches, drawings, and photos. And *Painting Technique* explains how to build the painting from the first strokes to the final touches; how to make your brushstrokes lively and expressive—and what to do when things go wrong!

Throughout these first five chapters, you'll find closeups of significant portions of paintings by George Cherepov, a master of the direct, spontaneous method of landscape painting described in this book.

Then, five more chapters explain how to paint all the familiar components of the landscape. *Forms of the Land* explains how to paint deserts, dunes, meadows, rocks, hills, and mountains. *Trees and Growing Things* explains how to paint trees, grasses and wildflowers, and tropical forms like palms and cacti. *Water, Snow, and Ice* tells you how to paint water in all its forms: lakes, ponds, streams, snow, and ice. *Skies and Weather* analyzes how to paint various cloud forms; clear and stormy weather; and the dramatic effects of sunrise, sunset, twilight, and moonlight. Finally, *Manmade Structures and Figures* tells you how to paint the forms that man adds to the natural landscape: barns, fences, dirt roads—and figures too.

In these five chapters, George Cherepov shows, step-by-step, how to paint these typical landscape components in thirty-two black-and-white demonstrations. Then, in eight full-color demonstrations, he assembles these landscape components into full-scale pictures.

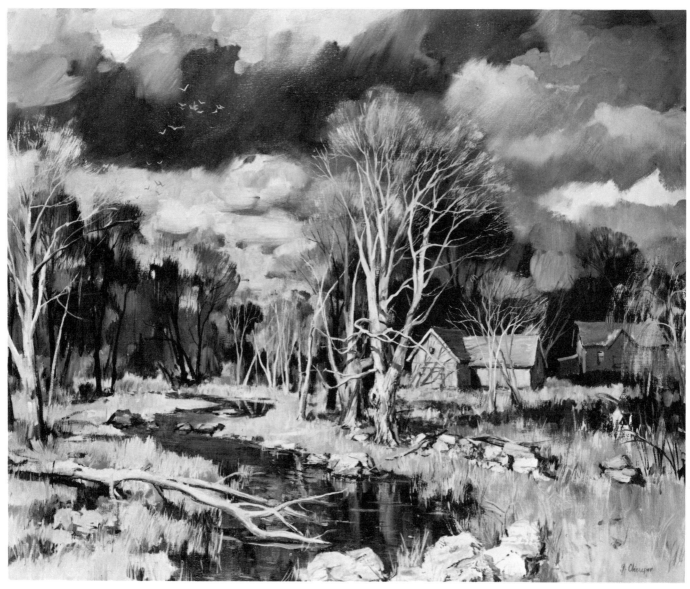

After April Shower by George Cherepov, oil on canvas, 36″x42″, private collection. In oil painting, it's important to choose the right brush for the right job. Each brush leaves its own distinctive mark. In this landscape, we see the imprint of several different brushes. The broad, soft strokes in the stormy sky are painted with a large bristle brush, which could be either a so-called flat or a filbert, both of which have long, springy bristles. In contrast, the short, thick strokes on the foreground rocks are the work of a so-called bright, a squarish brush with short, stiff bristles that carry a heavy load of paint and leave a thick, richly textured stroke. Slender, fluid strokes, like the tree-trunks, branches, grasses, and weeds, can be painted either with a round, pointed softhair brush or with a slender flat or filbert. Painters often save old, worn bristle brushes—with the bristles splayed out —for scrubby strokes like the foliage on the trees. The foreground rocks could also be executed with deft strokes of the painting knife.

1

MATERIALS AND EQUIPMENT

Most painters love art supply stores; the shelves look so tantalizing that you're tempted to buy everything in sight. But it's best to restrain yourself and start out with a very limited selection of materials and equipment—for two reasons.

First of all, it's important to buy the best equipment you can afford. But really good materials and tools cost more every year and you can really wreck the family budget if you get carried away. So, given a certain amount of money to spend, it's best to pay high prices for just a handful of top-quality brushes and tubes of color.

An equally important reason for keeping your gear simple—aside from purely financial limitations—is that you must get to know every brush, every knife, and every tube of color so intimately that you can predict its behavior, very much as you can predict the habits of an old friend. You'll want to learn precisely what each tool and color can do. This takes time and practice. If you surround yourself with a huge, bewildering assortment of art supplies, it takes that much longer to get to know them all. Too much equipment in the studio can actually *slow down* the learning process.

So, in this chapter, I'm going to recommend a fairly simple selection of supplies, just enough for you to buy as a starter—if you don't already have some of them. When you get to know these reasonably well, then you can go on to buy some others and try them out. But you'll eventually discover that your painting tools and colors are like friends: some will become intimate friends and you'll become deeply attached to them, relying on them constantly; others will be nothing more than pleasant acquaintances whom you'll turn to only on special occasions.

BRUSHES

The most widely used tools for oil painting are bristle brushes, which are made of stiff, white hog bristles set in a handle somewhat longer than the common pencil. There are three kinds of bristle brushes and each has its uses.

Flats have long, springy bristles. The rectangular body of bristles ends in a squarish tip. However, as you use the brush, the bristles will begin to wear away and the end of the brush will become slightly rounded. The flat picks up just enough paint for most purposes, and its flexible bristles make a fairly smooth stroke.

The *brights* have shorter bristles than flats. Because they're shorter, they're a lot stiffer and can pick up much more paint. These stiffer bristles can deposit more paint on the canvas and generally leave a rougher paint surface. In a bright, as in a flat, the rectangular body of bristles comes to a squarish tip, but the brush becomes a bit rounder with prolonged use.

Filberts have long, springy bristles, like flats, but are designed so that the rectangular body of bristles ends in a rounded tip, very much like a brush that's been used for awhile. Many professionals prefer filberts because they make a soft, "natural" stoke that seems less harsh than the stroke left by the chisel-ended flats and brights. You have to use a flat or a bright for quite some time before it will develop a rounded tip that looks something like a filbert.

For general use, it's best to rely on the long-bristled flats or filberts, saving the brights for passages of thick color or rough texture. Of course, if you discover that you like to paint thick, you may discover that the brights are your favorites. But for reasons which I'll explain in Chapter 5, *Painting Technique*, it's always best to start out a painting with thin color, even if you're going to add thicker color later on. So it's hard to do without flats or filberts, even if you're going to end up painting as thick as van Gogh.

In oil painting, softhair brushes—like sables and oxhairs—come under the heading of "special purpose" tools. For drawing lines and adding small details, a slender, pointed sable brush is useful. For very smooth paint layers, a flat sable, shaped like a bright, is helpful. Oxhair is a less expensive substitute for sable—not quite as good in the round, pointed shape, but probably just as good in the flat shape.

There's also a family of softhair brushes called blenders. These are generally large, flat brushes—as much as 1″ wide, sometimes even wider—that are used for smoothing wet color, softening the edges of color areas, and blending one color into another. Most professionals feel that it's best not to overuse blenders, and many painters avoid them altogether. Such brushes are usually made of oxhair, badger, or (believe it or not) squirrel. They cost very little.

BUYING BRUSHES

Now, with all these possibilities, which brushes do you buy *first?* There are two rules that are worth keeping in mind when you buy brushes. . . .

The noted portrait and figure painter John Howard Sanden always advises his students to use the brush that looks "just a bit too big for the job." So the first rule is to buy big brushes rather than little ones. Big brushes encourage you to work broadly and boldly.

The second rule is to buy brushes in pairs because it makes sense to *use* them in pairs. Let's say you're painting a landscape with lots of trees, some of them green and some beginning to turn red and gold. You're working on the green trees with one brush and you probably need a brush of the same size for the red and gold trees. It's a nuisance to clean that green brush so you can pick up reds and yellows on it; besides, the brush will retain some traces of the cool green color, which will dull the hot red and yellow colors. What you need are two brushes of roughly the same size, one for cool colors and one for warm. This kind of situation comes up so often that it's wisest to have pairs of brushes that are approximately the same size.

Applying these rules, begin with a couple of really big bristle brushes, roughly 1″ wide, for your biggest color areas; you might pick a number 12 and a number 11 to give you a bit of variety in size—and one could be a flat and the other a filbert to give you some variety in shape.

Then you'll need two or three brushes in what I'd call the medium-size range. Your pair could be a number 7 and a number 8, roughly ½″ wide, perhaps one flat and one filbert again. You might turn this pair into a trio by adding a number 9 bright.

These are all bristle brushes and they're all big enough to encourage bold, juicy painting. However, you probably feel the need for a couple of smaller brushes that will allow you to paint details like branches on trees and ripples on water. I think the smallest bristle brushes worth owning are a number 3 and a number 4, which generally run ¼″ to ⅜″ wide. These should both be flats or filberts because their long, slender bristles will give you better detail. If you'd like a bright in this size range, choose something slightly bigger, like a number 5.

With these eight bristle brushes I think you

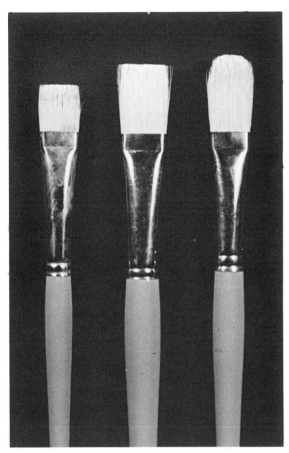

The brush at right is a filbert, a flat bristle brush that comes to a round tip and leaves a particularly soft stroke. The center brush is simply called a flat; it's similar to the filbert, but comes to a squarish tip and therefore makes a more precisely defined, squarish stroke. The brush at left is a bright, which has shorter, stiffer bristles than the filbert or the flat, carrying more paint and digging more deeply into the painting surface, so it leaves behind a more heavily textured stroke.

can do just about every painting job. You might want to fill in with some other flats, brights, and filberts in the intermediate ranges, but it's not necessary to spend the money unless you really want them.

Sables, oxhairs, and other softhair brushes may be useful, but they're really optional. You might find it helpful to buy one slender, pointed sable brush for an occasional precise note: you can do most line work with a round sable, about 1/16″ wide where the hairs protrude from the ferrule—the metal cylinder that grips the hairs. Manufacturers' numbering systems vary, but this will probably be a number 10 or 12. If you want to try a couple of flat softhair brushes, get one that's ¼″ wide and another that's about ½″ wide, probably a number 8 and a number 12. Flat sables are fine if you can afford them, but oxhair or some cheaper softhair will do almost as well. And if you want to try a blender, get a big one—1″ wide—in some cheaper softhair like squirrel.

Later on, if you really fall in love with the very smooth, fluent stroke of softhair brushes, you can then invest in sables or oxhairs in the ¼″ and ½″ sizes that I've recommended for bristle brushes. But don't overload yourself with brushes just yet. You can paint for years with just the six or eight bristle brushes I've recommended as your basic set.

CARE AND CLEANING OF BRUSHES

Brushes are fragile. If you use them frequently, store them in a big jar—bristle end up, so they don't all squash against one another and bend their bristles out of shape. If you don't paint that frequently, you can store your brushes in a drawer; but buy one of those plastic silverware trays with long, slender compartments for knives, forks, and spoons—and use them for your brushes, so all the brushes lie parallel and don't crush one another. In summertime, throw some granules of moth killer into the tray. A drawerful of brushes is a choice meal for moths.

When you're finished painting for the day, it's not enough to rinse your brushes in turpentine or some other solvent and just put them away. The solvent always leaves some residue on the bristles; this residue gradually builds up and stiffens the brush.

Clean each brush methodically by squeezing out the paint between a couple of layers of

newspaper. Then wet the palm of your hand and rub it against some mild kitchen soap like Ivory. Lather the bristles against your soapy palm by moving the brush in a steady circular motion—that circular motion is important so you don't squash the bristles—and make sure that the lather works all the way up to the ferrule. Paint clings most tenaciously to the ferrule area, which is where the gradual stiffening of the brush begins; if you don't get the wet color out, the brush soon loses its spring, becoming wiry and unresponsive. If necessary, squeeze the lather into the ferrule area with your fingertips.

When the brush is fully lathered, rinse away the soap in cold or lukewarm (never hot) water and lather it again. Repeat the lathering and rinsing process until the lather is snow-white, which means that you've gotten rid of all paint residue that you can reasonably expect to wash away. Don't worry if those white hog bristles discolor slightly after a few painting sessions. As long as you lather them until the foam is absolutely white, you've done a good cleaning job.

After washing sables, oxhairs, and other softhair brushes, gently press them back into their original flat or pointed shape while they're still wet. Stand them—hair end up—in a jar until they're dry. Then put them away in a drawer if you like. But never put a wet softhair brush directly into a drawer, where even the slightest pressure will distort the shape of those very tender, wet hairs.

PALETTE KNIVES AND PAINTING KNIVES

For mixing paint on your palette, for scraping paint off the palette at the end of a working session, and for scraping unsuccessful passages off a wet painting, a palette knife is an essential piece of equipment.

The usual palette knife has a flexible steel blade that comes to a rounded tip. One type of palette knife has a blade that protrudes straight from the wooden handle. Another kind, the spatula type, has a blade that turns downward from the wooden handle and then moves forward. Which one you buy is a matter of taste. But those who like the spatula design say that you're less likely to get your knuckles into wet paint when you're mixing or scraping.

A note of caution: after prolonged use, a

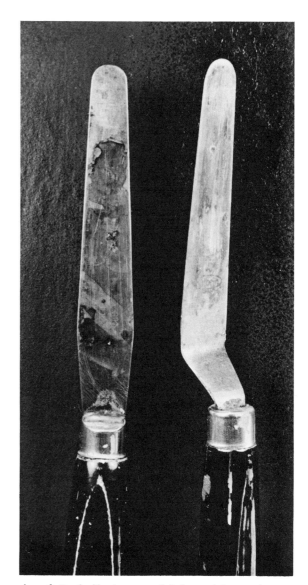

A palette knife is essential for mixing paint on your palette, for scraping wet or dry paint off the palette, and for scraping your canvas when you want to make a correction. At right, you see a spatula-type of palette knife, which some painters prefer because it keeps your knuckles clear of wet paint. The straight palette knife, at left, is often springier, which is why some painters prefer it for mixing paint.

palette knife is apt to develop sharp edges which can give you a nasty cut if you're not careful. You can blunt these sharp edges with a flat metal file from the toolbox. Or you can do the job with one of those flat abrasive stones used for sharpening knives.

Painters sometimes talk about "painting" with a palette knife. But the ordinary palette knife is too long and slender—and usually too rigid—for applying paint. There *are* knives specifically designed for applying paint, but they're generally shorter, broader, and more flexible than a palette knife. If you'd like to experiment, buy one with a blade about 2" long—an elongated diamond shape with a rounded tip. It can be useful for applying big, slablike strokes when you're painting rocks or brilliant patches of light on water, for example. But knife painting is a whole separate "language," beyond the scope of this book. Coulton Waugh's *How To Paint with a Knife* is the best book on the subject.

When you're finished using your palette knife or painting knife, wipe it absolutely clean with a rag, a paper towel, or a scrap of newspaper. Don't let any paint dry on the blade or the blade will develop a crusty, irregular surface which is very frustrating to use.

PAINTING SURFACES

Canvas is the most widely used painting surface, although there *are* other alternatives, which I'll mention in a moment. Basically, there are three kinds of canvas: linen, cotton, and canvas boards. The best linen canvas is handmade and has a slightly irregular surface which is particularly pleasant to paint on. The less expensive cotton canvas is normally machine made and has a much more regular surface—more mechanical-looking than the linen —but it's a perfectly adequate painting surface if you're watching your money. Canvas boards seem to be made of very inexpensive cotton which is glued to stiff cardboard. For on-the-spot painting and for experimental work while you're still learning, canvas boards are cheap and convenient; but when you feel that you're ready to paint masterpieces, you'll want to work on linen or cotton canvas.

You can buy cotton or linen canvas mounted on a wooden stretcher, which is a rectangular wooden frame. But it's a lot cheaper to buy canvas by the yard and stretcher strips with slotted corners so you can put them together, and then stretch your own canvas. First assemble the stretchers and then cut a rectangle of canvas that's 1" bigger all around than the rectangle formed by the stretchers. The canvas will have a layer of white paint on one side— the side you're going to paint on—so place the canvas rectangle white side down on a tabletop. Assemble the four stretcher bars—using a carpenter's square to check that the corners are all at right angles—and then center the stretcher on the back of the canvas sheet. Turn up one edge of the canvas and bang one nail through it, dead center, to the rim of the stretcher bar. (You can use carpet tacks, ½" nails with flat heads, or even staples fired from a staple gun.) Repeat the process on the stretcher bar directly opposite, pulling the canvas tight as you hammer that nail. Then repeat the process on the other two sides, so you've got a nail driven into the dead center of each of the four stretcher bars.

Now it's fairly simple to finish the job. Nail down one complete side, with the nails about 2" apart. Then do the same on the opposite side, pulling the canvas tight as you hammer. And finish up the remaining two sides in the same way. When all four sides are nailed down, you'll find a little triangle of canvas sticking out from each corner; you can either nail it down to one of the edges or fold it in on itself and tuck it under. And if the canvas is still a bit slack in the corners, remember the triangular wooden "keys" that come with the stretcher bars. Hammered lightly into the slots on the inside corners of the bars, these should tighten the canvas just enough.

One tip: If you're inexperienced in stretching canvas, don't hammer the nails all the way in until you're sure you've done the job right. Leave a little space beneath the head of the nail so you can yank it out and try again.

What size should a stretched canvas be? If you'd like to experiment with three popular sizes, I'd suggest you start with 16" x 20", 20" x 24", and 24" x 30". This will give you two fairly modest sizes—each about as big as a large sketchpad—and one size which is big, but not *too* big for a beginner to handle. These are sizes that the professionals like, and you'll learn by painting on three different scales.

Most painters agree that you should buy canvas boards that match the size of your paintbox, which I'll tell you more about soon. The standard paintbox is designed to hold several 12″ x 16″ canvas boards for painting on location. So 12″ x 16″ would be the most useful size for your canvas boards. You can also buy much bigger canvas boards, but by the time you work yourself up to 20″ x 24″, you should really "graduate" to stretched canvas.

It's also worthwhile to paint some pictures on panels to see whether you like the smoother, more rigid surface better than the springy, stretched canvas. The best panels are made of hardboard. Your art supply store may carry readymade panels, coated on one side with a smooth layer of white paint, but it's cheaper to make your own. Also, if you make them yourself you can control the kind of surface you'll be painting on.

Buy *untempered* hardboard at your local lumberyard or building supplier and ask him to cut it to several standard sizes, such as 12″ x 16″, 16″ x 20″, or 20″ x 24″. (Don't go beyond 20″ x 24″, because bigger panels are apt to bend.) Roughen one smooth side of the panel with sandpaper and then coat that side with acrylic gesso, which you can buy in cans or big jars from your art supply store. Acrylic gesso is specially made for artists who want to create their own painting surface. Used straight from the can, acrylic gesso is almost as thick as pancake batter; if you brush it on with a nylon housepainter's brush, the bristles will leave a slightly irregular texture which you might enjoy painting on. On the other hand, if you'd rather paint on a smoother surface, you can thin the gesso with water to a consistency more like that of light cream, then brush on several coats which will dry with very little texture.

If you'd like to try a panel with a really rough, irregular surface, skip the acrylic gesso and brush on one or two layers of white lead oil paint—or "white lead in oil" bought in a can from your local paint store—using a stiff bristle brush and varying the direction of your strokes.

Strictly for sketching, you might want to try canvas-textured paper, which comes in sheets or pads specially prepared for oil painting. Several manufacturers make a tough, thick paper, embossed to look like canvas. Although the surface looks mechanical and lacks the "bounce" of stretched canvas, it's convenient for quick painting on location.

Surprisingly, very few contemporary painters remember that the old masters often painted small oils on paper. Particularly for quick studies on location, paper is ideal: not nearly as bulky as a canvas or even a canvas board, and very inexpensive. You can take any sturdy sheet of drawing paper, watercolor paper, or illustration board, give it a couple of thin coats of acrylic gesso (on both sides to prevent warping), and you've got a splendid painting surface in a matter of minutes. If you discover that your oil studies on paper begin to look good enough, you may want to do your "serious" painting on a top-quality watercolor paper like Arches or illustration board like Strathmore, both of which are 100% rag and will last as long as canvas if properly primed with acrylic gesso. That gesso is important: it prevents the oil from sinking into the paper and rotting the fibers. With this one safeguard, paper is as permanent as any other surface.

PAINTBOX

Artists and manufacturers have come to some sort of unofficial agreement that the ideal paintbox is roughly 12″ x 16″, with compartments inside for brushes, paints, bottles of medium, a few accessories, and two or three canvas boards that measure 12″ x 16″. The canvas boards slide into slots in the lid of the box, which can be flipped up and held in place by a metal hinge or hook; the upright lid functions as an "easel" when you're working in the field and want to paint with the box in your lap or on the ground.

A simple wooden paintbox is as good as anything, provided that it snaps securely shut —so everything doesn't spill out when you're climbing over the rocks—and stays securely open when you're working on a painting inside the lid. You can pay more for metal boxes or wooden boxes with very elegant graining and dovetailing. But the cheapest box will do.

Try to develop the habit of wiping out the inside of the box when you come back from a painting expedition. Clots of wet paint and oil spills can ruin your brushes, and can soil your canvas boards and make them hard to slide in and out.

EASELS

The function of an easel is to hold your canvas firmly at the right level for convenient work. The vertical wooden shafts of the easel must be steady enough not to wobble when you whack the canvas with a big brush. And the two wooden grippers that hold the top and bottom of the canvas—almost like two hands—must be big and heavy enough to hold the canvas in place.

Although these factors are important in any kind of easel, indoor and outdoor easels are radically different.

When you buy an easel for use at home or in the studio, bear in mind that you'll probably paint much bigger pictures indoors than outdoors. So you want the heaviest easel you can afford. The cheapest practical easel for indoor work is the typical art school easel, which is one heavy vertical board that rests on a base shaped something like the letter T and has two sliding grippers to hold your canvas. The art school easel is far from ideal, but it's a lot steadier than most tripod-shaped easels, which have three skinny legs, forming a kind of pyramid. If you can afford it, the best studio easel has three vertical struts and a rectangular base with wheels, so you can move the easel to whatever location gives you the best light. This sort of easel can cost a great deal, but you can sometimes buy them secondhand. A sturdy, battered old easel is a better investment than a flimsy new one.

The ideal easel for outdoor painting is in many ways the exact opposite from the ideal studio easel. Here you want something that's lightweight, foldable, and portable. The tripod easel is the usual solution, but some are steadier than others. The easel can be either wood or metal tubing, but be sure to test several models by opening them up in the store and seeing how easily they tip over. Some outdoor easels are constructed so they'll hold your paintbox; this is not only convenient, but the paintbox adds some weight to the easel and holds it in place more securely.

Although some outdoor easels are better balanced and therefore steadier than others, they're never as unshakable as studio easels. There are two tricks that you might want to try. Some outdoor painters travel with a big rock or a cinder block, which they rope to one of the horizontal members of the easel after they set it up. Presumably, this makes the easel heavier and steadier. But not everyone wants to carry this much dead weight on an outdoor painting trip. I also know some painters who sharpen the legs of their wooden outdoor easels or drive huge nails into the three feet of the easel; the sharpened legs or protruding nails stab into the ground and help hold the easel in place.

But do you need an easel at all? If space is tight at home—and the budget may be tight too—it's perfectly feasible to rig up a "painting wall" instead of an easel. Do you know those metal strips with slots in them to hold brackets for adjustable shelving? I know several painters who've mounted such metal strips on a wall and hold their canvases in place with shelf brackets. Another possibility is a sheet of pegboard mounted on the wall; your canvas could be held in place with appropriate hooks that slide quite easily into the pegboard. Try to find a "painting wall" that's near a window and then add a couple of overhead lamps to make sure you've got the kind of light you need at any time of day. The adjustable type of architect's lamp called a Luxo can be screwed or clamped to any sort of moulding. An even simpler solution would be a couple of photographic floodlights, which you can clamp to practically anything that protrudes.

Nor do I think that an outdoor easel is absolutely essential. Many outdoor painters find it a bother to lug around an easel. They'd rather carry everything they need in the paintbox. This way, they just sit down wherever they please, flip the box open, and paint on a canvas board or a gesso panel inside the lid.

PALETTE

If you buy the standard 12″ x 16″ paintbox, it usually comes with a 12″ x 16″ wooden palette. This is a perfectly practical size for outdoor painting or for painting in the studio. Before you use your new wooden palette, rub it with plenty of linseed oil on both sides, let the oil sink in and harden for a week or so, and don't put any paint on the palette until you're sure the surface is really dry. The linseed oil seals up the wood and makes it nonabsorbent, so the color won't sink in and stain the palette. That dried coating of linseed oil also makes the

palette easier to wipe off when you want to clean it after a painting session.

However, you may find it confusing to mix your color on brown wood and then apply the same color on white canvas. The color will look different when you move it from the brown background to the white. Lots of painters do work on brown wooden palettes, which proves that you can make the necessary mental adjustment; but lots of *other* painters prefer to mix their color on a white painting surface, where it looks the same as it does on the canvas. If you prefer to mix your colors on a white background, buy a 12″ x 16″ paper palette, which is actually a pad of white oilproof paper cut to the shape of a palette; it fits neatly into your 12″ x 16″ paintbox and you can tear off the top sheet at the end of the painting session instead of having to clean it.

Another good solution, strictly for use at home or in the studio, is a slab of white marble or a sheet of glass set on top of a white cardboard—or painted white on the underside. If you find that you want a larger painting surface than 12″ x 16″, this homemade studio palette could be as big as 16″ x 20″. Naturally, you won't want to lift it; just set it on a table. Better still, buy one of those little, rolling kitchen tables on wheels, with several white enameled shelves; put the palette on the top, and you can rest your paintbox and other supplies on the shelves beneath.

ACCESSORIES

So far, I've listed all the obvious items you'll need in your paintbox or in your work area. Here are some others that may be less obvious, but which are hard to do without:

Palette Cups. Your art supply store will stock metal cups which are a couple of inches in diameter and are designed to clip to the edge of your wooden palette. Get one for painting medium and another for turpentine—more about these in the next chapter.

Charcoal. For sketching on the canvas before you start to paint, some sticks of natural vine charcoal are useful. These are literally sticks of charred wood with which you can draw a black or gray line. And charcoal dusts off easily if you want to make a correction. Don't buy charcoal pencils or sticks of compressed char-

coal; they contain some greasy substance that makes the charcoal harder to dust off the canvas.

Putty Knife. For scraping dried paint off your palette or your painting surface, you'll want a much tougher blade than a palette knife. Buy a putty knife 2″ or 3″ wide.

Rags or Paper Towels. For wiping your brushes, cleaning your palette or painting knives, and wiping mistakes off your painting surface, stock up on old rags. The right rag is smooth, absorbent, and lint-free. Muslin is better than flannel. Old sheets, pillowcases, and discarded shirts are particularly good. A roll or stack of absorbent paper towels is also good for cleaning brushes and knives. But don't scrub your canvas with a paper towel; it may leave some fibers sticking to the paint.

Newspapers. A stack of old newspapers is useful for wiping your brush when you've dipped it in turpentine to get rid of one color and you're ready for another. And as I said earlier, you'll need newspapers for cleaning your brushes before you wash them in soap and water.

Chamois. A piece of chamois, roughly the size of the page you're now reading, is ideal for wiping away the marks of vine charcoal. Keep it dry and don't use it for wiping brushes or knives.

Mahlstick or Dowel. The old masters used to keep an elegant, polished, cylindrical stick near the easel to help them paint tricky details. This mahlstick was 3′ or 4′ long. The painter would hold the stick at one end and rest the other end on the upper edge of the canvas, so the stick crossed the canvas diagonally without touching; then he could rest his brush hand somewhere on the stick to steady himself when he wanted to paint some tight detail. You may be able to buy the old-fashioned mahlstick in a particularly elegant art supply store, but a dowel from the lumberyard is just as good. A stiff, 3′ wooden ruler works too.

Bottle or Jar Opener. The caps on tubes of paint, as well as on bottles of turpentine and painting medium, have a nasty habit of sticking. Buy one of those bottle or jar openers that many people have in their kitchens. There are lots of different kinds, but they're all designed

to grip a small jar or bottle top and give you better leverage to crank it open.

Jars and Silverware Trays. A moment ago, I suggested storing your brushes in jars or compartmented silverware trays. The best jars are the quart size; make sure that the neck is as wide as possible. The compartments in your silverware tray should be long enough to leave some space at either end of the brush so that the bristles won't get squashed.

Housepainter's Brushes. For coating hardboard panels, sheets of paper, or sheets of illustration board with acrylic gesso, one or two nylon housepainter's brushes are cheap and useful. They're also good for varnishing. Get one that's 2″ wide and another that's 3″ wide. Use one for gesso and the other for varnishing—and never interchange them.

Hammer, Nails, Staple Gun. If you're going to stretch your own canvas, a hammer with a magnetic head is a blessing, since it holds onto the nails all by itself. The nails themselves can be carpet tacks or any other flat-headed nail that's about ½″ long. A heavy-duty staple gun will also do the job, though it certainly costs more than a hammer.

Ruler and Scissors. If you're going to stretch your own canvas, you'll also need a ruler to measure the canvas and a scissors to cut it. A metal ruler with a cork back is particularly good because it won't slide around as easily as a wooden ruler.

I've probably left out *some* painters' favorites, but these are all the accessories that strike me as essential.

OUTDOOR PAINTING KIT

If you limit your painting equipment to the essentials I've listed so far, you can get everything but an easel—which not everyone considers essential—into a 12″ x 16″ paintbox. It will comfortably hold two or three 12″ x 16″ canvas boards; six or eight brushes; a palette knife; a wooden or paper palette; a couple of palette cups; a few rags or a wad of paper towels, tightly folded up; a couple of sticks of charcoal and maybe a small chamois; ten or twelve tubes of color, plus a big tube of white; a small bottle of painting medium and another small bottle of turpentine. That should do it, though you may want to carry a lightweight, folding easel and some other conveniences . . .

Hat. To keep the sun out of your eyes and off your neck, a hat with a big brim can be a blessing on a hot day.

Umbrella. When you're painting outdoors, it's important to keep your painting surface in shadow, not in direct sunlight, so you can see the colors more clearly. If you work with bright sunshine on your canvas, the colors will look amazingly different when you get the painting indoors. So professionals often carry a lightweight beach umbrella to create a "tent" of shadow to work in. Other professionals feel like packhorses when they carry anything more than a paintbox; they simply arrange to work under a tree or in the shadow of a barn. In any case, do remember to work in the shade.

Insect Repellent. The most delightful outdoor painting session can be sheer hell if you're constantly swatting mosquitoes and flies on your arms and neck. A small bottle or stick of insect repellent can make all the difference.

Other amenities might include rubber-soled sneakers or crepe-soled shoes for climbing; a small cushion (perhaps inflatable) if your backside isn't sufficiently padded; trousers of some tough, smooth fabric that won't snag on thorns and twigs; an unbreakable stainless steel thermos filled with something hot or cold; and perhaps a small 35mm camera to record things you don't have time to paint.

Finally, here are a few don'ts. Don't paint with your sunglasses on; your colors will look totally different when you take your sunglasses off. If you're painting in unfamiliar woods, don't stray from the path; you'll find plenty of good subjects within sight of the path. Don't perch yourself on a coastal rock formation without keeping an eye on the tide; the tide has a way of creeping in so gradually that you suddenly look around and find that you're stranded. And don't throw away your soiled paint rags or empty tubes in some farmer's meadow; you may find him coming after you with a pitchfork!

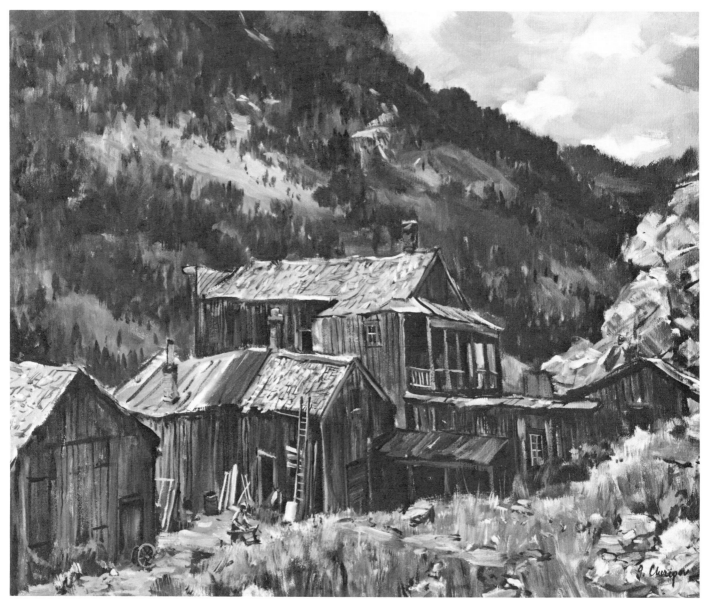

Silver Plume, Colorado by George Cherepov, oil on canvas, 24″x30″, courtesy Grand Central Art Galleries, New York. As it comes from the tube, oil paint is a thick paste that's too stiff for most painting jobs. The artist adds painting medium—usually a mixture of turpentine, linseed oil, and a varnish like damar, copal, or mastic—to make the paint more fluid and easier to brush. The artist may add more or less painting medium to the tube color, depending upon the paint consistency he wants for the particular job. For soft, washy strokes, like in the sky in the upper right, the artist has to add a great deal of medium. The small, ragged strokes on the distant mountainside are also quite fluid and the paint obviously contains a high proportion of medium. But the old, weather-beaten boards of the buildings are painted in slightly thicker color to express their irregular texture; the artist has retained some of the original stiffness of the tube color and added just enough medium to make the paint "brush out" more easily. The weeds and rocks in the immediate foreground are also thickly painted; the tube color contains just a touch of medium, but the paint is still thick enough to express the lively texture of the subject. Professionals often paint lighted areas more thickly than shadows: the dark tones of the buildings contain more medium than the light strokes on the roof, which could be painted directly from the tube.

2

COLORS, MEDIUMS, AND VARNISHES

The most dazzling display in any art supply store is the rack of tube colors. There are dozens of delicious-looking tubes, and you feel like a kid in a candy store. But if you looked on a professional artist's palette, you'd be amazed to discover that there are rarely more than a dozen mounds of color. He's probably just as dazzled as you are by the display in the art supply store, but he doesn't yield to the temptation because he knows that it takes very few colors to paint a picture.

After years of painting, most professionals find that they have a few favorite colors that can do practically every job. These are the colors they habitually squeeze onto the palette. Then, in a drawer or an old cigar box, they may have a few extra colors that they pull out for special subjects. After years of trial and error, the professional develops his own basic palette and sticks to it most of the time. One artist's basic palette may not be exactly the same as another's, but there are certain colors which practically every painter uses—and these are the best colors for you to start with. I'll tell you more about these "workhorse" colors and then I'll suggest some alternatives that you might also like to try.

BLUES

For your basic palette it's a good idea to buy colors in pairs, just as you did with brushes. Thus, if you select two blues, one can be warm and the other cool; one can be dull and the other bright. And each will behave quite differently in mixtures. (As you'll see in a moment, this principle works equally well if you buy pairs of reds, pairs of yellows, and pairs of browns.) The two most useful blues for beginning landscape painters are . . .

Phthalocyanine Blue. This is a brilliant, very clear, cool blue that has terrific *tinting* strength —which means that a little of it goes a long way in a mixture. In fact, phthalocyanine blue is apt to dominate any mixture, so add just a little at a time. Phthalocyanine blue makes particularly bright greens when mixed with a bright yellow like cadmium, a rich violet when mixed with alizarin crimson, a beautiful range of grays and gray-browns when mixed with burnt umber or burnt sienna, plus white. Not every color manufacturer uses the chemical name, phthalo-

cyanine blue: Grumbacher calls it Thalo blue; Winsor & Newton calls it Winsor blue.

Ultramarine Blue. Here's a much more restrained, slightly warm blue, with moderate tinting strength, so it's less likely to dominate a mixture. Ultramarine produces subtle greens when mixed with yellows, muted purples when mixed with reds, and very soft grays when mixed with brown and white.

An interesting alternative to phthalocyanine blue is the older *Prussian blue,* which many professionals prefer because it produces particularly deep, rich greens for landscape painting. Like phthalocyanine, Prussian has great tinting strength. And Prussian gives you beautiful grays when mixed with browns and white. It's worthwhile to buy a tube of Prussian, try it, compare it with phthalocyanine, and see which you prefer.

As an alternative to ultramarine, you may want to experiment with *cobalt blue,* which has a delightfully delicate, airy tone that George Cherepov prefers for skies. Although you may still keep ultramarine on your basic palette, you may find cobalt so useful that it becomes your *third* basic blue.

A particularly lovely "special-purpose blue" is *cerulean blue,* which is popular for skies and for delicate, atmospheric green mixtures.

YELLOWS

In selecting your pair of yellows, you can follow the same strategy. Most experienced painters would agree that these two yellows will cover your basic needs . . .

Cadmium Yellow Light. When you shop for yellows, you'll see that cadmium comes in three different variations—light, medium, and dark —but cadmium yellow light is the "truest" yellow, while the others tend more toward orange. It's very bright, warm, and clear, and its powerful tinting strength goes a long way in mixtures. Cadmium yellow light produces a brilliant green when mixed with phthalocyanine blue, a more subdued green when mixed with ultramarine blue, and a glowing orange when mixed with cadmium red. Because of its powerful tinting strength, add just a little cadmium yellow light at a time.

Yellow Ochre. This dull, tannish yellow may not look like much when you squeeze it from the tube, but it's one of the most useful colors on your palette. Because it's a quiet color, not nearly as bright or as warm as cadmium yellow light, and with far less tinting strength, yellow ochre can be added to a wide variety of mixtures. It produces lovely, subtle greens when mixed with both blues—the kind of greens that melt back into the landscape, rather than pop out. Yellow ochre produces subdued oranges and copper tones when mixed with the reds— the tones of an atmospheric autumn landscape —and adds a wonderful warmth to grays. In fact, yellow ochre will warm up almost any mixture without actually taking over. Because of its moderate tinting strength, you can add yellow ochre more freely than you'd add cadmium yellow light.

A third yellow, quite unlike the other two, is *strontium yellow,* which has a cool, rather lemon yellow tone. After you get to know cadmium yellow light and yellow ochre, try strontium. You might want it as a third basic yellow. *Naples yellow* is a special-purpose yellow which has an unusual combination of qualities: it's both sunny and subdued, so it may be just what you want for certain atmospheric effects where you need a rich yellow that "stays in its place"— or for mixtures in which you need a hint of sunny warmth. *Raw sienna* is something like yellow ochre, but darker, earthier, and slightly closer to brown; some painters prefer it to yellow ochre. *Hansa yellow light* is just as bright as cadmium yellow light, but not nearly so dominant in mixtures—which can be an advantage if you're bothered by the terrific tinting strength of cadmium.

REDS

There are two reds that nearly every painter has on his palette. They balance each other so perfectly that you can even mix them.

Cadmium Red Light. Like all the cadmiums, cadmium red light is brilliant, very warm, and dominant in mixtures because of its greater-than-average tinting strength. Because it's so bright, it's hard to use by itself except for an occasional touch—perhaps the focal point of the picture. Mixed with cadmium yellow, it produces a stunning orange; with yellow ochre, you get a much more subdued orange. But cadmium

red light behaves unexpectedly in mixtures with blue: instead of getting the bright violet you might expect, you get various browns and coppery tones—which are more useful in landscape painting than violet would be anyhow. And the brightest red you can get is a mixture of cadmium red light with alizarin crimson!

Alizarin Crimson. This is your cool red, inclining slightly toward violet, more subdued than cadmium red light and with much less tinting strength. A hint of alizarin crimson will warm phthalocyanine blue; somewhat more crimson will produce a rich purple. Alizarin and ultramarine blue will give you much more subdued purple. Mixed with cadmium yellow light, alizarin yields a strong orange; alizarin mixed with yellow ochre produces a much more subdued tone, more like a muted copper.

A third red, which you might want to add to your basic palette, would be one of the powerful red-browns like *Venetian red* or *light red.* They're both rich, coppery colors with great tinting power, and they both produce deep, rich browns in combination with the blues, as well as luminous golden tones when combined with the yellows.

BROWNS

Although you can mix browns by combining any red, yellow, and blue, brown is such an important color that you'll want a pair.

Burnt Umber. This dark, dull, relatively cool brown is uninteresting in itself, which is precisely why it's so useful. You'll rarely use it alone, but burnt umber is enormously versatile in mixtures. With blue or black, plus white, burnt umber will give you a beautiful range of warm and cool grays, so essential in landscape painting. Combined with the yellows and the reds, burnt umber contributes depth and subtlety to all the warm tones in a landscape. Burnt umber has moderate tinting strength and won't dominate a mixture unless you get carried away and add too much. And for some reason, burnt umber will shorten the drying time of any mixture.

Burnt Sienna. Your hot, bright brown ought to be burnt sienna, which has a distinctly orange or coppery tone. Because it has moderate tinting strength and behaves in some unpredictable

ways, burnt sienna can be especially valuable in mixtures. With a strong blue like phthalocyanine or Prussian, burnt sienna gives you a deep, moody green. With ultramarine or black, plus white, burnt umber produces an interesting range of warm and cool grays. Burnt sienna and the various yellows produce golden tones.

A couple of browns should be enough, but I might mention that some painters prefer *raw umber* to burnt umber. Raw umber is even cooler and duller, uninteresting in itself, but so subtle that it produces particularly delicate mixtures.

BLACK AND WHITE

Not every painter has black on his palette, though it's obvious that you can't get along without white. You need white to *lighten* your color mixtures, but black is the worst possible color for *darkening* them. Adding black is the quickest way to turn a mixture to mud. And for powerful, dark notes, you can mix darks that are a lot more interesting than plain black. But black *is* worth having on your palette if you treat it as a *color*—a hue that produces interesting mixtures.

Ivory Black. This is the standard black which practically every professional uses. Don't use it by itself; it's inclined to crack if it's not mixed with some other color. But do combine it with yellows to make fascinating, subdued greens. With browns and blues, plus white, black will give you a particularly broad range of grays. In fact, you can treat black as if it's a member of the "blue family," adding it to any mixture where you might want to use blue—you'll be surprised what interesting mixtures you get. But *never* mix a gray with just black and white; that's the most lifeless gray of all!

Flake White. There are several different whites available in your art supply store and all of them have their virtues. But I'm going to come out flatly in favor of the classic white of the old masters—flake white. This is a variety of white lead, which has a particularly warm, rich tone and dries to a tough, leathery paint film that's more durable than any other white. Since practically every color mixture contains some white, a really permanent white is essential, and flake white is the one that's proven itself over the

centuries. The buttery consistency of flake white has a much juicier feel as you brush it onto the canvas. Partisans of flake white claim that it literally makes painting more fun.

The alternatives to flake white are *zinc white, titanium white,* and various mixtures of zinc and titanium. Both these whites are a bit bluer than flake white, and both are very luminous. But alone or combined, they don't have that buttery consistency under the brush. Of course, some painters actually prefer a cooler, less juicy white, and you may too; if so, buy a titanium-zinc combination.

It's hopeless to try to itemize the characteristics of white in mixtures. White does something different to every color. For example, blues look dark and dull until you add white, so a touch of white is essential to bring out the full richness of most blues. For some reason, reds turn cooler when you add white and lose some of their richness. Like the blues, nearly all dark mixtures need some white to bring out the full richness of the color. To learn just what white will do, it's a good idea to run a series of tests, adding just a touch of white to every color on your palette. You're in for some surprises.

SECONDARY COLORS

You've probably noticed that I've recommended a basic palette of just ten colors: two blues, two yellows, two reds, two browns, black, and white. The blues, yellows, and reds are called *primary* colors, which means two things: all other colors can be mixed from the primaries; but you can't create a primary by mixing other colors.

I've left out the secondary colors—greens, oranges, and violets—because you can create them by mixing primaries. Landscapes are full of greens, but the readymade greens aren't nearly as interesting as the greens you can get by combining blues and yellows, black and yellow, or phthalocyanine blue with a hot brown like burnt sienna. You'll rarely need violet in a landscape, so why buy a readymade violet when you can mix blues and reds? Red and yellow mixtures make a wider range of oranges than you can buy in tubes. So all secondaries are really optional.

Of course, there's no law against experimenting with secondaries once you've mastered the primaries. Phthalocyanine green, which be-

haves something like phthalocyanine blue, is the most brilliant green of all and fun to paint with, though you've got to subdue it so it doesn't pop out of your landscape. Viridian is another bright green which is quieter and easier to handle than phthalocyanine. Chromium oxide green is a deep, subdued green that many landscape painters like. If you *must* have a violet handy—if only in a drawer—two of the brightest are quinacridone and thioindigo violet, while the cobalt violets are more subdued. Cadmium orange is the best of the oranges; cadmium scarlet and vermilion are exciting red-oranges.

PALETTE LAYOUT

There's no one ideal way to lay out the colors on your palette, but it's good to develop the habit of squeezing out the same color at the same spot each time, so you instinctively know where to find it. One simple plan is to run all the cool colors—blues, greens, and black—along the left-hand edge and run the warm colors—reds, oranges, yellows, browns, and so on—along the top edge. Then squeeze out a big dab of white at the corner where the two rows meet. Keep the center of the palette absolutely clear for mixing.

But there's nothing sacred about this arrangement. You may find some other sequence that makes more sense to you. For example, you may want to establish permanent places for the "basic" colors and some special corner for the "optional" colors. Or you may prefer to squeeze out two or three separate dabs of white so that when one pile becomes discolored you'll have a fresh pile waiting. (You'll always use more white than any other color, so be sure to buy it in 8-ounce or 16-ounce tubes.) Palette layouts are all very personal, so it's worthwhile to experiment. But once you arrive at a system you like, be consistent.

PAINTING MEDIUMS

When you squeeze a dab of paint from the tube, what comes out is a blend of powdered color (called pigment) and a vegetable oil called linseed oil. The linseed oil turns the powdered pigment into a paste which you can spread on canvas. And when the oil dries, it functions as a kind of glue to hold the colored granules to the painting surface.

But tube color isn't the ideal consistency for painting. It comes out the consistency of toothpaste and most painters find it too thick. You can add a *thinner* like turpentine, mineral spirits, or what the British call turpentine substitute. This makes the paint more liquid so you can spread it on the canvas more easily; when the turpentine evaporates from the canvas, the paint returns to its original thick consistency.

But most professionals modify the paint consistency with more than turpentine. They either buy or concoct a *painting medium,* which they add to the tube color in order to produce the exact consistency they prefer. Your art supply store will carry various painting mediums, most of which contain three kinds of ingredients: a thinner like one of those I've just mentioned; linseed oil—perhaps a thicker, heat-processed variety to give the paint a more sensuous flow; and some varnish like damar, copal, or mastic, which also helps to make the paint more "brushable" and adds luminosity when the paint dries.

Painters argue constantly about mediums and there's no general agreement about what's best. Everyone experiments with several before he decides what's best for him. Some mediums are thick and some are thin. Some dry quickly and some dry more slowly. I'd start out by trying just two: one thick, heavy-bodied medium, and one that's lighter-bodied and more fluid. Two of the best are Copal Medium Heavy and Copal Medium Light, both formulated by the noted painter Frederic Taubes and manufactured by Permanent Pigments.

When you clip your two palette cups to the edge of your palette, fill one about halfway with painting medium and fill the other with turpentine. You can dip your brush into the medium to thin your color, then dip your brush in the turpentine to make the color even more fluid if you wish. To clean the brush quickly while you're working on location, dip the brush into the turpentine and carefully press the bristles between two folds of a rag. Or wipe the brush on a paper towel.

When you're working at home or in the studio, of course, you can keep a big jar of turpentine nearby and swirl the brush around in the jar. But before you use the brush for painting, wipe off the turpentine on a towel or a scrap of newspaper; otherwise your oil paint will turn as thin as watercolor!

VARNISHES AND VARNISHING

When an oil painting is dry to the touch, which generally takes a couple of weeks, some of the colors may seem duller than they looked when the painting was wet. This is a good time to add a thin layer of retouching varnish, which is a small amount of damar or mastic resin dissolved in a lot of thinner. You can buy retouching varnish in a spray can or in a jar. If you use it from a jar, brush it on with a very soft housepainter's brush, and work with light strokes so you don't dissolve the paint. This will restore the brightness of your color—though not permanently.

After at least six months—some professionals say a year—the paint isn't merely dry to the touch, but *reasonably* dry all the way through (one of the odd things about oil paint is that it takes years to become bone dry). By this time, your colors will probably have "sunk in" again and you're ready for a final varnishing. In the United States, most painters use damar or copal picture varnish, which produces a tough, transparent, protective layer that not only restores the brightness of the paint, but protects the painting from dirty fingers and airborne pollutants. In Britain and on the European continent, mastic picture varnish is more common—as is mastic painting medium.

Although some picture varnishes do come in spray cans, I think it's better to buy a bottle and brush on the varnish with a soft housepainter's brush, which produces a thicker, tougher coat than the spray. If you don't like a picture varnish that dries to a shine, you can buy matte picture varnish, which dries to a satin finish.

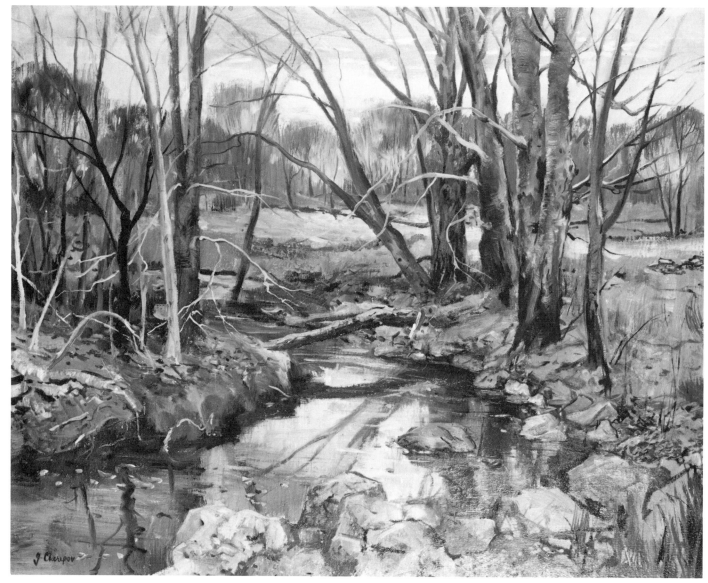

Blind Brook by George Cherepov, oil on canvas, 24″x30″, private collection. A successful landscape is the product of intense observation. Here, the artist has established the position and direction of the light, which is low in the sky, beyond the distant trees, throwing the trees along the horizon into silhouette and emphasizing the silhouettes of the trees in the foreground. Aerial perspective has been carefully rendered: the foreground shows greater detail, darker values, and more obvious contrast than the paler, simpler shapes in the distance. The shape of the brook, irregular at first glance, is painted in linear perspective, narrowing as the shape recedes into the distance. The artist has watched for contour lines that establish the shapes of the land and water: tree shadows move across the distant meadow, tilting slightly to suggest that the land isn't absolutely flat; lines of shadow and fallen leaves establish the curves of the nearby banks; and the reflection of the fallen log, a dark line moving across the center of the stream, establishes the flatness of the water. Each treetrunk and rock has its own distinctive shape and there are at least three separate varieties of trees, each painted with careful attention to its unique character.

3
OBSERVING NATURE

Learning to paint means learning to look. In this chapter, I'm going to make some suggestions about what to look *for*.

CHOOSING YOUR SUBJECT

The first thing you're going to look for, of course, is a subject to paint. Whether you're simply carrying a sketchpad to record "field notes"—which will become paintings when you get back home—or you're carrying a fully equipped paintbox for painting on location, your first job is to find a subject that inspires you. This can be as easy or as difficult a task as *you* make it.

Beginners can waste hours traipsing across the landscape, looking for that perfect grove of trees or that picturesque old barn. By the time they find it—if they ever do—they're often so tired that they're in no mood to paint. They make a few sketches and go home, or they make a halfhearted attempt to paint, do their best, but find that the mood is gone.

Professionals, on the other hand, have learned that practically *anything* can be turned into a successful painting. Instead of plodding across fields and climbing rocks for hours, the professional sets up his easel in front of the first subject that gives him an *idea* for a painting. He doesn't look for the perfect grove of trees, because he knows he won't find it. What he looks for, instead, is a cluster of trees that can be *made* into a picture.

He settles for a subject that's more-or-less right because he knows he can move those trees around and make some taller and some shorter; move that rock formation a bit farther forward; play up some colors and play down others; and leave out anything that gets in the way.

Professionals also know that just about *any* subject can make a good picture under the right light or weather conditions. A subject that looks routine at midday can take on extraordinary drama early in the morning, when the sun is just above the horizon and the light is *behind* the subject, throwing trees and hills into dramatic silhouette. A rock formation that looks hopelessly confusing in bright sunlight can be transformed by a light snowfall; the snow-covered top planes and the shadowy side planes of the rocks suddenly form a fascinating abstract pattern. And haze or mist can lend an air of

mystery to the most pedestrian kind of landscape. So professionals often look not at the subject itself, but at weather conditions and light conditions at various times of day.

Give up looking for the ideal subject. Nature rarely gives you readymade pictures. Instead, search the landscape for *ideas* for subjects: a group of shapes or a fleeting light effect that makes you want to *create* a picture out of nature's raw material.

OBSERVING LIGHT AND SHADOW

Many professionals will tell you that when they go on a painting expedition, the first thing they actually look for is the right light effect. It's not enough to discover a subject that rings the bell; the magic of that subject is inseparable from the direction of the light, the pattern of light and shadow, and the color of the light.

The time of day is critical to most landscape painters. They generally agree that midday light is least flattering; because the sun is directly overhead, each shape in the landscape seems to sit directly on top of its own pool of shadow. Many landscape painters prefer the light of early morning or late afternoon, when the light is behind the subject or comes from the side. It casts longer shadows that move *across* the landscape, creating more interesting patterns than midday light. And as I mentioned a moment ago, the light of very early morning or very late afternoon can be *particularly* dramatic because the sun is low in the sky; with the light behind them, the shapes of the landscape appear in silhouette with slight touches of luminosity around the edges.

It's also important to watch the *direction* of the light. After all, both you and the sun are moving. The sun is like a giant floodlight that keeps changing its position in the sky as the day goes on. And each time you turn, walk a few steps, climb up or down hill, your own relationship to that floodlight changes too. So, depending upon the time of day and upon where you choose to stand, you can have the light coming from right or left, from behind you or in front of you, and so on.

Obviously, you can't move the light around to suit you as a photographer does in his studio, but you do have *some* control over light direction. Walk around until you see the light effect that suits you. You may want to see more of

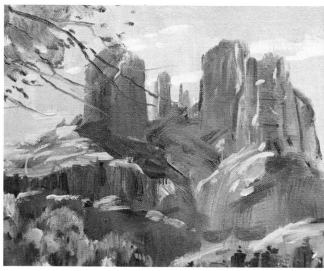

The complex shapes of these Western rock formations become much simpler to paint if you have a clear idea of the direction of the light. The light is obviously behind the rocky shapes, somewhat above and to the left. Thus, the forms are thrown into shadowy silhouette, with touches of light along their tops and along their left-hand edges. This kind of back lighting is particularly effective when you're painting mountains and other strong shapes that you want to dramatize.

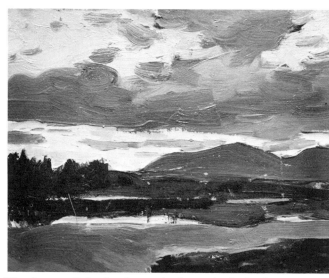

The forms of the landscape look particularly dramatic when the light is low in the sky. From dawn until mid-morning and from mid-afternoon until sunset, the light emphasizes silhouettes like the dark shapes of the mountains and trees along the horizon, as well as the dark, backlit clouds.

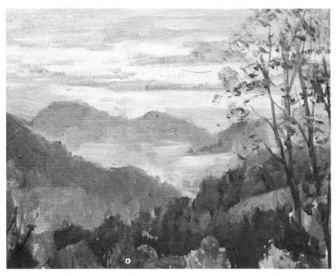

This section of a much larger painting shows how the landscape can be visualized as four distinct values that correspond to different spatial divisions. The darkest values are in the foreground plane. A middletone is in the middleground and an even lighter middletone appears at the horizon. The lightest tones are reserved for the sky and for the sky color reflected in the water. Some touches of middletone also appear in the sky.

A closeup of a similar section from another large painting is also divided into value planes. But here a light value is in the immediate foreground and the darkest value is in the middleground. A middletone appears at the horizon. The lightest tone and the middletone both appear in the sky. The brightly lit foreground trees are in the same light value as the immediate foreground. None of these tonal areas is entirely consistent, which would be monotonous. Note how both the darks and the lights contain many touches of the middletone.

the shadow side and less of the lighted side of your subject, for example, and this may mean, shifting your position so that the sun seems to be coming more from the right or left. You can also turn or stroll until the shadows seem to be moving in the right direction for your pictorial design. And even if the sun isn't *exactly* where you want it, you can move it in your picture.

You should also develop the habit of watching the *color* of the light. Natural light isn't the pure controlled light of the photographic studio; the light changes dramatically at different times of day and in different kinds of weather. We all know the ruddy light of dawn and sunset— which can literally make a green tree turn gold —but there are times when the light on the landscape might be any color in the rainbow: yellow, orange, red, violet, blue, even green. Don't simply assume that light is white; on the contrary, determine the color of the light before you start to mix your colors and you'll add new vitality to your landscape painting.

Just as light isn't white, shadows aren't merely gray or black. Shadows contain light and therefore contain color. There are no "rules." Some shadows take on the color of whatever they fall on: a shadow on green grass may just be a darker green. But a shadow may also pick up light reflected from somewhere else: the color of the water, for example, often appears in the shadows on nearby rocks.

OBSERVING VALUES

Although landscape painters are fascinated by color, you can't paint a successful landscape without developing an eye for values. This means cultivating the ability to look at your subject as if you were a camera loaded with black-and-white film, which records every color as a shade of gray, black, or white. You've got to learn to see your picture as an arrangement of darks, middletones, and lights, at the same time as you're seeing the colors.

The simplest way to do this is to visualize the landscape before you in just three or four values. What's the darkest area in the picture, and where else do these darks occur? What's the lightest area, and where else do these lights occur? Can the rest of the picture be reduced to one or two middletones, somewhere between the two extremes of dark and light?

Having located these three or four values, you can use this information when you start to mix your colors. Each color you mix will be either a dark, a light, or a middletone. This may mean lightening or darkening some colors to make them conform to the "value scheme" of your picture, but you'll be amazed how this method will unify your painting and create a convincing sense of space.

The three-or-four-value method works for a surprisingly simple reason. A landscape usually can be divided into so-called planes: foreground, middleground, and background. Let's say you're painting a rocky landscape. You may find that the foreground rock formations are in shadow and are the darkest element in the landscape; that the sun is shining brightly on the rocks in the middle distance, making them the lightest element in your picture; and that the distant mountains are neither as dark as the foreground rocks nor as bright as the sunstruck rocks, but form a kind of middletone between the two extremes. But on a slightly overcast day, with no sun to spotlight any particular part of the landscape, you may get a simple progression from dark foreground rocks to somewhat paler middleground to still paler mountains in the distance. Either way, you've got three values, with the sky constituting a fourth.

Even if the landscape doesn't divide up quite so neatly, it's a good idea to *visualize* it this way. You can decide to *see* your picture in three or four planes and mix your colors accordingly. However, you don't have to be absolutely rigid about keeping all your darks in one plane, all your lights in another plane, and all your middletones together too. Once you've established these three or four planes of different values, you can then strike in those few contrasting notes that bring a painting to life—like dark rocks scattered across a field of snow or sunlit patches of sky breaking through shadowy woods.

Of course, not all pictures contain a complete range from deep darks to middletones to bright lights. On the contrary, landscape painting would be terribly boring if everything conformed to such a formula. Professionals often talk of a picture painted in a high key or a low key. A high-key subject is *predominantly light,* like a landscape dominated by snow or haze. A low-key subject is *predominantly dark,* like shadowy woods or a landscape at dusk. And there are lots of gradations in between.

Whether your key is high, low, or something in between, the three-or-four-value system still works. It's still possible to establish darks, middletones, and lights, and visualize your landscape in the form of planes. But if you decide that a subject is high key, all your tones are apt to be fairly light, even your darks: the darkest treetrunk looks pale on a misty day. At the other extreme, all your tones will be fairly dark in a low-key landscape, even your lights: after all, snow looks dark at night.

The main purpose of establishing the key of your landscape is to achieve a kind of tonal consistency. If you remember the predominant key of the picture as you mix your colors, you won't mix anything that's too dark or too light, therefore disrupting the unity of the painting.

OBSERVING COLOR

Beginning painters too often paint the colors they *expect* to see, rather than the colors that are actually there. They're always painting treetrunks brown or gray, ignoring all the extraordinary greens, blues, violets, reds, and yellows that actually occur—if they'd only look! So the first thing to do is chuck out all your preconceptions about what colors things are *supposed* to be. Try to look at each subject as if you'd never seen it before, then ask yourself these four questions:

1. *What hue is it?* Hue simply means color. You've got to see the color that's really there. You may know that a certain kind of tree has deep green leaves, but you've got to put that knowledge aside and see that the brilliant sunlight is turning the leaves yellow-green. You may think you know that snow is white, but the rays of the late afternoon sun may turn snow pink or violet. Learn to turn off your memories of trees and snow and paint what you *see*.

2. *What's the value?* I've already explained the importance of seeing the entire landscape as if it were a black-and-white photograph. But now you've got to learn to see *each color* in terms of value too. How dark or light is the color that you see before you? Once again, you've got to chuck your preconceptions about how things are *supposed* to look. You may imagine that water is pale and limpid, but a

pool of water in deep woods can turn out to be as dark as a treetrunk. Almost every beginner paints clouds and snow dead white; but a black-and-white photograph would actually record these "white" subjects in tones of pale gray, with just a touch of white here and there. People usually err in the opposite direction when they paint the shadow sides of rocks and trees too dark; shadows are often full of reflected light.

3. *How intense is the color?* Intensity is another word for brightness. Because we all like rich colors, beginners often paint things brighter than they actually look. Is that tree really as bright as the green you're mixing on your palette? Is the sky really that blue? If you look carefully at nature, you'll see that very few colors actually pop out at you. On the contrary, nature's colors tend to hold their place in space; they don't shout at you. Most trees are a fairly soft green, and skies are usually a more delicate blue than you'd expect. Even the hot, dazzling colors of autumn are more restrained than most beginners paint them.

4. *What's the color temperature?* When painters speak of color temperature, they're actually talking about two different phenomena. First of all, there are cool colors and warm colors: blues and greens are usually considered cool; yellows, oranges, reds, and violets are usually considered warm. But the second point is more complicated: some cool colors are warmer than others, while some warm colors are cooler than others. So, when you look at a sunny sky, it's not enough to decide, "Oh, that's blue—so it must be cool." You've got to look closely and see if that supposedly cool blue doesn't actually contain a warm hint of pink or violet. A field of golden yellow flowers can be just as tricky: if that yellow tends toward orange, it's obviously a warmer yellow than if the tone contains a hint of green. Every color in nature—like every color on your palette—can lean toward the warm or the cool side.

Naturally, these four "color phenomena" all happen at the same time. But you've got to train yourself to observe them *separately,* then put them all together when you mix a color on your palette. You've got to look at that red barn and say: "It's red, but it's not nearly as hot a red as that other barn we just passed down the road. In fact, it's got a faint hint of violet. It's

also a bit paler than that other barn, and not nearly as bright." When you look at that lush, green meadow, learn to say to yourself: "There are actually some shadowy parts which are darker and really blue-green, while the sunlit parts are lighter and more like yellow-green. And come to think of it, the yellow-green parts are a lot more intense."

AERIAL PERSPECTIVE

Color is inseparable from aerial perspective. And aerial perspective is your most important means of establishing a sense of space and atmosphere in a landscape painting. On a clear day, with the light evenly distributed across the landscape, here's what you're likely to see if your eye travels from the foreground to the middle distance to the remote horizon:

1. *Things grow lighter in value as they recede.* The components of the landscape that are nearest you look darkest. Things in the middle distance seem somewhat lighter. Objects at the horizon seem lightest of all. In other words, your three basic values—dark, middletone, light—seem to correspond to the three planes of the landscape.

2. *The landscape grows cooler as it recedes.* You've probably noticed that distant mountains always look bluer than the stones at your feet, even though the mountains may be made of exactly the same kind of rock. The nearby stones may be a warm gray, but they become a cooler gray in the middle distance and positively blue at the horizon.

3. *Intensity also decreases with distance.* If you're standing on a hilltop overlooking rolling farm country, you'll see that the nearest red barn looks a lot brighter than the barns in the distance. Green meadows and fields of golden grain also grow dimmer as your eye moves toward the horizon.

4. *Contrast decreases with distance.* Going back to that rocky landscape once again—since it's a particularly good example—you'll see a strong contrast between the lighted tops of the rocks and the shadowy sides of the rocks in the immediate foreground. But when your eye travels to similar rocks in the middle distance, the lighted tops won't look nearly so bright, and the shadowy sides won't look so dark. The

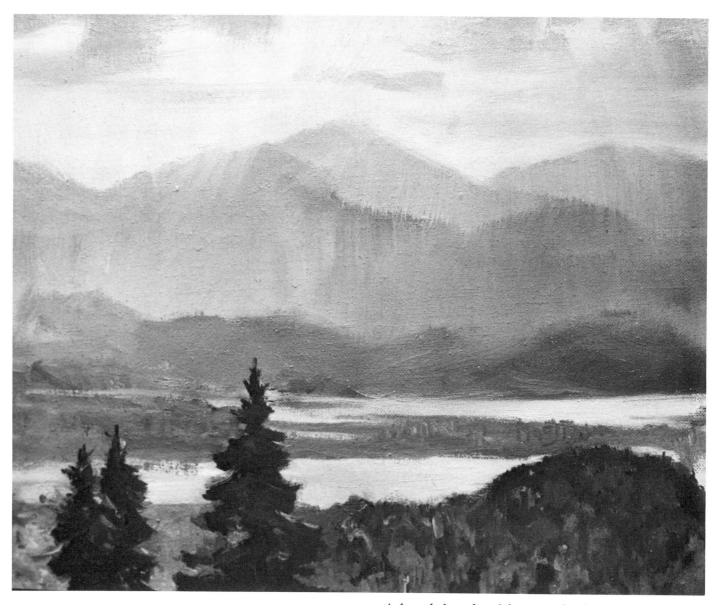

A knowledge of aerial perspective is essential to the landscape painter. As you see here, the immediate foreground tends to be darker, more contrasty, and more clearly defined than the more distant areas. As the eye moves back into the picture, forms grow paler, simpler, less detailed, and less clearly defined. As the distant mountains divide into three distinct planes, each plane is paler and less sharply defined than the preceding plane.

mountains along the horizon—which are just big rocks, after all—will seem to have very pale shadows which hardly contrast with the lighted areas. The same is true of color contrasts: the contrast of the red barn and the green field doesn't look nearly as dramatic in the distance as it looks close up.

5. *Detail diminishes as things recede.* Close up, we can see every crack in the rock and every leaf on the tree, but we can see only a few cracks and only a few leaves in the middle distance. And as the eye moves toward the horizon, all we can see are the overall *shapes*.

I hasten to add that these are guidelines, not rules. You can exploit them, but you can also ignore them if you've got a good reason. Besides, they're not always true.

There are times when the sun acts like a searchlight, picking out certain parts of the landscape in the middle distance or even at the horizon. So it's perfectly possible for the brightest colors, the strongest contrasts, and even the most significant details to appear in some unexpected portion of your picture. In his rare landscapes, Rembrandt liked to spotlight some distant clump of trees. Turner would often focus a shaft of light on some distant peak or headland. And many great painters have used cloud shadows to darken some unexpected portion of the landscape. All these phenomena occur in nature and are fascinating precisely because they don't quite conform to what we expect of aerial perspective.

However, most of the time aerial perspective works. In fact, many painters actually *create* aerial perspective even when the landscape doesn't cooperate. A painting often gains an illusion of greater realism if you paint a few sharp-focus details, exaggerate your colors or contrasts, and darken your values in the foreground or where the foreground merges into the middle distance. The illusion may be even more convincing if you purposely leave out a lot of detail, reduce your contrasts, and play down your colors as you move farther away into the middle distance—painting the horizon with radical simplification.

LINEAR PERSPECTIVE

For landscape painting, it pays to know something about linear perspective, though it's far less useful than aerial perspective. Practically every landscape contains some effects of aerial perspective, since it's hard to find a painting that doesn't contain a foreground, middleground, and background. But linear perspective is useful mainly for landscape elements—like roads, streams, and buildings—that have lines that move away from you toward the horizon.

The basic principle of linear perspective is that parallel lines, as they move away from you toward the horizon, seem to converge at some *vanishing point* on that horizon. We've all seen photographs or diagrams of railroad tracks whose rails are far apart in the foreground and meet at the horizon. Linear perspective teaches us to see the walls and rooftops of houses, the rails of wooden fences, and the edges of roads as if they were like those railroad tracks.

This is fairly easy to do when you're dealing with something geometric like a house or a wooden fence. First locate the horizon in your subject, then draw it across your canvas as a simple horizontal line. If you're standing high on a hill, looking down at your subject, the horizon line will probably be high up on your canvas and most objects in the landscape will be below the horizon line. Conversely, if you're looking up at your subject, the horizon line will probably be fairly low on the canvas, and most objects in the landscape will be above the horizon line.

Next, try to find the parallel lines that seem to be slanting off toward the horizon. These lines are likely to be the peak of a roof, the foundation line of a wall, the top and bottom edges of windows. All these parallel lines will seem to be converging toward an invisible vanishing point on the horizon. Try to establish where that vanishing point is, even if it's off your canvas to the right or left. Then draw the lines as if they were railroad tracks leading to that vanishing point. If the house (or fence or road) is below the horizon, all the parallel lines will seem to lead upward to the vanishing point. If they're above the horizon, the lines will seem to lead downward to the vanishing point.

If you have trouble visualizing the lines and where they're going, it's not a bad idea to carry a pocket ruler which you can hold up in front of your eye and line up with the edges of the house or fence. You can then make a better guess about where the lines are leading and

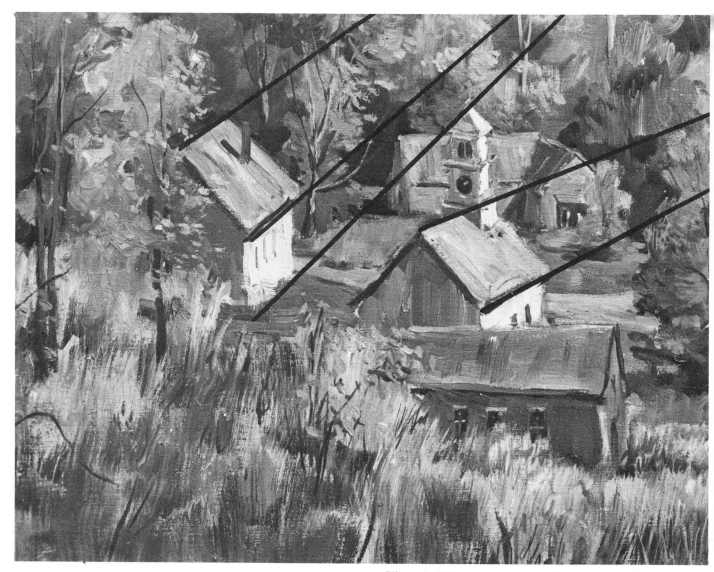

These buildings occupy a small corner of a large landscape, but the painter pays careful attention to linear perspective. Notice how the parallel lines of rooftops and walls converge toward unseen vanishing points on a distant, unseen horizon. Because the buildings aren't exactly parallel to one another —as they might be on a city street—each building has its own separate vanishing point. The edges of the walls and the rooftops are roughly painted and a bit irregular, not mathematically perfect like an architectural rendering. Nor does the perspective have to be absolutely perfect, but it ought to be accurate enough to be convincing.

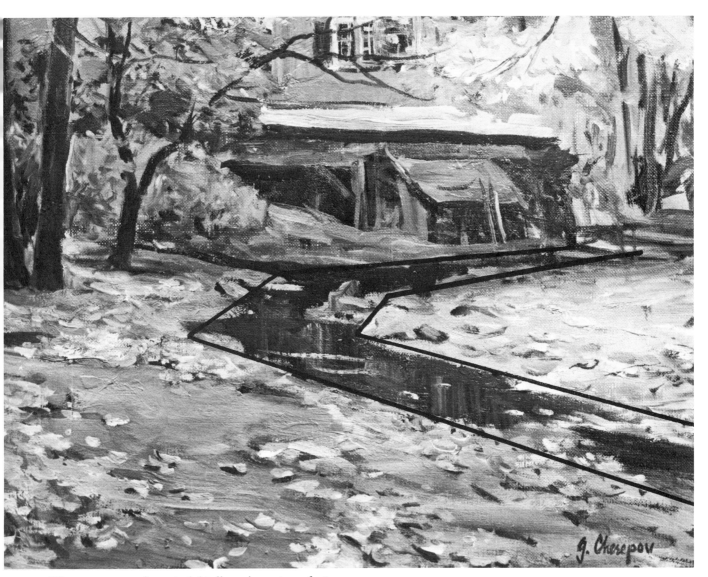

There are very few straight lines in nature, but you'll find lots of shapes that need to be painted in reasonably accurate perspective. As the shadowy stream recedes into the background, the shape does conform to the laws of linear perspective, more or less. The banks aren't exactly parallel, of course, but they do tend to narrow and converge as the stream moves into the distance. Even though you may not draw these perspective lines on your canvas, it's a good idea to keep them in your head as you paint the wandering shape of a stream, a country road, a path in the woods or across a meadow.

where the vanishing point might be. There's nothing wrong with making a guess, as long as it looks reasonably right. After all, you're not doing an architectural rendering, but a free-hand painting.

But how often do you paint a landscape that contains architecture or a fence or a highway? Not often. However, a knowledge of linear perspective also helps when you're painting a wandering shape like a country road, a stream, or even a cloud formation. Although streams and roads tend to zigzag, you can treat each "zig" and each "zag" as a segment of that imaginary railroad track. You can start out by drawing each segment as a pair of parallel lines leading to a vanishing point—which means that each stream or road might have several vanishing points on the horizon—then soften the edges and make the shape more irregular when you get the perspective more or less right. You don't have to draw perspective lines when you're painting a cloud formation, but it's helpful to remember the basic principle of linear perspective: the nearest clouds, farthest up from the horizon, are biggest; the more distant clouds, as they move closer to the horizon, grow progressively smaller.

OBSERVING CONTOUR LINES

Perspective lines may be imaginary, but contour lines are very real. All around you, lines are moving back and forth across the landscape, telling you about the shapes of things. They tell you when objects are flat, rounded, squarish, regular or irregular. But you may not notice them because you don't think of them as lines at all.

Cast shadows are the most typical contour lines. When a treetrunk casts a shadow, the shadow traces a contour line across the landscape: if the landscape is flat, the shadow line will move horizontally; but if the landscape curves upward or downward, the shadow line will follow the upward or downward pitch of the form. Be sure to watch the direction of cast shadows and use them to create a three-dimensional feeling in what otherwise might seem like flat, lifeless land.

Geologists tell us that the landscape is something like a piece of cracked, folded, crumpled paper. If you watch for those cracks and creases, your landscape paintings will look

A snowy landscape may look flat at first, but the drifting snow actually creates a wavy, irregular surface. The most effective way to suggest this surface—and to relieve the monotony of all that snow—is to look at cast shadows very carefully and use them as contour lines. Notice how the artist paints long, slender, wandering strokes for the shadows, suggesting that the landscape dips here, turns upward there.

This detail of a snowy slope is a particularly dramatic example of the way in which cast shadows can function as contour lines. Two strong, diagonal patches of shadow—one in the foreground and one just beyond—cut downward from left to right and give the landscape a strong tilt. The downward slope is accentuated by the strip of light between the two bands of shadow. Notice how the foreground shadow curves in the center to suggest a bulge, then moves downhill again.

much more real. For example, if you're trying to paint a rock formation so it looks really solid, trace the course of the major cracks that wander over the face of the rock. Look for the ravines and gullies that trace the shapes of hills and fields in the same way that cracks reveal the shape of a rock.

The most obvious contour lines are man-made, of course, like footpaths, wood and stone fences, and roads that wind across the land-scape, moving up and down with the shape of the terrain. But nature creates similar effects: the wind blows the autumn leaves, leaving them in trails that can also function as almost invis-ible contour lines; the sea will leave trails of debris on a beach, often forming very clearly defined contour lines. And watch the direction of snowdrifts or the subtle contour lines caused by the wind when it blows across the water or bends the tall weeds in a meadow.

Don't forget that you're free to *invent* any-thing that your picture needs. There's nothing wrong with creating contour lines if you can't find the right ones. Add a few cracks to that rock; exaggerate the shadow cast by that big tree in the foreground; design those fallen leaves so they drift rhythmically across the landscape.

LOOKING FOR DISTINCTIVE SHAPES

Just as you have to put aside your preconcep-tions about colors—not all trees are bright green and not all treetrunks are gray—you have to look at shapes as if you've never seen them before. There's no such thing as a typical tree, a typical cloud, or a typical rock. They're all different. Each has its own unique shape and personality.

A tree isn't an amorphous mass of green leaves stuck on top of a cylindrical trunk like so much cotton candy on a stick. The mass of a tree has a distinctive shape which you may be able to see more clearly if you squint slightly and throw the individual leaves out of focus. As you gain experience in landscape painting, you begin to see that each variety of tree has a char-acteristic shape, just as it has a characteristic color. Get to know these shapes—memorize them if you can—so you know when you're painting an elm, an oak, or a birch. But once you learn to recognize these shapes, don't as-sume that all elms, oaks, or birches look alike; trees, like people, are all unique and you've got

to study the shape of the *particular* tree you're painting or drawing that day.

Resist the temptation to paint a cloud as if it were a balloon or a puff of smoke. If you look at clouds carefully, you'll see that they have shapes that are just as distinctive as trees. There are big, puffy clouds; slender, streaky clouds; clouds that form long, horizontal layers, one above the other; clouds that are broken into short wisps; clouds shaped like an anvil—they're actually called anvil clouds; and the familiar mackerel sky, which actually looks like rows of fishscales. All these clouds have technical names assigned by meteorologists, but the names aren't important. However, it *is* im-portant to learn to identify these different kinds of clouds and define their shapes and patterns clearly when you paint them.

Don't assume that rocks all look like shoe-boxes or hardboiled eggs. Once you look at rocks carefully, you don't have to be a geologist to see that some rocks are rounded and others are blocky; some rocks form strata like a gigan-tic broken layer cake; some rocks have flowing, rhythmic forms that look like solidified lava, which is probably what they are; some are smooth and some are jagged—well, you get the idea. Rocks, like trees and clouds, have a dis-tinct personality that goes with the terrain in which you find them. You've got to look at their shapes carefully to paint them convincingly and make them look like they *belong* in your land-scape.

Because trees, clouds, and rocks stand out above the landscape, their shapes are easy to recognize once you're used to looking for them. But, in reality, *everything* in a landscape has a distinctive shape or pattern of shapes. A patch of wildflowers in a field has an overall shape if you look at the wildflowers as a group. A stream may have a meandering, snakelike shape, or perhaps a jagged, hard shape as it zigzags back into the picture.

And don't overlook the shapes *between* the shapes in your landscape: when you're painting a group of trees, don't just look at the shapes of the trees themselves, but at the shapes of the spaces between the trees—what painters call negative shapes. Watching for shapes—positive *and* negative—and recording them faithfully is one important key to painting a landscape so that it looks like you've really been there.

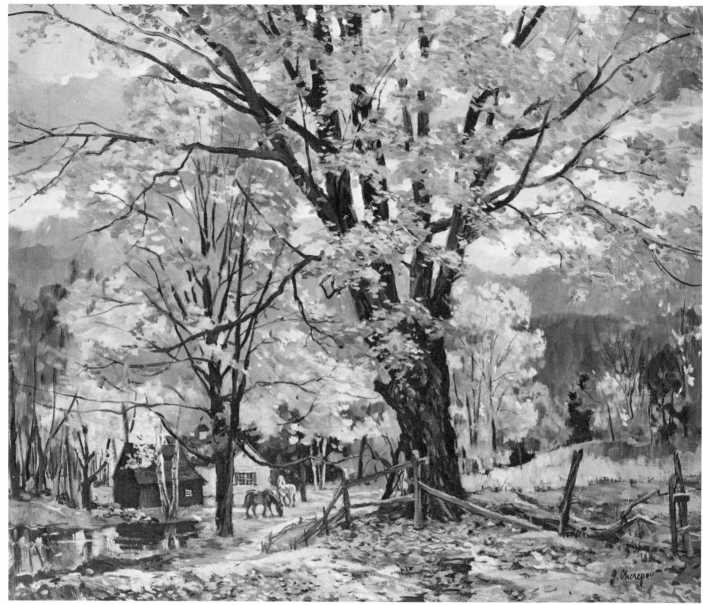

Evening in Halifax, Vermont by George Cherepov, oil on canvas, 30"x36", courtesy Grand Central Art Galleries, New York. An important compositional rule-of-thumb is to place the focal point of the picture slightly off-center. Here, the center of interest is the gigantic tree, which the artist places slightly to the right of the midpoint of the canvas. Thus, the tree divides the canvas vertically into two unequal areas and avoids spatial monotony. For the same reasons, the artist places the horizon line well below the center. To lead the viewer's eye to the focal point, the artist uses the broken fence that wanders in from the right, the light patch of ground that moves in from the left, and the leaves that trail across the foreground and pile up against the base of the tree. The two small buildings and the tiny figures of the horses lend an important sense of scale: they make the old tree look that much bigger. So does the smaller tree to the left, which balances and echoes the big tree that dominates the picture. The large tree is also dramatized by placing the dark trunk against a pale tree mass in the distance.

4

PLANNING THE PICTURE

Having selected a promising subject, you're ready to plan your picture. But you don't just dive in and paint. First, you have to visualize the picture in your mind's eye. You have to visualize the color scheme, composition, and lighting. You must decide what you're going to put in and what you're going to leave out. And if you're planning to paint the final picture in your home or studio—rather than working on the spot—it's important to make the right kind of sketches so you'll have all the information you need.

KEEP IT SIMPLE

Winslow Homer once said that you need only two waves to make a successful seascape. His advice applies just as well to landscape painting. Nature always provides infinitely more material than you can use in one picture, so it's important to leave out more than you put in.

Don't try to paint the entire forest or the entire grove of trees; a few clumps of trees will do, and it's usually a good idea to make one or two trees your focal point. Even if you're deep in the woods, painting one of those dense forest interiors that so many landscape painters love, it's best to focus on just a few tree trunks and let the rest of the forest melt away into the shadows.

The sky may be full of clouds, but two or three big cloud shapes are enough to tell the story. Don't paint cloud after cloud, so the sky seems filled with a herd of white, fluffy sheep. Study the shapes of the clouds and pick the shapes that look best. Just paint those and leave out the others—or merge all those little clouds into a few big ones.

Nothing is more majestic than row upon row of mountains, one behind the other, but two or three rows are enough for a picture. If you paint them in proper aerial perspective, each row paler and bluer than the row in front, you'll create that awesome sense of deep space with just a few mountains.

A rocky landscape usually gives you more rocks than you can possibly use. Pick a few big rocks and focus on these. Or try to find one or two really dramatic rock formations and leave out the others.

Many of the world's greatest landscape painters spent years living in just one place, walking out each morning to paint the same scenery and

never wandering more than a few miles from home. But they never ran out of subject matter because they always painted just a bit of what they saw. They knew that each tree and each rock has its own unique shape, color, and personality; each clump of trees and each rock formation can be the starting point for a new picture. And like Monet, who painted the same two or three haystacks again and again at different times of day, the masters of landscape painting knew that the same tree or rock becomes a totally different subject when the light changes.

DON'T BE AFRAID TO REORGANIZE

Simplification goes hand in hand with reorganization. Just as you're free to leave things out, you're equally free to move things around, enlarge or reduce them, and generally redesign the raw material that nature gives you.

The components of a landscape are usually scattered, so don't be afraid to group things or move them closer together. If you've got too many trees of different shapes and sizes, try rearranging them so they form one or two large clumps with their foliage merging into one large shape and one or two smaller shapes. You can do the same thing with scattered rocks: move the big ones around into clusters or assemble them into a rock formation. If it's just rained and you're fascinated by all those shining pools scattered about like bits of broken glass, merge them into just a few bigger pools. And as I said before, blend all those little clouds into a few big ones.

When you're trying to make a satisfying composition out of scattered shapes, it also helps to exaggerate. Your picture needs both large and small shapes for variety. And a few shapes—usually the biggest ones—ought to dominate the picture, so you'll have a center of interest. Don't be shy about making certain trees, rocks, clouds, and bodies of water a lot bigger than they actually appear in nature. And feel just as free to make other things smaller, so they won't compete with the big, dominant shapes.

The sculptors of ancient Greece had an idea which is worth trying in landscape painting. They knew that they could never find one model who was perfect, head to toe, so they'd use one model for the legs, another model for the torso, still another for the arms, and perhaps someone else for the head—until they'd put to-

gether a god or goddess like a magnificent jigsaw puzzle. In the same way, you may find that you like the trunk of one tree, but prefer the big, leafy shape of another. There's nothing wrong with assembling two trees into one, provided that they're both the same variety of tree. Don't try putting oak leaves on a birch!

You're also free to redesign the color scheme of your landscape. But more about this in a moment.

USING A VIEWFINDER

In order to zero in on one particular segment of the vast natural landscape, many painters like to use a viewfinder. This is just a rectangle of cardboard with a rectangular window cut into the center. You hold the viewfinder up before your eye and use the window to "frame" various segments of the landscape until you find the composition you're looking for. The landscape in the window won't be perfect, but you'll have a specific idea to work with. Now put the viewfinder away, remember the outer limits of the picture you saw through it, and start organizing the components of the landscape into a painting.

The overall size of the viewfinder and the exact size of the window are a matter of preference. If the window is too small, you've got to hold the viewfinder too close to your eye in order to take in enough of the landscape. Conversely, if the window is too big, you've got to hold the viewfinder at arm's length so it *doesn't* take in too much of the landscape. I think a good window size is 4½″ x 6″ cut into a sturdy piece of cardboard that's roughly 8″ x 10″. This window size is just big enough so you don't have to hold the viewfinder too close. Equally important, the window size is in the same proportion as the 12″ x 16″ canvas board that fits into your paintbox. Paint the viewfinder gray or black so it will contrast sharply with the scene in the window.

PICK THE RIGHT TIME AND PLACE

In the previous chapter, *Observing Nature*, I pointed out that a great deal depends upon the time of day and where you choose to stand when you're painting. It's important to think ahead about both these factors.

It's a good "rule" to get going early in the morning so you have plenty of time to observe

the light before you start to paint. I pointed out in the previous chapter that most landscape subjects look best when the light is behind them or coming from one side, so you're apt to find the most flattering light between dawn and mid-morning. The short, dense shadows of midday are hardest to handle.

Another advantage of starting at dawn—like a dedicated fisherman—is that you have plenty of time to find the right vantage point to set up your easel. Do you want to include lots of landscape and very little sky? If so, you'll need time to climb to the top of a hill or headland so you can look *down* at your subject. Do you want to paint a picture with a low horizon, showing only a bit of landscape and lots of sky? Then you've got to search for a low, flat patch of land that allows you to look *up* at your subject.

What color do you want the light to be? Do you want the cool, bluish light of dawn, just before the warm rays of the sun come up? Do you want the pinks, reds, and oranges of the sunrise? In either case, you'd better be out there with your paintbox *before* dawn. Do you want the mildly warm but not blinding light of mid-morning? Then you've got time for an early breakfast; but do get going before the sun is high in the sky. Do you want the brilliant white light of midday, so you can try to paint the high contrasts of light and shade at noon? Then you can sleep a little later still; but get out there by mid-morning. As you can see, the whole trick is to get out, ready to paint, at least an hour *before* the light turns the color you want to paint. Select your subject; compose it in your head and sketch it out on your canvas; have your colors laid out on your palette; and allow yourself plenty of time to study the light before you make that first brushstroke.

PLAN YOUR COLOR SCHEME

You'll soon discover that the sun doesn't stand still. The direction of the light, and its color, keep changing from moment to moment. In an hour or two, you'll be looking at a different landscape from the one you saw when you started to paint.

With experience, you *may* learn to work fast enough to catch these fleeting effects of light and color with the fewest possible strokes, before they vanish completely. But surprisingly few painters—even professionals—can really work that fast. The sun moves faster than most people can paint and a specific light effect may be gone in an hour or two; but it can easily take you all morning, perhaps all day, to paint a picture on location. If you're working at home from sketches, you may want to work on the picture for weeks. So how do the professionals do it?

The secret isn't to *observe* a color scheme and then try to record it at top speed, but to look carefully and then *plan* a color scheme which you'll remember long after the light has changed. Let's look at the toughest subject of all: a sunrise or a sunset. With the sun coming up or going down like a rocket, those dramatic color effects are gone in half an hour, usually less. The painter can't possibly mix and paint all those colors before the light changes. So he's got to study them intently, fix the color scheme in his mind, and be prepared to continue painting for hours after the colors are no longer there. But he can neither record nor remember every possible nuance of color, so he comes up with a *simplified* version of those colors—a color scheme which he *creates* out of nature's raw material, just as he creates a pictorial design by simplifying and reorganizing the scattered components of the landscape.

A sunrise or a sunset usually contains so many different nuances that you can neither paint them on the spot nor remember them afterwards. Besides, *too many* colors are just as bad as too many trees: you've got to leave some of them out. So the experienced painter says to himself: "I'm going to simplify all those hot colors to just two shades of red—a couple of streaks of bright crimson and one streak of pale pink. Yes, there are some wisps of orange, but I'll keep just one orange streak for a change of pace. Actually, those low-lying clouds are several different shades of blue, violet, and gray, but I'll mix just two compromise tones which should do the job—one blue-violet and one violet-gray." With just five colors to remember, the painter can mix them quickly, block them in with a few strokes, then refine and adjust these colors hours later or even days later.

Of course, not every landscape subject changes as rapidly as a sunrise or a sunset, but *every* outdoor subject is in a state of constant change. As the sun moves, not only does the color of the light change, but the pattern of

light and shadow changes too. Shadows shrink as lighted areas enlarge; conversely, lighted areas shrink as shadows enlarge; and colors change as more or less light falls on them. In a few hours, a sunny sky can turn overcast; just as quickly, an overcast day can turn sunny. Clouds come and go. Snow melts as you paint it. So, whatever you're painting, establish a simple color scheme and stick with it.

But remember that nature doesn't give you readymade color schemes any more than it gives you a readymade pictorial design. Nature simply gives you the raw material for a color scheme that *you* create. You begin by observing the colors of nature, but then you *organize* these into a satisfying color scheme.

In planning the colors of a landscape, here are some good principles to bear in mind:

1. It's often a good idea to decide that your picture is going to be dominated by cool colors, relieved by a few warm notes, or dominated by warm colors which you'll then relieve with a few cool notes. In an autumn landscape, the browns, reds, golds, and oranges will certainly run the show, but an experienced painter often introduces a few evergreens. The sandy, rusty tones of the desert usually need a blue sky. Those endless greens of midsummer can be so monotonous that you have to *invent* a few brown trees, even if you can't find any. In general, a picture which has an even balance of warm and cool tones is less interesting than a picture which is predominantly warm *or* cool.

2. Don't neglect the marvelous variety of warm and cool grays in the natural landscape. Nature gives you so many bluish, greenish, brownish, even purplish or reddish, grays, that many great landscape painters have worked almost entirely in grays. Furthermore, it's the grays that make the other colors sing. Have you ever noticed that a field of wildflowers or a cluster of autumn trees looks most stunning on a gray day? If the landscape doesn't actually give you enough grays, it often pays to *invent* grays or move grays around to where you need them. There's nothing wrong with moving that gray rock formation behind those wildflowers or casting a gray mist over those background trees in order to make the trees in the foreground more vivid.

3. Colors with a *common component* generally look good together. If you're planning a cool picture, like a landscape just before dawn or at twilight, remember that blue, green, purple, and bluish gray are apt to look good together because they all contain blue as their common component. The sandy tones of the desert and the rusty mountains in the distance will work well together if you remember that their common component is yellow or red. Don't think of colors separately: when you're planning a picture, think of what your colors have in common.

4. When you're looking for that cool note to relieve a warm picture or that warm note to relieve a cool picture, you may have to *invent* it if you can't find it in the natural landscape. It helps to know *complements*. Thus, if you're working on a landscape in which the common component of most colors is yellow, remind yourself that the complement of yellow is violet; a few notes of reddish or bluish violet, perhaps even a violet gray, may be just what you need. If most of the colors in your picture have blue as their common component, remember that the complement of blue is orange—but keep in mind also that your note of relief doesn't necessarily have to be a bright orange; it could also be a red-orange, yellow-orange, a coppery brown, or several of these. Feel free to *imagine* these colors even if nature doesn't provide them. You're free, for example, to introduce a warm glow into a cool sky, which means that you can paint some warm reflections in the pond below.

5. If the colors in the natural landscape seem to be all over the map, all bright and all fighting one another, with no one color dominating and no common component to tie all the colors together, grays are often the answer. All the trees don't have to be bright green; some of them can be gray-green. The sky doesn't have to be bright blue, either; it could be gray-blue, or you could enlarge some of the clouds and exaggerate their gray undersides. And those patches of bright yellow sunlight on the rocks could be grayish yellow. If you introduce enough grays, your colors will stop fighting one another; most of them will melt back into the picture, and you'll be able to decide which dominant hues should remain center stage.

SOME SUGGESTIONS ABOUT COMPOSITION

Just as it's important to compose your color scheme before you start to paint, you've got to

organize your major pictorial elements into a satisfying composition. Most professionals distrust "rules" about composition, since every so-called "rule" has been broken by some great painter. But here are some guidelines that I think you'll find helpful:

1. It's usually a good idea to place the focal point of your picture—the subject which you want to command the viewer's attention—a bit off-center. Don't shove a mountain peak or a clump of trees right into the center of the canvas like a bull's-eye. Move the focal point a bit to the left or right of center. Consciously or unconsciously, professionals often place it about one-third of the way in from the right- or left-hand edge of the canvas.

2. Keep your horizon line a bit above or a bit below the center of the canvas. Once again, you often see that a professional places his horizon line roughly one-third down from the top or one-third up from the bottom. By placing the focal point and the horizon off-center, you avoid dividing the painting into equal parts, which is one of the main causes of monotony in pictorial composition.

3. Vary your shapes and contours. Even if all the rocks are fairly blocklike, make some of them squarish and make others oblong; don't make any two rocks the same size. If you're painting a grove of trees, make sure that the trees vary in height. And look carefully at the spaces *between* the trees; make these spaces different sizes and shapes—even if some methodical landscape architect has planted the trees in neat, evenly spaced rows.

4. Keep the viewer interested by making lines go in different directions. Let's say you're painting a row of mountains at the horizon, with the peaks zigzagging up and down. When you paint a second row of mountains in front of the first, make sure that the peaks zigzag at different angles and at different places, so the two rows of mountains don't look like identical paper cutouts. When you paint the pattern of cracks in a rock formation, try to make them run in somewhat different, unpredictable directions, even if nature makes them run fairly parallel. Once again, the important thing is to avoid monotony.

5. Lead the viewer's eye into the picture, not out

of it. Nature and man often oblige the painter by providing some pictorial element that functions as a path for the eye: a winding stream or road; a wooden fence or stone wall; a wandering deposit of fallen leaves or seaweed; a strip of light or ripples across water. If you set up your easel at the right spot, you can paint these motifs so they lead the viewer's eye to your center of interest, to some point nearby, or simply through various parts of the picture like a fascinating roadmap. And if the motif doesn't go exactly where you want it to go, you can redesign it. But whatever you do, don't let that stream or fence pull the viewer's eye *out* of the picture: don't let it appear in the foreground and then suddenly veer off to right or left and disappear; don't let it chop in from the side and then swing around and disappear at that same side. Often, a stream or some body of water doesn't actually lead into the picture, but simply runs straight across, providing a very stable, restful kind of composition; keep it that way if you like, but make sure that the stream (like the horizon) doesn't cut your canvas into two equal halves.

6. Look for variety in scale. It's important to give the viewer large, medium-size, and small things to look at, so the eye remains alert and interested. Big rocks look bigger and more rugged if there are small rocks and even pebbles nearby. If you're painting slender young trees, set them against a shadowy mass of big, gnarled older trees.

7. Variety of movement is as important as variety of scale. The curving shapes of weather-beaten, twisted trees will look even more dramatic against the quiet, horizontal lines of a flat horizon and long, flat, lazy clouds. The jagged shapes of mountain peaks may be enhanced by rounded cloud shapes, or they may look best of all against a cloudless sky where there are no moving shapes at all. The majestic calm of an unruffled lake will be even more haunting if the horizontal lines of the water are broken, just here and there, by a few vertical and diagonal reeds.

8. Use open space creatively. Remember that spaces are part of your picture. Don't feel that you've got to fill up every square inch of your canvas with detail. A snowy landscape may be most effective if nearly all the canvas looks prac-

tically bare: large patches of gray and white with just a few trees, rocks, or patches of dead grass. Try painting a picture in which most of the canvas is bare sky—not even a cloud—and all the details of the landscape are concentrated toward the bottom of the picture; the great Dutch landscape painters were masters of this kind of composition. Where patches of sky break through the leafy mass of the trees, or where patches of smooth water appear between rocks, look carefully at the shapes of these spaces; observe them and redesign them, if necessary, so that their shapes are just as interesting as the rocks or trees.

Above all, if you remember that every square inch of your picture is important, you'll plan every square inch so it commands the viewer's attention—and he'll never be bored.

SKETCHES, DRAWINGS, AND PHOTOGRAPHS

Some artists like to paint on location; others prefer to gather pictorial information in the form of sketches, drawings, and photographs, which they use to develop finished paintings in the studio. Whichever way you prefer to work, it's still important to learn *how* to gather pictorial "notes" quickly and efficiently. Each artist has his own way. Here are various methods you might like to try. Eventually, you'll discover which method works best for you.

Thumbnail Sketches. The simplest sort of sketch is called a *thumbnail* because it's so small. You carry a pocket-size sketchpad and some very simple drawing instrument like a pencil, a fiber-tip pen, a crayon, or a graphite stick. When you see a likely subject, you draw a rectangle that seems like the right shape for the finished painting, jot down the composition in just a few lines. The purpose of the thumbnail sketch is not to record detailed information about shapes, colors, textures, or the pattern of light and shade. The thumbnail is really a kind of organizational sketch, recording a compositional idea, indicating the relative scale and placement of things. A good thumbnail sketch usually consists of just a few lines or a few blocks of tone. Many artists carry a pocket-size sketchpad with them all the time, on the chance that they may stumble upon a pictorial idea when they least expect it. Even if your easel is all set up for an on-the-spot painting session, it's a good idea to make some

thumbnail sketches of various compositional arrangements before you start to paint; you can then pick the right design before you make a mark on the canvas, thus saving yourself the time and trouble of experimenting with various compositional arrangements on the actual painting surface.

Color Notes. You can use the same pocket-size sketchpad—or maybe one that's just a bit bigger—to make a line drawing with color notes. Instead of drawing a little box for the shape of the canvas, use the whole page to draw the outlines of all the shapes in your picture. Then, with a sharp pencil or pen, actually *write* your color notations within the outlines. The words you use are entirely up to you, but be consistent so that you'll know what your notes mean when you get back home. Some artists like to record possible color mixtures: they draw the outline of an evergreen, for example, and write inside the outline, "Prussian blue, yellow ochre, black." Other artists prefer to jot down generic color names: within the outlines of a cloud they might write, "Yellow-white top, cool gray shadow." If you don't have the time or the inclination to make an actual color sketch on the spot, a line drawing with color notes is a very rapid way to assemble a lot of information to take back home.

Tonal Sketches. In Chapter 3, *Observing Nature*, I emphasized the importance of planning the value scheme of your picture, and I suggested visualizing the painting in just three or four values: dark, light, and one or two middle-tones. Many painters consider a value sketch the most important single step in planning a painting. The famed watercolorist John Pike often carries a small sketchpad and several sticks of hard pastel in black, white, and several shades of gray. When he discovers a subject he wants to record, he quickly reaches for the chalks that match the value scheme he has in mind and then he blocks in the tones with just a few strokes. Like the thumbnail, this tonal sketch doesn't focus on details, but records a design idea in simple terms: it establishes the pattern of light and shade; defines foreground, middleground, and background planes; and simplifies the subject to a value *plan* that makes the job of painting a lot easier. You can take this sort of sketch back home or you can use it

The purpose of this charcoal sketch is to record the tonal distribution and the pattern of the shapes. The artist isn't concerned with the precise detail of the trees or the brook, but with the four basic values: the darks of the foreground brook and the trees to the right; the middletone of the distant trees; the pale tone of the sky; and the brilliant light of the snow.

Watercolor is a particularly effective medium for making a color sketch. After sketching in the main forms with quick pencil lines, the artist establishes the main colors in a few washes and strokes. He also establishes the distribution of tones: the darks of the foreground; the dark middletones in the middle distance; the lighter middletones of the buildings against the sky; and the light tones of the sky and water.

for quick planning before you start a painting on location. (By the way, you can buy a pocket-size box of hard pastels in a complete range of grays, plus white and black, and carry the box with you as a kind of "tonal palette" for sketching. If you'd rather carry just one drawing instrument for tonal sketches, try a graphite stick, a Conté crayon, a medium-grade charcoal pencil, or any kind of pencil with a soft, thick lead.)

Detailed Drawings. If you have the time and the patience, you can do a much larger, more detailed drawing that includes various kinds of information. If you carry a sketchpad roughly the size of the book you're now reading—or even a bit larger, if you prefer—you can make a precise line drawing that records all the contours of your subject. You can then fill in these lines with tones that will establish your value scheme. You can even fill them in with color. There are several combinations of media that work well: hard pencil for the outlines and soft pencil for the tones; hard pencil or fiber-tip pen for the lines and washes of gray watercolor for the tones; pencil or pen for the outlines and watercolor or pastel for the colors. The idea is to use a sharp, linear drawing instrument to record the contours and then fill these contours with tone or color. You can also use the sharp drawing instrument to record a certain amount of detail, like the texture of a treetrunk or the pattern of ripples in water. If you're painting on location, such a detailed drawing eats up too much time, but it's an excellent record to take back to the studio if you'd rather paint indoors.

Color Sketches. A field sketch can also be something like a small painting if you want to record your subject in full color. If you like to sketch in watercolor, you can buy a pocket-size watercolor box that holds just enough tubes or pans of color, plus two or three brushes. With a small pad of sturdy paper or a small block of watercolor paper, plus a canteen of water clipped to your belt, you're set to go. You can also buy a small box of pastels that will fit into an overcoat pocket; pastels work well on a small pad of regular, white drawing paper, but you can also buy small pads of handsome colored papers, manufactured specifically for drawing in pastel or charcoal. A pocket kit of markers is a great convenience if you'd rather not wait for a watercolor sketch to dry—markers dry in-

This pencil closeup records the precise shape of the treetrunk, branches, and masses of foliage. In the trunk, the artist is interested mainly in the silhouette, though he does suggest some light edges on the right, thus indicating the direction of the light. In the clusters of leaves, he clearly defines the areas of light and shade. Although he doesn't draw each leaf, his scribbles indicate the textural quality of the leafy masses. Note how carefully he defines the placement of the shadow beneath the tree.

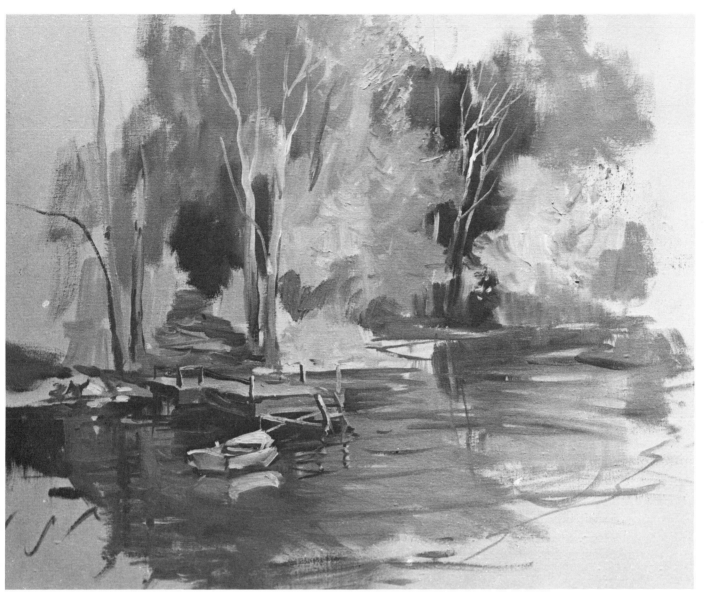

Painted on-the-spot, an oil sketch needn't be finished. The artist has stopped as soon as he's established the composition; the broad areas of color and tone; the direction of the light, which strikes the trees and dock from the right; and a few significant details like the trees, boat, dock, reflections, and contour lines in the water. The sketch might be carried to completion in the studio or might simply be the basis for a larger painting.

stantly—and you're worried about a pastel sketch smudging.

Closeups. Although you may not want to record every element of your picture with precision, there are often specific portions that you'll want to record with special care because they contain complex detail. A few thumbnails, a value study, or even a color sketch may not be enough if your picture contains something intricate—like a fallen tree, with its elaborate bark textures and pattern of roots; a wall made of stone in many different shapes, sizes, and textures; or a weathered barn which is particularly fascinating because of the wood grain. This is the time to draw a closeup in pencil, pen, or some medium that permits you to draw in sharp-focus detail. This kind of drawing is particularly useful if you're planning to paint in the studio. There are also times when you start a painting on location, block in the general shapes and colors, but then take it back to the studio for completion; when you're back in the studio with a half-finished painting, those closeup drawings really come in handy.

Oil Sketches. Many artists feel that the sketch and the finished picture should both be in the same medium. They feel that something is lost when you "translate" from a drawing, watercolor, or pastel into an oil painting. If this idea makes sense to you, carry your 12″ x 16″ paintbox into the field with the idea that you're gathering *material* for paintings, not creating finished paintings. Slide two or three canvas boards into the lid and regard them as your "sketchpad." Learn to block in your shapes and colors quickly, without too much attention to detail, and stop as soon as you've got enough information on the canvas board. It doesn't matter if the sketch looks unfinished, since it's just reference material. On the other hand, don't be surprised if the sketch turns out to be a handsome little painting precisely because you're *not* trying to make it polished and perfect. You might also try oil sketching on paper: instead of carrying canvas boards, take along some sheets of watercolor paper or sturdy drawing paper, thinly coated with acrylic gesso, and you'll find that these take oil paint beautifully. They also weigh less than canvas boards and take up less space.

Photographs. Certainly a camera is the most convenient device for recording information to take back home. But I'd strongly advise *against* painting from photos unless you've already spent a lot of time painting and drawing directly from nature. Working from nature stocks your memory bank and cultivates the habit of reorganizing, simplifying, and interpreting what you see—not just copying. Once you've learned how *not* to copy, then you're ready to use photographs *creatively,* employing the photo as a piece of raw material, like any other sketch. But if you start right out using the camera, you'll be tempted to let the camera do your thinking for you: the camera takes the picture and you've got to fight the temptation to copy it. Now, if you think you're ready to paint creatively from photographs, buy an inexpensive, single-lens-reflex 35mm camera and shoot slides, which distort the color less than color prints. Better still, shoot in black and white, since the camera records values more faithfully than it does color.

After you've tried all these different fact-gathering techniques, you'll probably settle on two or three that work best for you. As you can see, you're gathering information about four things: composition, values, color, and detail. You need a fact-gathering technique for each of these, though you may find that a particular technique does more than one job.

One possible combination is using thumbnails for composition; watercolor or pastel to record color and value at the same time; and pencil for detailed closeups. Another possibility might be black-and-white chalk drawings for both composition and value; marker sketches for color; and photographs for detail. (Notice that the camera is regarded as just one sketching tool, not the universal fact-gathering medium!) A really good oil sketch might give you composition, value, and color, aided by some closeups in pencil or pen.

If you draw and sketch directly from nature over the years, you'll soon develop a rich archive of pictorial information. Try to develop some reliable filing system, so you can find what you need without sorting through stacks of papers. With all this pictorial information at your fingertips, you'll be able to combine and recombine this raw material into totally new pictures—pictures you never dreamed of when you made the drawings years earlier!

SUGGESTIONS ABOUT WORKING ON LOCATION

If you've got lots of painting experience and know exactly what you want to do, you may be able to set up your easel without a moment's hesitation and start painting immediately. But even a seasoned professional usually does some advance planning.

At the very least, the professional often makes some thumbnail sketches before he makes those first charcoal or brush lines on his canvas. Even when he's picked his subject and the easel is set up in exactly the right spot, the professional tries several compositional ideas in a pocket sketchpad, perhaps moving the horizon up or down, enlarging or reducing certain shapes, moving some and leaving out others. He knows that he can make these decisions a lot faster in thumbnail sketches than he can on the canvas. And every minute counts when you're working on the spot.

Done on a slightly larger scale with chalk or a soft pencil, the thumbnail can also function as a value sketch, establishing the tonal arrangement of the painting to follow.

Still another outdoor painting technique is to budget your time so that you get the painting *started* on location—while the light and weather are right—and then finish the picture in the studio. You'll go home with a canvas that has the colors and values blocked in, but very little detail. You'll bring home detail information in the form of pencil or pen closeups, plus a roll of film that records such transient effects as the light and shadow patterns of the clouds or the dark ripples created by the wind on the water. With your drawings and photos spread out before you in the studio, you can then *select* the additional information you need to complete the picture.

Another interesting method—if you have time to go back to the same spot more than once—is what I'd call the "dress rehearsal." Here, you paint your picture in two versions. On the first day, you paint a small-scale picture on a canvas board inside the lid of your paintbox. On a modest scale, you work out the problems of composition, value, and color. You try out your color mixtures and decide which ones will work. You'll discover the problem areas of the painting and (hopefully) you'll decide how to solve them. Then, when you come back for your second painting session, bring along a bigger canvas and go straight to work, having planned your attack during the first session. If you've invested enough time and care in the "dress rehearsal," you'll move swiftly and decisively across the larger canvas.

Well, no, it doesn't *always* work! Sometimes the small, "dress rehearsal" painting, with all its evidence of groping and experimentation, is more exciting than the big painting which went more smoothly. But you still come out ahead. If the "dress rehearsal" is a successful picture, fine! Now you're free to experiment on the larger canvas and come up with a new and different interpretation of the same subject. In fact, this method often gives birth to a whole *series* of pictures—variations on a theme—like Monet's cathedrals.

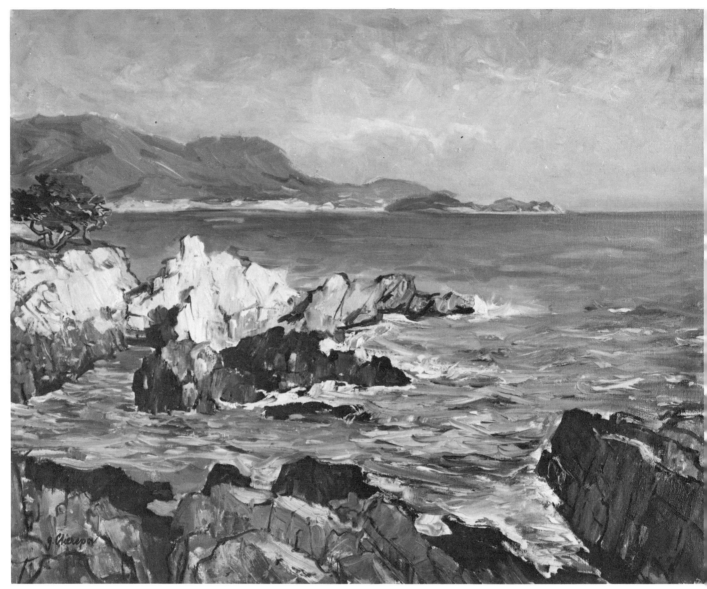

Point Lobos by George Cherepov, oil on canvas, 24"x30". The brushstrokes and paint quality are carefully matched to each area of the subject. The rocks are executed in short strokes of thick paint, which retain the imprint of the stiff bristles and suggest the rough texture of weatherbeaten stone. The sunlit areas of the rocks are painted more thickly than the shadows. The nearby water is painted in slender, slightly curved, horizontal strokes which suggest the movement of the waves rushing into the shore. At the tip of the rock formation in the middle distance, a splash of foam is painted with an upward pull of the brush. The twisted Monterey pine on the cliff to the left is painted with twisting strokes. As detail and texture gradually disappear on the distant water, the artist paints with broad, smooth, horizontal strokes of thinner color. The slanting slopes of the land forms along the horizon are painted with flat, diagonal strokes. And the brilliant light of the sky is suggested by flickering strokes of thin color, crisscrossing one another in many directions, to suggest the vibrations of the light. In general, the thickest color and the most rugged brushwork are kept in the foreground, while thinner color and more fluid strokes make the distant sea, shoreline, and sky stay back in their places.

5
PAINTING TECHNIQUE

Contemporary landscape painters generally prefer what's called the *direct* technique. This means aiming for the final effect from the very beginning and painting the picture in one continuous operation. You work quickly and decisively, sketching in a few lines to indicate the major forms on the canvas; blocking in your colors with broad strokes; refining forms and colors with more precise strokes; adding the last details; not allowing one layer of paint to dry before you apply the next layer, but always painting wet paint on top of wet paint. Even if you need several sessions to complete the picture, this direct, wet-in-wet technique produces that fresh, spontaneous feeling of a picture completed "in one go."

In this chapter, I'm going to give you some guidelines for executing landscapes in the direct oil technique. Then, in the chapters that follow, George Cherepov will demonstrate how the direct oil technique is used in painting the subjects you're most likely to face when you go out to paint landscapes.

DRAW WITH THE BRUSH

Before you begin to paint, you'll want to sketch out the major forms of the landscape on your canvas. You'll want to indicate the overall shapes of the trees, clouds, hills, mountains, or whatever you've selected as your subject. The simplest way to do this, of course, is with lines.

This is where those few sticks of charcoal come in handy. You can sketch in the broad outlines of your composition with charcoal strokes and feel free to change your mind—moving some forms, eliminating others, drawing in new forms—because you can easily dust the charcoal off with the chamois or even a facial tissue. So your first step is to organize your picture with charcoal strokes on canvas.

But your next step—surprisingly enough—is to get rid of that charcoal drawing! Blow on it or dust it lightly with the chamois so that the charcoal lines practically disappear, leaving behind nothing more than ghostly traces. Then dip one of your smaller brushes, preferably a long-bristled filbert or flat, into the turpentine. On the tip of the brush, pick up some fairly quiet color from your palette, like ultramarine blue or burnt umber. Scrub your brush on the palette a bit, so the turpentine and the color

mingle and form a thin wash. Then redraw the charcoal lines with this fluid paint.

Yes, I know that you could spray the original charcoal lines with fixative or just go over them with a brushful of turpentine to make the lines adhere solidly to the canvas. But one "rule" of the direct technique is to have nothing on your canvas but paint. Those harsh, black charcoal lines are terribly hard to get rid of once you're stuck with them! You need a lot of paint to cover them and the lines seem to inhibit a lot of painters: you may find yourself painting inside them and around them, rather than brushing freely over them.

The whole point about those first few lines on the canvas is that they *should* disappear as you paint. Those lines of wet paint will soon blur and finally vanish as you cover your canvas with big strokes of color. After all, you're not making a drawing and then filling in the lines with colored paint. Your final painting will consist entirely of masses of color, with no lines at all—except for details like twigs or cracks in a rock formation.

And since your original brushlines will soon disappear under masses of color, don't make those lines too precise. Draw as few lines as possible; indicate the overall shapes, but don't worry about details. Treat the leafy mass of the tree as one big silhouette and don't draw every branch. Brush in the contours of the pond so it's one big, flat shape, and don't worry about the ripples.

START THIN, FINISH THICK

As soon as you've indicated the big shapes with brushlines, begin covering the canvas with color. It's a good idea to begin with your largest brushes, so you'll work with big, broad strokes and not fuss about precise details at this stage. Now you want to establish the general distribution of color throughout the picture, replacing the linear shapes with colored shapes. It doesn't matter if the lines disappear—they're only guidelines for colored shapes that will have the same contours, more or less.

When you're first applying color to the canvas, it's important to work fairly thin. Use plenty of medium, so the paint is rather fluid, not thick or buttery. Make sure the paint is thin enough so it doesn't obliterate the texture of the

canvas. Thin paint is easy to push around, to wipe or scrape away, while you're trying to get things right in the formative stage of the picture.

However, when I suggest that you start with fluid color, I don't mean that you should dilute your color with turpentine to the consistency of a watercolor wash. Your color *should* have body—it should be thick enough to leave a solid layer of paint on the canvas, not merely a stain.

As the painting progresses, when you're sure that you've got the composition and the color right, you can gradually work with thicker paint. Once you begin to apply thicker color, every stroke counts: decide where the stroke goes, place it there decisively, and don't push the paint around too much. This way, it won't lose its freshness.

Let's see how this works if you paint some common subject like a tree. First you indicate the rough outlines of the tree in strokes of charcoal—just the outlines of the trunk and one big shape for the leafy area. Then you dust off most of the charcoal and redraw the lines freely with ultramarine blue or burnt umber diluted with lots of turpentine. Now, reaching for a big, broad brush, block in just a few large areas of tone: let's say one shade of green for the lighted part of the leaves and another shade of green for the shadowy part; one tone for the lighted area of the trunk and the major branches and another tone for the shadowy part of the trunk. These first tones are quite thin, applied flat, and don't worry if the color slops over the lines and begins to obliterate them.

Having established the big color areas with fluid paint, now go back into these areas with medium-size brushes and thicker paint. Adjust the colors; brush in the shapes of the color areas more precisely; and begin to suggest certain details like branches and breaks in the mass of leaves where the sky shines through. At last, working with medium-size and small brushes, add details like the leaves, the texture of the bark, and the twigs—using really thick paint where you want the texture to stand out, like in the gnarled roots of the tree, a few prominent branches, and some lightstruck leaves here and there.

One important technical point about diluting paint. When you're working with really thin paint in the early stages, dilute your tube color with medium *and* some turpentine. In the later

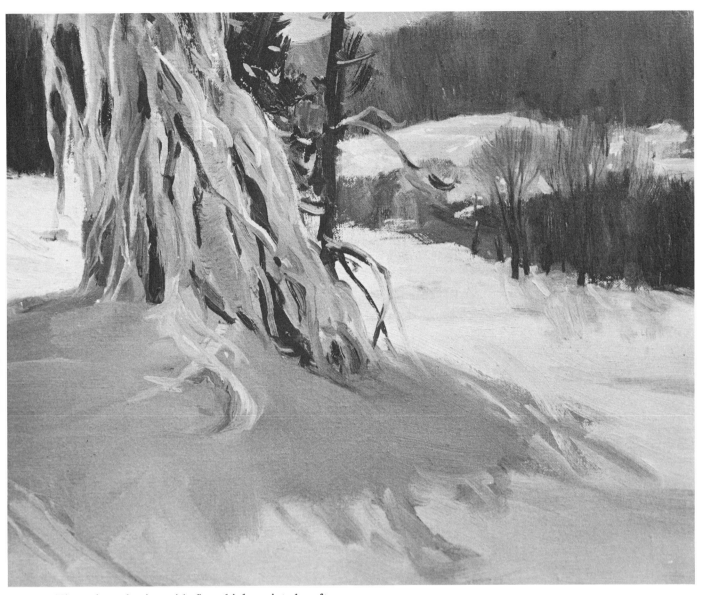

The painter begins with flat, thinly painted, soft-edged masses of tone like the dark shapes of the distant trees and the shadow in the foreground. More complex forms, like the snow-covered tree in the upper left and the nearby treetrunk, also began as soft scrubs of color; then the artist gradually works from thin color to thick and from soft focus to sharp, building the details of the snow-covered tree with thick, clearly defined strokes. A few sharp touches define the dark treetrunk and the distant trees, but most of the picture remains thinly painted and soft-edged.

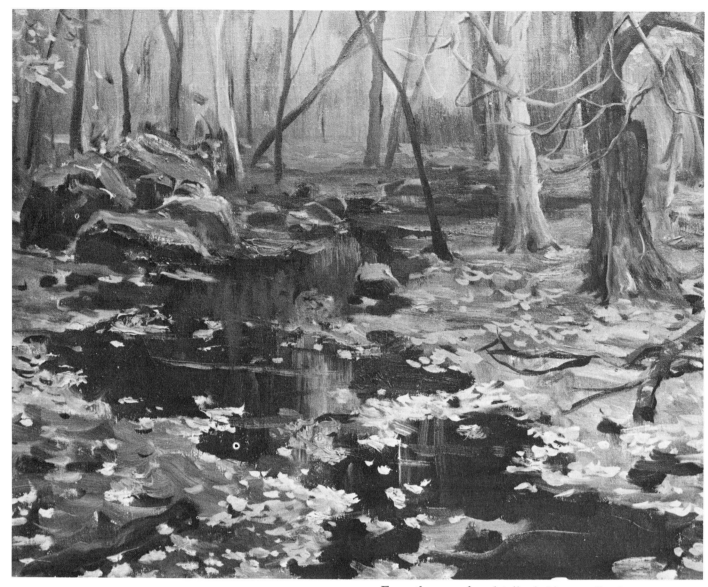

Even the complex detail of this woodland scene begins as broad, softly defined masses of thin paint, which still show in the dark shape of the pond and the lighter shapes of the shore. Over these broad tones, the painter applies quick, thick touches for the leaves; broad, heavy strokes for the tops of the rocks; and slender, calligraphic strokes to sharpen some of the treetrunks and suggest branches here and there.

stages, when you're painting thicker, you can use medium alone.

WORK FROM SOFT FOCUS TO SHARP FOCUS

If you begin with broad, rough brushstrokes, you'll soon cover the entire canvas with big, flat, soft-edged forms. The big colored shapes will blend into one another, slop over one another, and have a generally ragged, blurred feeling like a photograph which is slightly out of focus. Even in the middle stages of the painting, when you're still concentrating on getting the colors and the overall shapes right, the edges of these shapes should remain soft. Only in the final stages of the painting should you concentrate on sharpening edges and focusing on details.

Let's look at the tree once again. Even when you've reached the stage where you're building up thicker color and blocking in the shapes more precisely, think of the light and shadow areas of the trunk and mass of leaves as big, broad tones. Don't paint a single leaf just yet. Try to see the mass of leaves as a large form with a distinct shape, still rough around the edges. Then, when those big forms are exactly right, you can begin to add some leaves here and there, add some branches in sharp focus, and cut into the mass of leaves with touches of sky.

But even in these final stages, when you're drawing the viewer's attention to certain details, be selective. Don't sharpen up every edge—just a few. A few sharp edges and a few details go a long way. You can leave most of your brushwork fairly rough if the viewer has a few well-placed details to seize upon—suggesting more detail than you've actually painted.

The principle, here, is to work from soft focus to sharp focus, and from broad strokes to precise strokes. But always leave some rough, unfinished, soft edges. There's nothing more monotonous than a painting in which all the edges are hard and all the details are in sharp focus.

WORK ALL OVER THE PICTURE

One of the worst traps a beginning painter can step into is to fall in love with one part of the picture and neglect the rest. Beginners become so fascinated with a particular light effect on the clouds or the reflections in the water that they suddenly discover they've finished this part of the painting, but that the rest of the job remains to be done. No matter how hard they work on the rest of the painting, those clouds or that patch of water will stick out like a sore thumb! The final painting never looks "all of a piece," but has a peculiar, disjointed look, dominated by a part that may not even be the center of interest.

An experienced painter knows that every part of the painting is just as important as every other part. The background has to be painted with just as much attention as the foreground. You can't concentrate all your efforts on the center of interest and then paint the areas around it as if they were an afterthought—if you do, the center of interest won't look like it's part of the same painting. A painting is like a chain: every single link must be carefully forged or the whole thing will fall apart.

The secret is to bring along every part of the painting at the same rate of development. Keep working over the entire surface of the canvas, rather than zeroing in on one particular spot. When you're blocking in your broad color areas, work on all the areas from the very beginning. Then, when you begin to refine these areas and sharpen them up, do *this* job on every part of the canvas too. And when you begin to focus on those last details and sharp edges, don't concentrate on just one spot—just the leaves or just the cracks in the rocks—but decide on *all* the areas that need to be sharpened up and gradually add a sharp edge here, a precise stroke there, so they'll all come into focus at the same rate.

KEEP THAT WET-IN-WET FEELING

The ideal of the direct oil painting technique is a picture that looks like it was painted in one session, with each stroke painted next to or over another wet stroke. When every stroke is applied on a wet canvas, you get that wonderful feeling achieved by the impressionists: that the picture is like a perfectly woven fabric in which every strand intertwines with all the others and the colors seem to melt together. This melting effect is the secret of the wet-in-wet technique. When you apply a fresh stroke on top of (or next to) wet paint, the new stroke seems to melt into the wet skin of the canvas.

If you're fast enough and decisive enough to

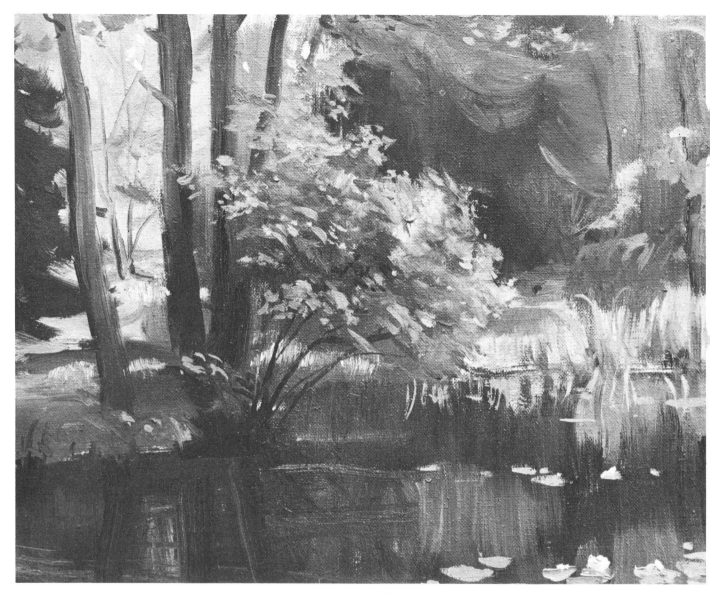

Throughout this section of a landscape painted in deep woods, the artist retains that fresh, wet-in-wet feeling. Masses of wet paint merge with one another and strokes are painted into these wet masses, so the picture has the look of a continuous "wet skin." Only the crisp touches of light—the sunstruck leaves, weeds, and lily pads—are purposely painted after the picture is dry, so these touches will seem more luminous.

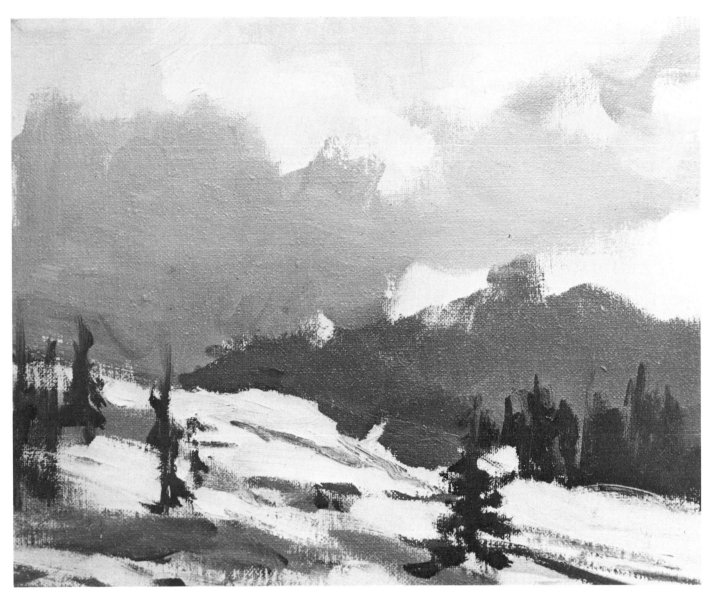

In this extreme closeup of a small section of a
snow scene, we see how freely applied strokes of
flat, fluid color naturally blend as they overlap.
The dark horizon naturally blurs into the shadowy
clouds. The wet strokes of the snow and the wet
strokes of the shadows naturally produce soft
transitions. And painted into all this wet color,
the trees naturally melt in, with no harsh edges
anywhere.

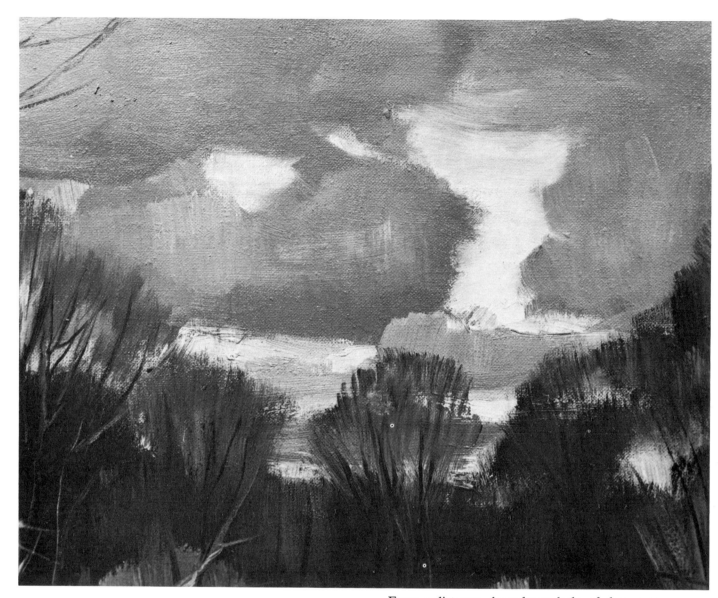

From a distance, the velvety darks of these trees and clouds might look as if they've been carefully blended. But seen close up, they're composed of broad, quick strokes, placed side by side or brushed over one another, so they blend naturally. The brushwork is surprisingly rough and the tones are never ironed out by repeated brushing.

paint a successful picture in one session or on several successive days before the paint dries, it's not hard to achieve that wet-in-wet feeling. As I've already said, the important thing is to cover the entire canvas with wet paint as early as possible and keep working across the entire canvas so the picture will stay wet from edge to edge until the painting is done. If you're painting one stroke next to another, overlap your strokes slightly so they blend a bit. If you're painting a fresh stroke on top of wet color, the blending effect tends to happen automatically. Above all, don't let any one part of the picture dry before the whole picture is done. A wet stroke on a dry painting always has a slightly harsh effect and never looks as fresh as a stroke applied wet-in-wet.

But what if you can't finish a picture in one session? What if you've got to interrupt the painting to go to work or meet some other obligation the following day? In a few days, the picture will start to dry and there's nothing you can do to stop it. But there *is* a way to re-establish that wet surface when you take up your brushes again. Simply brush a thin layer of your painting medium over the dry canvas before you begin your next painting session. Don't apply too much or your brush will slither indecisively over the canvas when you start to paint. If necessary, wipe off some of the medium with a rag and leave the canvas just a bit damp. If the canvas is *very* dry, some professionals recommend rubbing in the medium with the palm of the hand or the ball of the thumb, forcing the moisture into the surface and making it feel more like wet paint when you strike the surface with your brush. This old master technique of "oiling out" the canvas makes your strokes look fresher and more fluid—and helps retain that wet look.

DON'T BRUSH YOUR PAINT TO DEATH

If you look over a professional's shoulder as he works, you'll discover that he not only applies his paint with a minimum of strokes, but does a minimum of blending. He doesn't apply a stroke and then poke at it again and again to smooth it out, spread it, or blend it. Most of the time, he paints in strokes of *flat color,* creating gradations and subtle changes of color by placing wet strokes side by side. He doesn't scrub the paint and blend the strokes into one smooth, continuous tone. Instead, he lays the strokes

side by side or one over the other, letting them blend naturally as they overlap.

In contrast with professionals, beginners are obsessed with smooth, velvety tones and have a passion for blending one color into another. But the more you brush a color, the less vital it becomes. With every stroke of the brush, even the brightest tube color will gradually lose vitality. So the professional learns to avoid the repeated, back-and-forth blending stroke that creates velvety gradations, but turns colors to mud and destroys the texture of the paint. He may do a bit of blending when he paints something as smooth as a clear sky or a pond, but he generally paints in flat strokes, placing various tones side by side and letting them blend in the viewer's eye.

Let's say you're painting a rock formation and you're trying to make the rocks look really round. The *wrong* way is to paint the lights, halftones, shadows, and reflected lights in lots of small, picky strokes, then blend them all together so the rocks look like so many billiard balls. The *right* way is to paint these tonal areas in bold, ragged strokes, laid side by side, blending them slightly by overlapping one wet stroke onto another. The rough strokes of flat color will *seem* to blend when the viewer looks at your painting from a distance; the rocks won't only look round, they'll look rough and hard, as rocks really are.

MAKE YOUR BRUSHSTROKES EXPRESSIVE

An experienced painter doesn't just dive in and start slapping paint on canvas; he thinks about each stroke before he swings the brush. He knows that each stroke has its own unique character. Strokes can be long or short, wide or narrow, straight or curved, horizontal or vertical or diagonal. They can be little dots or big blobs. They can be smooth or rough, thick or thin. And he chooses the right stroke to express the character of the subject.

Before you apply a stroke, decide what kind of stroke you want to make. What kind of stroke best expresses the form? If you're painting a rough, blocky rock formation, try making your strokes follow the form: horizontal strokes for the top planes and vertical or diagonal strokes for the side planes. For smooth, slender treetrunks, vertical strokes may be best. But for thick, rough treetrunks, you may want to try

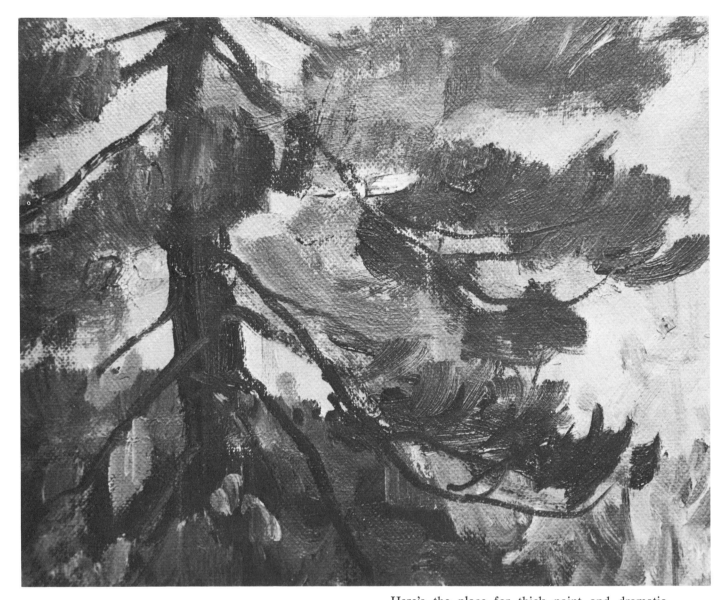

Here's the place for thick paint and dramatic brushwork. The trunk is painted with broad, downward jabs of a heavily loaded brush. The branches are slashed diagonally across the canvas. And the dense foliage is rendered in short, upward sweeps of heavy color that retain the imprint of the bristles, suggesting the texture of the pine needles.

short, curving strokes that wrap *around* the forms. For painting curly foliage, the impressionists often used a stroke shaped like a coma. Actually, different kinds of foliage may demand totally different strokes: the small, flat leaves of a birch may suggest little dabs of the brush, while the massed needles of a spruce or pine may demand bigger, more ragged strokes.

Your strokes should also express the "gesture" of your subject. You may choose long, lazy, horizontal strokes for the horizontal movement of flat cloud layers. Short, quick, choppy strokes might be just right for the erratic rhythms of a mass of twigs. Fluent, curving strokes may suit the rounded forms of snowdrifts.

The texture of your subject may also suggest the appropriate stroke. The roughness of an old wooden fence may suggest that you pick up lots of thick color and press your brush hard against the canvas, so the bristles leave ridges in the paint. Fleecy clouds may seem to need light touches of very thin paint. The glare of light on ice may need strokes that are both smooth and thick.

Your brushstrokes can also convey a sense of space. Big, bold, thick strokes are usually best in the foreground or the middle distance. As you move into the distance, it's generally best to work with smaller strokes of thinner paint. But this is no hard-and-fast rule. If your center of interest is a distant mountain peak, for example, you may want to command the viewer's attention with a few big, thick strokes for the snow; but these strokes will have maximum impact if they're surrounded by smaller, smoother strokes.

MAKE CORRECTIONS RUTHLESSLY

When some area goes wrong in form, color, or texture, don't hesitate to wipe or scrape it off and start again. Don't keep piling on more paint to try to cover up an error. The thicker the paint, the harder it is to make it behave; you'll soon have a gummy mess that looks about as fresh as old pancake batter. Nor should you keep pushing the paint around, brushing it back and forth until it turns to mud. The only way to restore lost vitality is to make a fresh start, trying again to paint the subject in decisive strokes.

If the offending passage is thinly painted and it's still wet, you can probably get the paint off with a dry rag or a rag moistened with turpentine. If it's thickly painted and it's still wet, scrape it down with a palette knife. Try to take off enough paint so that the original texture of the canvas comes through; the weave of the canvas has a pleasant texture that will enliven your brushstrokes when you make a fresh start.

If the offending passage is dry, you've got a tougher job. Recently dried paint may not be as dry as you think; it may merely be dry to the touch. You can probably get some of it off with a turpentine-moistened rag if you rub hard enough. If the dry paint is fairly thick, try scraping it off with your palette knife. If the blade of the palette knife isn't stiff enough, try a putty knife. If you can't scrub or scrape down to absolutely bare canvas, just try to scrape away enough paint to expose the original grain of the canvas, even if there's still some paint left between the fibers. If you get down to the original canvas texture and rub in some medium, you've still got a responsive surface to work on.

Don't scrub or scrape out so carefully that you leave a hard edge around the area you've removed, like a paper cutout. When you repaint the passage, it will be terribly difficult to get rid of that hard edge. If you rub or scrape so that you leave a soft edge around the passage you've cleaned away, your fresh strokes will blend a lot more easily into the surrounding paint.

The most painful decision is to scrape away some portion of a painting which is generally bad, but which has a few good details. How do you scrape out that wooden fence without eliminating those nicely painted patches of weeds that appear between the fenceposts? It just doesn't pay to try to save those few areas. You can't possibly paint a new fence in bold, decisive strokes if you've got to work *around* the weeds. If you painted the weeds right the first time, you can do it again. So be ruthless: scrape out the fence and the weeds too.

Above all, don't be embarrassed to admit a mistake, wipe the canvas clean, and start again. All the masterpieces of direct painting look so fresh and decisive that you're sure the artist got it right the first time. But you're wrong! They look so effortless because the artist had the courage to paint and scrape out again and again, until he got it right at last.

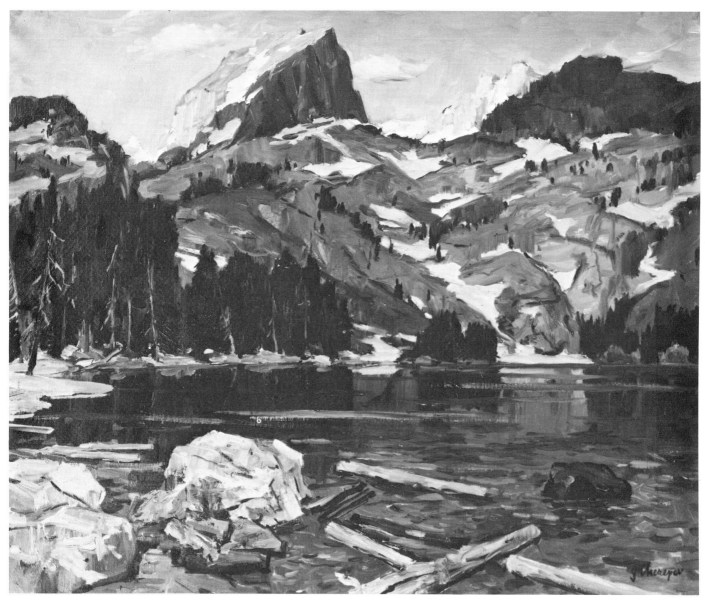

Bear Lake by George Cherepov, oil on canvas, 24"x30". The most awesome forms in the landscape are mountains, but painting mountains is no more difficult than painting rocks. In the foreground rocks, the artist begins by establishing the basic geometric forms, which is precisely what he does when he paints the distant peak. Not all rocks are blocky—some are shaped like eggs, others like pancakes—but the rocks in this picture are somewhat like fractured cubes with the sides askew. And the distant peak is like a tilted cube. With this in mind, the painter establishes the planes of light and shadow with broad strokes. Then he adds selective detail: a few lines for cracks in the foreground rocks and for crevices in the peak. The brushwork is rough to suggest the rocky texture. The lights are thickly painted on the rocks, as is the patch of snow on the distant mountain. The slopes leading down to the lake are visualized as a simplified pattern of light and dark shapes. The trees are painted in silhouette (with a minimum of detail) to provide a dark "frame" for the focal point of the picture.

6
FORMS OF THE LAND

The biggest shapes in a landscape are the shapes of the land itself: the clearly defined forms of hills, mountains, mesas, and other rock formations: and the subtle forms of open fields, beaches, and the desert. Here are some suggestions about painting the forms of the land.

PAINTING FLAT LAND

Perhaps the hardest thing to paint is a stretch of flat land, such as an open field, a meadow, or the desert. At first glance, it may look as flat and monotonous as a billiard table. How do you give it an "interesting shape" when it doesn't seem to have any shape at all? The great Dutch landscape painters lived in one of the world's flattest countries and transformed those fields into masterpieces. How did they do it?

To begin with, that flat landscape may not be as flat as you think. That meadow may have a slight roll to it. There may be a suggestion of dunes on that sandy beach or desert. Look for a hint of shadow that indicates an almost invisible tilt in the surface—then exaggerate that shadow to dramatize the slight irregularity. A few shadows will suggest concavities and convexities in a meadow, or dunes on the beach or desert.

As I suggested in Chapter 3, *Observing Nature,* contour lines can make an enormous difference. Look for paths, wooden fences, stone walls, a gulley, or the bed of a dried stream. Look for debris such as seaweed or fallen leaves deposited by wind or water. They'll all trace patterns across the landscape: horizontal, diagonal, or meandering up and down. By exaggerating these elements, you can create dips and bulges. Just as important, you can use these motifs to divide flat land into interesting shapes.

But what if the land is *really* absolutely flat? There are still ways to enliven it. The flattest desert is often dotted with rocks and pebbles; you can move these around on your canvas, exaggerating their shapes and their cast shadows to create an interesting pattern. A meadow is often covered with grass and weeds that are ruffled here and there by the wind, very much as the wind ruffles the water; the windblown weeds will bend, often showing up as shadow areas which you can emphasize to break the monotony. And don't forget that clouds often cast shadows on the landscape below; study cloud shadows and learn how to place them

At first glance, nothing looks more monotonous—
and therefore more difficult to paint—than the
flat terrain of the desert. But look closely and
you'll see many subtle changes of tone and tex-
ture, as the artist reveals in this foreground detail
of a desert landscape. He also enlivens the flat
ground by emphasizing the sharp contrasts be-
tween the light planes, shadow planes, and cast
shadows of the small rocks and pebbles, which
become sharply three-dimensional.

where you need a dramatic tonal change on the land.

Your brushwork itself can enliven the landscape. As you paint the grass and weeds in a meadow, change the direction of your strokes slightly, so the vegetation will seem to lean this way and that. Paint some of the vegetation as a soft blur—with large, scrubby strokes—then paint other areas with crisp, clearly defined strokes. When you paint a sandy beach, try broad, long, rhythmic strokes for the sandy areas; then interrupt these with crisp, choppy strokes for the patches of vegetation. Try broad strokes of thin paint for the desert soil, interrupted with dabs of thicker paint for the rocks and pebbles.

PAINTING ROCKS

To paint rocks convincingly, you've got to emphasize their three-dimensionality. Begin by observing their shapes carefully to fix the silhouettes clearly in your mind. Then define the light and shadow areas and exaggerate them. Above all, rocks should never look mushy. The way to make them look solid is to emphasize the contrasts of light and shade.

Look carefully at the geometry of rocks. They're not all round or blocky. Some are as flat as pancakes. Others are like segments of a broken column, piled one on top of the other. Try to imagine which geometric form comes closest to the particular rock formation you're painting and keep that form in mind as you work. People usually think of rocks as cubes or spheres or eggs. But some rocks are cylinders and others look like broken pyramids. Whatever the shape, you'll paint the lights and shadows more convincingly if you look for the basic geometry of the rock.

Carefully observe the cracks in and between rocks. As I pointed out earlier, these cracks can function as contour lines that move across, around, and down, strengthening the three-dimensional feeling of the form—if you render those lines faithfully.

But when you're painting a complicated rock formation, with lots of different forms and lots of cracks, it's important to decide what to leave out. Be selective about detail. Paint the more distant, less important rocks very simply, just indicating lights and shadows and perhaps a few contour lines. Pick the biggest, most important shapes—probably the ones nearest to you—to paint in detail. But you can still simplify these forms if there are too many different planes. And just paint the major cracks, not every little fissure; a few well-selected contour lines can emphasize the form, but *too many* contour lines can break up the form and destroy it.

Lots of painters love to paint rocks because they can try so many different kinds of brushwork. For rough, blocky rock formations, short strokes of thick paint may be best. For smooth, rounded rocks, you may want to try curving, rhythmic strokes of thinner paint. For those rock formations that look like a layer cake, you can try alternating thick and thin, rough and smooth. And it's fun to take a pointed softhair brush and trace calligraphic lines for the cracks —though you've got to guard against getting carried away and painting more cracks than you need.

PAINTING HILLS AND MOUNTAINS

In a sense, hills and mountains are just big rocks, so the problems aren't really that different. Even though the contours of rolling hills may be softened by trees and greenery, remember that there are rocks underneath, just as there are bones beneath your skin. And jagged mountain peaks are simply the biggest rocks of all.

Once again, the trick is to look for the basic geometric forms and emphasize the lights and shadows. If you're painting jagged mountain peaks that look like gigantic blocks or pyramids, it's easy to define the light and shadow planes. But even if you're painting green mountains or hills covered with vegetation, don't be deceived by the mass of detail. If you squint and throw those treetops slightly out of focus, you'll see that the hills have big, simple shapes after all, like hemispheres, eggs, flattened cones, or pyramids. Paint the big masses of light and shade first, then suggest a few details of the vegetation by painting them *into* the overall tones. Even though each tree actually has its own pattern of light and shade, don't paint each tree; merge them into the light and shadow pattern of the hill. The trees on the shadow side of the hill should be generally darker than the trees on the light side.

When you're painting hills and mountains,

it's important to watch cloud shadows. A passing cloud can throw an entire hill into darkness, thereby spotlighting a nearby hill which is in sunlight. You can take advantage of these accidents and make them happen at will. If you want to focus attention on a distant peak and play down the nearby hills, place cloud shadows on the hills and keep the peak in brilliant sunlight.

Observe edges and transitions. Rocky peaks may have hard, jagged edges, but mountains and hills tend to have soft, slightly blurred edges when they're covered with vegetation. When you're painting a series of rolling green hills, don't make them look like so many paper cutouts or rows of smooth, green eggs; because of the soft vegetation, the hills will seem to blur into one another.

Try soft, scrubby brushwork for hills and mountains that are covered with greenery. Some painters actually save old, battered brushes—with the bristles splayed out—for just this purpose. If the rolling hills are covered with an infinite number of trees, it often works to paint these hills in short, soft strokes that suggest the texture of the trees without the detail. Save your choppy, sharply defined strokes for the rocky areas. A good trick to remember when you're painting rocky peaks—and rocks in general—is to paint shadows in thin color and save the thick color for brightly lit areas.

ROCK, SOIL, AND SAND COLORS

Although I've pointed out that not all rocks are brown or gray—nor is sand always yellow or soil always brown—these common landscape elements are often in the brown-tan-beige-gray color range. These *neutral* colors, as they're called, come in an extraordinary variety of warm and cool tones. You can't just squeeze out some burnt umber and mix it with white to get a nondescript tan that will do, somehow, for soil and sand. Nor can you just mix ivory black and white to get a steely gray for "rock color." There are infinitely more possibilities, and here are some to try.

Mixtures of blue, brown, and white will produce far more interesting grays than mere black and white. Experiment with ultramarine blue, burnt sienna, and white; by varying the proportions of blue and brown, you can get a variety of warm and cool gray tones which become more delicate and smoky as you add more white. Phthalocyanine blue, burnt umber, and white—in varying proportions—will give you another range of warm and cool grays. And you can obviously interchange the blues and browns so that you're working with phthalocyanine blue and burnt sienna, or ultramarine blue and burnt umber. Some yellow ochre will add a hint of earthy warmth to any of these mixtures. Some viridian will add a hint of green—yes, there *are* greenish rocks.

Although black and white produce a lifeless, steely gray by themselves, you can produce interesting grays by adding one other color to the mixture. Ivory black, yellow ochre, and white produce beautiful grays with a slight olive tinge. You can substitute black for one of the blues in the blue-brown-white mixtures. In all these combinations, black functions as a cool color, rather like blue, which you play off against a warm brown. The proportion of warm to cool color in the mixture will determine whether you get a warm or cool gray.

Actually, these same mixtures will produce a wide variety of browns, tans, and beiges if you allow the warm color to dominate the mixture. You can also introduce a hint of Venetian red or light red for a ruddier brown. Raw sienna will produce warmer browns and tans than yellow ochre. As you add more and more white, you'll probably notice that white not only lightens a warm tone, but often makes it a trifle cooler.

When you begin to try these mixtures on specific subjects, observe your subject very carefully. You'll notice that supposedly brown rocks are usually a lot grayer than you think; don't paint them chocolate brown! And supposedly gray rocks are often more colorful than you might expect; they can be bluish gray, purplish gray, gray-green, and even a kind of grayish gold. When you paint rocks in warm tones, try introducing a few strokes of cooler color for variety. And when you paint rocks in cool tones, a few hints of warmth will enliven the generally cool color.

Nor is soil apt to be as brown as you might think. It's usually grayer or more yellowish than beginners paint it. If the soil contains lots of clay or iron oxide, it can be reddish or even tend toward purple. But whatever the color of the soil, it's rarely very dark or very bright; keep it

The actual rock formation certainly contains much more complex detail than you see here. But the artist renders this profusion of detail with a minimum of broad strokes for the sunlit tops, shadowy sides, and cast shadows. The entire job is done with a big, broad brush. He then picks up a slender brush and strikes in just a few dark lines to suggest cracks, but stops before he's carried away with more detail than he needs. The lights are more thickly painted than the shadows.

subdued and look for places to introduce grays to keep the soil from popping out of the picture.

A common mistake in painting desert sand is to make it too red or yellow. And despite the travel literature that describes golden beaches, a sandy beach is rarely bright yellow. At its brightest, desert sand can be a kind of dusty pink or yellowish tan. Sandy beaches are sometimes a golden beige in bright sunlight, but they're more often a warm gray.

It's true that desert rock formations can amaze us with their hot reds, pinks, oranges, and yellows. But they're rarely hot enough to paint with the hottest colors on your palette, like cadmium red, alizarin crimson, or cadmium yellow. Stay with the richer earth colors— Venetian and light red, burnt sienna, raw sienna —and even these will have to be modified by white, by touches of cool color, and by subdued earth tones like burnt umber and yellow ochre to conform to reality. Venetian and light red make surprising pinks when lightened with white. These pinks can be warmed to a more golden tone with a touch of yellow ochre or raw sienna. And you'll find that both these quiet yellows are strong enough for the most golden sands.

In fact, the best advice I can give you about painting soil, sand, rocks, and mountains is to rely *mainly* on mixtures of earth colors. After all, they're called earth colors for a perfectly logical reason: although most of them are now products of the modern chemical laboratory, they were first dug out of the earth. Because of their mineral origin, they really *are* the colors of dirt, clay, and rock. With the help of blue and black—plus an occasional hint of green or violet—these earth colors can give you practically every mixture you need for painting the soil and rock which is *literally* the foundation of the landscape.

Step 1. After roughing in the composition with a few charcoal lines—you can still see some of them in the foreground—the artist draws firmer lines with a slender brush and tube color diluted with lots of turpentine. These lines don't define precise edges or contours, since heavier paint will be brushed freely over the lines. At this stage, the artist simply wants to indicate the shapes, sizes, and placement of the main pictorial elements. He'll refine the shapes when the canvas is covered with paint.

Step 2. Except for the sky, which he saves for the final stage, the artist covers much of the canvas with paint. He still doesn't worry too much about contours, but wants to put the right patches of tone and color in the appropriate places. He blocks in lights and shadows on the distant mountains. He also establishes the middle tone of the foreground, leaving a few lines for the cacti at the edge of the road. The sky will be the lightest of the four values and he leaves this blank for the moment.

Step 3. Now he covers the rest of the foreground with a variety of roughly painted middletones, adding touches of light and dark to suggest rocks and pebbles. At the same time, he completes the very simple tone of the sky, which gradates from a pale horizon to a slightly darker tone at the top of the picture. The final touches are a few dark and light strokes for the cacti and some additional darks to sharpen the mountains. The original guidelines in Step 1 have been obliterated and the final shapes have been modeled in solid paint.

DEMONSTRATION 2: DUNES

Step 1. The soft, rolling shapes of dunes are entirely dependent upon light and shadow, so no line drawing can possibly do them justice. Knowing this, the artist begins with the simplest possible brush drawing, merely to indicate the divisions between sky, water, shore, and a few big sandy shapes. He's aware that the painting will soon look nothing like his line drawing—that the real job will be to model the dunes in broad strokes that create the illusion of three dimensions.

Step 2. Large strokes quickly sweep over the lines and establish the dark-to-light gradation of the sky; the dark of the water, which gradually lightens as it approaches the shore; the lighted areas of the sand and the luminous shadows. A common mistake in painting sand is to make the shadows too dark. The artist carefully avoids this, keeping the shadows pale and luminous, suggesting reflected light by brushing pale tones into the darks. He works in thin veils of paint to model the forms more easily.

Step 3. Now, in the final stage, the artist applies heavier, more decisive strokes, building up the lights with thicker, brighter color, and darkening just a few of the shadows. He also darkens the sea to make the sand look sunnier. At the last moment, he adds slender strokes for the underbrush and the wooden fence, which are carefully placed to accentuate the roundness of the dunes. The shadows sweep downward across the picture to emphasize the curve of the beach.

Step 1. Broad, rhythmic brush lines establish the divisions of sky, trees, hills, and the tonal areas of the meadow. The lower half of the picture is carefully divided into two horizontal shapes with curving edges. Recognizing the importance of creating a design that will enliven the potentially monotonous pattern of the grass, the artist "designs" the meadow in advance.

Step 2. Broad strokes establish the main areas of tone and color. The sky is now divided into a dark, cloudy area and a luminous area beneath, which remains bare canvas. The darks of the hills and the trees are blocked in. But most care is given to the meadow, which already reveals some sunlit areas, shadowy areas, a dark patch of cultivated field at the right, and a distinct division (marked by a strip of sunlight) between the foreground and the middle distance. The meadow is painted in vertical strokes to suggest the tall grass.

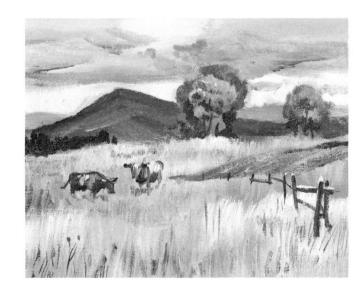

Step 3. The patches of light and dark in the sky are more precisely defined and the artist pays particular attention to the sunny strip along the horizon, since this strip of sunlight provides the light on the meadow. Now the meadow emerges as a rich pattern of lights and darks, with the edges of the foreground weeds caught in sunlight, the middle distance in shadow, and more sunlight at the edge of the meadow. Crisp strokes pick out a few foreground weeds and suggest a fence that leads the eye far back into the picture, making the meadow look even more three-dimensional and leading to the cattle, which create a center of interest.

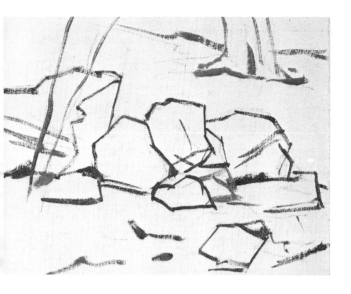

Step 1. Working almost entirely in short, straight brushlines, the artist draws the blocky shapes of the rocks. Note how he draws a sharp line to indicate the break between the lighted top plane and the shadowy side plane on the large rock to the extreme left; he does the same on the large rock at the right.

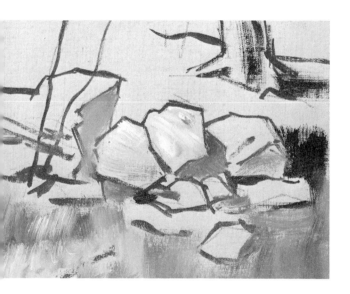

Step 2. Having drawn the light and shadow planes in line, the artist now blocks in the shadow areas so he can visualize these values more clearly. It's now obvious that the light is coming from the upper left and that the shadow planes are on the right-hand sides of the rocks. Cast shadows are added at the extreme right to reinforce the direction of the light. The foreground is scrubbed in broadly and won't be carried much farther, even in the final stage.

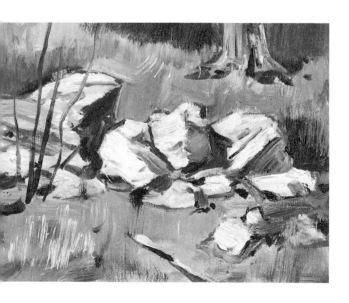

Step 3. Rocks are really so simple to paint that the final step is carried out all at once. The background is darkened to accentuate the rocks. The shadow planes are darkened. And the sunlit tops of the rocks are brushed in with thick color that retains the texture of the brushstroke. A few dark strokes are added beneath the rocks to suggest cast shadows.

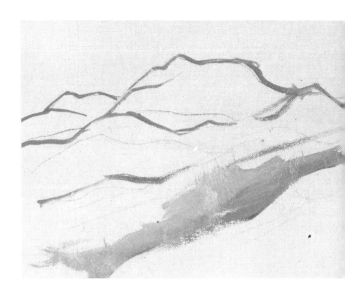

Step 1. Over a few faint charcoal lines, the artist draws quick, fluid brushlines to define the shapes of the hills. These shapes won't be followed rigidly in the final painting; the central hill will become steeper and the distant hill to the left will become rounder. A particularly important strip of shadow is broadly brushed across the lower right to indicate a break between the immediate foreground and the middle distance.

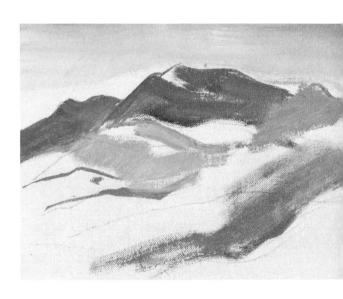

Step 2. The artist brushes in the gradated tone of the sky, leaving the canvas bare at the horizon so he can adjust this portion later on. The darks of the hills are brushed in and so are the shadow areas of the middleground. The artist leaves most of the foreground and middleground untouched until the final stages of the painting, when these will be executed in a few broad sweeps of the brush. At this moment, he focuses mainly on the distribution of tones: darks, middletones, and lights—which are still represented by bare canvas.

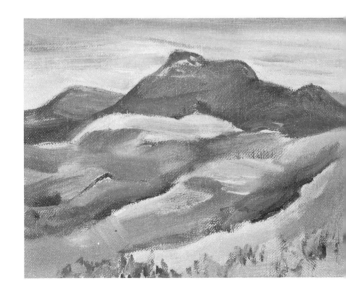

Step 3. The looming dark shape and the distant hill are redesigned for greater drama. Now the artist completes the lower sky, which he lightens to emphasize the dark hill shown in silhouette. The hills in the middle distance emerge as three-dimensional forms when the artist paints their lighted tops and shadowy sides. The triangular foreground shape becomes a slope when the artist adds diagonal shadow strokes and dark touches for trees.

Step 1. On a gray-toned canvas, the intricate outline of the peak is drawn with more precision than usual, since the artist wants to retain the character of this shape. Within the lefthand side of the peak, the artist draws a rougher line to indicate the edge of a shadow plane. Big, irregular strokes in the foreground indicate other shadow areas.

Step 2. The most important darks are now blocked in along the shadow side of the peak and in the distance. Some foreground shadows are suggested, but they'll be developed later on. The artist begins to brush in his lights at the top of the peak. He starts to bring down the sky, but leaves the horizon untouched so he can adjust this tone in the final stage.

Step 3. The shadow side of the peak is lightened to suggest reflected light from the sky. Foreground shadows and big splashes of light are added in thick paint. A few dark touches suggest crevices. And the sky is darkened to emphasize the lighted planes of the peak. The distant peak on the left is simplified to just two tones of light and shadow.

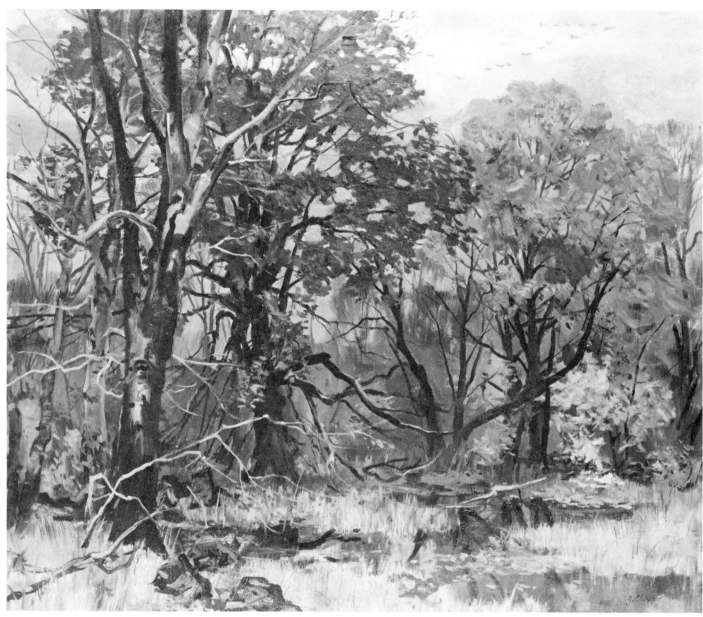

Autumn Mood by George Cherepov, 30"x36", private collection. In this wooded landscape, each tree is painted with a strong awareness of its individuality. Each trunk has its own unique shape and pattern of branches, and you feel that you'd recognize the actual tree if you saw it, much as you'd recognize the sitter for a portrait. The leaves are painted as flat masses of tone, with just a few individual leaves picked out to suggest more detail than you actually see. The leaves of the tree on your left are mostly in shadow, merging into dark masses interrupted by the light of the sky and forming a fascinating pattern of darks and lights. The more distant tree on the right shows the effect of aerial perspective: the leafy masses are paler and show even less detail, though you can still see "sky holes." And the most distant trees along the horizon—you can see them in the center of the picture—are just shadowy silhouettes. A small brush, loaded with thick color, brings out the lightstruck leaves and traces calligraphic strokes (to your left) to indicate branches caught in sunlight. The grasses and weeds in the foreground are painted with rough vertical and slanted strokes of heavy color to suggest their texture. The negative spaces between the branches and leaves are carefully designed: these spaces display an enormous variety of shapes and sizes which form an intricate and beautiful pattern.

7

TREES
AND
GROWING
THINGS

Trees, cacti, grasses, weeds, and wildflowers are the living things that "populate" the landscape. If you're going to paint landscapes, you've got to study these growing things as closely as the portrait painter studies the human face and figure. You can't get away with painting amorphous masses of green, punctuated by a few dark strokes for trunks and branches. If the viewer knows something about trees, he should be able to look at your painting and identify the specific kind of tree by its unique shape and its pattern of trunk, branches, and twigs. You should know enough about the personality of trees so that you could (if you wanted to) paint a "portrait" of a specific tree, so that people who live nearby would recognize it as an old friend.

STUDYING TREES

You probably know that there are two types of trees: deciduous trees, which lose their leaves in the winter; and evergreens, which keep their greenery all year round. The best time to study both these kinds of trees is in the winter. When deciduous trees lose their leaves, you can really study the pattern of the trunk and branches and see how to build the foliage over this skeleton, very much as the figure painter studies the human skeleton so he can build muscles and skin over the bones. Since evergreens don't lose their greenery in cold weather, it's hard to study their bare skeletons; but because there's less foliage around to distract you, it's easier to study evergreen *silhouettes* in the wintertime and I think it's somewhat easier to puzzle out their skeletons too.

As deciduous trees begin to leaf out in warmer weather, you can see how the masses of leaves relate to the tree skeleton underneath. Study these masses from a distance—outlined against the bare sky if possible—and memorize the overall silhouette. Then move in closer to study the three-dimensional forms: the big clumps of foliage, which may be blocky, spherical, conical, or even elliptical. These masses of leaves won't *really* take precise geometric shapes, of course, but it helps to visualize them that way, so you can paint them as three-dimensional shapes with planes of light and shadow.

Naturally, the best way to study trees is to make lots of drawings. Draw their skeletons in winter. Then, in the spring, draw the first

growth as it begins to emerge. Anytime in the year, you can draw the silhouettes of evergreens, but you've got to wait until summer to draw the silhouettes of deciduous trees in full leaf. Better still, make brush drawings of tree silhouettes in broad, flat strokes, so you stop thinking in terms of line and start thinking in terms of masses of paint. To study the planes of light and shadow, move in closer and try charcoal studies in big masses of tone—or make monochrome oil sketches in tones of gray and black.

COMPOSING TREES

When you're painting a landscape with lots of trees, the greatest danger is monotonous spacing. Above all, make sure you don't have equal spaces between all the treetrunks. Push some trees closer together and pull others farther apart. Study the spaces between the treetrunks and make sure that no two spaces are exactly the same size and shape. Paint some of the trees so that the masses of leaves merge, forming a variety of shapes. Don't make all the trees the same height; some should be taller and some shorter in your painting, even if they're not exactly that way in the landscape itself.

Unless you're painting a forest interior where you're literally walled in by trees, try to give the viewer some open space. Let some patches of grass or sky break through between the trees. No tree is ever an impenetrable mass of foliage; there are always some spaces between the branches and the masses of leaves. As the famed illustrator Harvey Dunn used to tell his students, "leave holes for the birds to fly through— big holes for the big birds and little holes for the little birds." Remember to design the spaces as carefully as you design the trees. Make sure that the sky shapes around the trees are as interesting and varied as the trees themselves. And when you're painting those holes that Dunn talks about, make sure that there are lots of different sizes and shapes.

Simplification is a particularly important compositional device. Don't paint all your trees in precise detail. Paint most of them roughly and broadly, emphasizing the broad shapes of trunks and leafy masses. Only the really important trees—where you want to focus the viewer's attention—should be painted in much detail. But don't paint every single leaf. Paint the big masses first, then indicate leaves, branches and trunk textures in selected areas— perhaps just those areas in direct sunlight or those edges which are silhouetted against the sky. Decide where you want the viewer's eye to go and then lead it there with touches of selective detail.

It's also important to be selective about light and shade. Although the sun may be shining brightly on every single tree, creating dramatic planes of light and shade wherever you look, you're free to play down these contrasts in your painting. Decide which trees are unimportant and alter the light and shadow pattern accordingly: darken the sunlit areas and lighten the shadow areas to reduce the contrast between them; or simply lighten or darken the entire tree so it offers less competition to the more important trees in the picture. Reserve the "spotlight effect"—the bright sunlight and the deep shadows—for the trees you want to place center stage.

BRUSHWORK FOR TREES AND GROWING THINGS

Trees and greenery give you more opportunity for spontaneous brushwork than almost any subject I can think of. It's enormous fun to match the subject with the appropriate brushstroke and (just as important) the appropriate paint consistency.

The massed needles of a spruce may suggest short scrubs of thick color, while the wispy growth of a willow may suggest long, lazy strokes with very little paint on the brush. The trunk and branches of an apple tree, constantly turning in on themselves, may need lots of quick, curving strokes of fluid color, but you may decide to paint the foliage in small dabs of thicker color. An old gnarled oak may call for lots of short strokes of thick color, while the slender trunk of a birch might be painted more effectively with long, graceful strokes of thin color.

But remember that these are all highly personal decisions. There's no one way to paint any tree. There are always several possible solutions to any one problem. One painter will render the domed mass of an elm with thin, curving strokes of fluid color; another painter will do the job just as effectively by piling on thick color with a palette knife. The important

When you paint closeups of trees, changes of scale and direction will keep your picture varied and interesting. This section of a woodland interior shows the contrast between the large, vertical shape of the nearby tree and the slender, diagonal shapes of the trees in the distance. The eye is also intrigued by the alternation of the dark tree shapes and the luminous shapes of the sunlit spaces between the trees. These contrasts of vertical and diagonal, light and dark, positive and negative, create a feeling of endless variety.

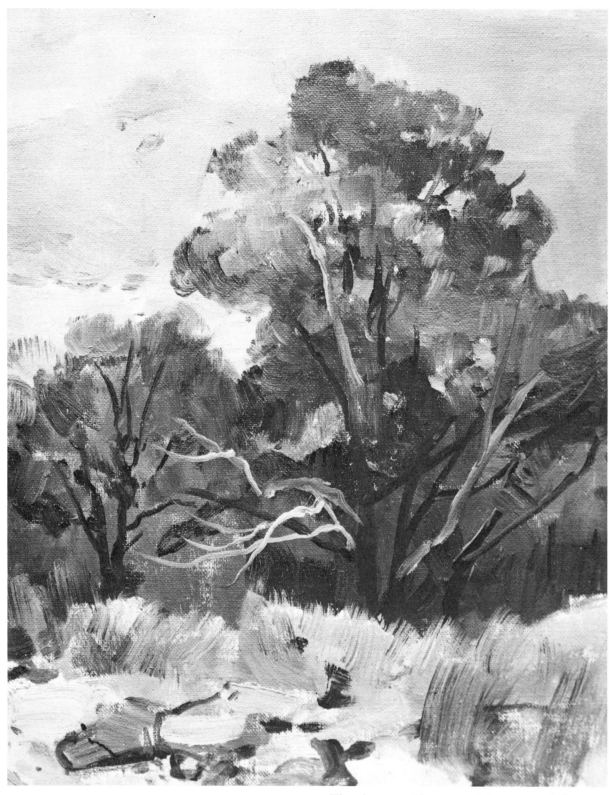

The clusters of leaves and the grasses below are painted with a broad, flat brush that makes big, soft strokes to match the character of the subject. A slender brush picks out the trunks and branches.

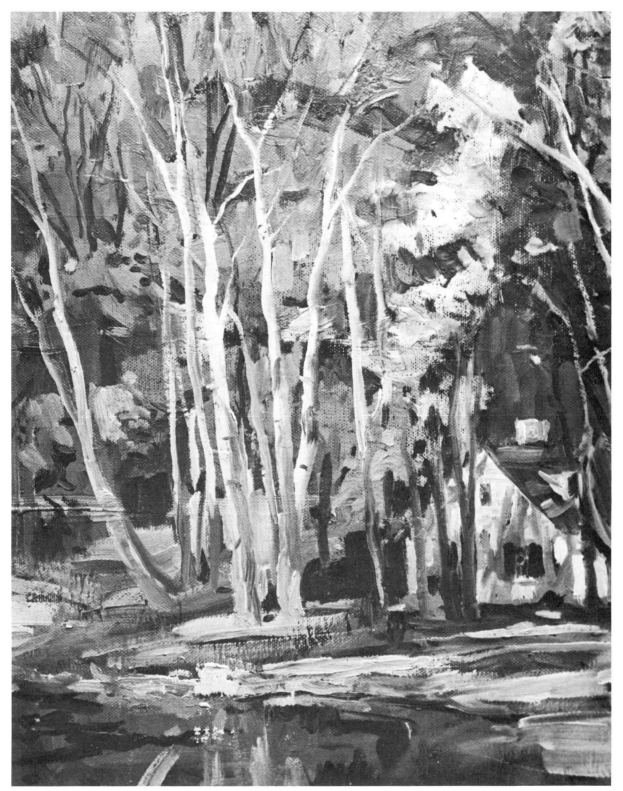

Matching the brush to the subject, the artist uses
a slender brush to trace the rhythmic, sunlit trunks
and branches. The splashes of light on the fore-
ground are also painted with long, slender strokes.
The artist literally draws with the brush.

thing is to *experiment* with different kinds of strokes and paint qualities until you find what's most natural to *you*.

Having said that there are no rules for painting trees, the closest thing to a rule is: "Keep your edges soft!" Trees shouldn't look like paper cutouts. The foliage of each tree should merge softly into that of the next tree. Even if the tree is spotlighted by the sun or silhouetted against a bright sky, the edges of the shape should be feathery, never harsh.

Grasses and weeds, too, should never look harsh and precise, like strands of wire. They should be painted with a soft touch so that the strokes melt into one another.

TREE COLORS

When Richard Schmid was working on his excellent book on landscape painting, he was tempted, for a moment, to call it *Do You Think It's Too Green?* That's the question he often asks his wife when he's working on a landscape with lots of trees and other greenery. There's always so much green around that the biggest problem is how to keep your color varied and interesting.

Even if the landscape looks like one continuous mass of spinach—as it often does in midsummer—it's your job to discover or create the variety that your picture needs. Begin by reminding yourself that there's no such thing as "green," but that there's an infinite variety of greens. Green can lean toward yellow, brown, gray, blue, or black. In the spring, there are even reddish and purplish greens! If you can find these in that monotonous green landscape, exaggerate them. If you can't find them, you may just have to invent them.

The key to color variety is establishing an effective balance of warm and cool tones. Push some of your greens toward yellow or brown to introduce some warm notes. Moving in the opposite direction, cool off some of your greens by pushing them toward blue or gray. No matter how bright they may look in nature, you're free to paint unimportant masses of foliage a subdued gray-green or even the smoky blue of distant objects in aerial perspective. To pull a shape forward in your picture, you're equally free to exaggerate the brilliance of sunlit foliage by adding lots of golden yellow. If you let enough sky break through, you can break up those greens with sky colors; try working some of them into the shadows, as the impressionists did.

Learning to mix greens is one of the great adventures of landscape painting. As I pointed out in Chapter 2, *Colors, Mediums, and Varnishes,* you can mix far more interesting greens than you can buy in tubes. Here are just a few of the possibilities.

Phthalocyanine blue and cadmium yellow will give you the most brilliant green you're likely to need; it's the closest thing to the dazzling green of summer trees in full sun. If you increase the yellow and decrease the blue, you'll get that gorgeous yellow-green or greenish yellow that you sometimes see when a patch of grass is spotlighted by the midday sun. With the more subdued yellow ochre, phthalocyanine blue produces a deep green that's especially good for painting evergreens. When you add a touch of white to these mixtures, the bright green loses some of its intensity and is less likely to pop out of the picture (though it's still strong), while the deeper green takes on a smoky, atmospheric tone which is fine for distant evergreens and masses of foliage in aerial perspective.

Ultramarine blue and cadmium yellow produce a delicate green which is bright but tender, like the first growth on many young trees in springtime. Blended with yellow ochre, ultramarine blue gives you an olive tone which is somewhat grayish, something you might want to try as a shadow color.

Before we had phthalocyanine blue, the closest thing was Prussian blue, which many painters still prefer because they feel that it produces greens which look more "natural." Prussian blue and cadmium yellow yield a rich, vivid green, which becomes softer and more atmospheric when you add white. Blended with yellow ochre, Prussian blue gives you a deep, bluish green which looks like blue spruce; this mixture turns into a more remote "background green" when you add white.

Ivory black also functions like a blue when you add yellow. With cadmium yellow, ivory black produces a rich olive. Mixed with yellow ochre, ivory black gives you a smoky brown-green, a color you often see in the woods on a rainy day.

For the deep, blackish green of evergreens

A flowering tree or a cluster of wildflowers will always look most brilliant against a simple, broadly painted background. Behind this dazzling array of blossoms, there's nothing more than a few broad color areas, mostly darks and halftones, freely brushed wherever they're needed to enhance the touches of bright color laid over them.

When you're painting huge masses of trees—like this tree-covered hillside—one of the greatest problems is to avoid the monotonous look of endless greenery. You've got to introduce variety by suggesting darks and lights, warm and cool tones, and changes in texture. Although not a single distinct tree appears on the hillside, you get the feeling that there are whole clusters of dark and light trees, open spaces, patches of sunlight, and even cloud shadows. And the entire hillside is modeled as a single three-dimensional form, with a light side to the upper right and a shadow side to the lower left.

deep in the woods, try mixing phthalocyanine blue, cadmium yellow, and a bit of black. For the mysterious, smoky gray-green that's so useful for effects of aerial perspective, try mixing phthalocyanine or Prussian blue, burnt sienna, and white. For the many brownish greens that you need to fight the "spinach effect" I warned you about a moment ago, try adding a warm color like burnt umber, burnt sienna, alizarin crimson, or a bit of cadmium red light to your blue-yellow mixtures.

But what about autumn trees, which aren't green at all, but all sorts of hot colors? The most brilliant orange you can mix is a combination of cadmium red light and cadmium yellow light, but this mixture is likely to be so brilliant that it will pop right out of the picture and look hopelessly garish. For autumn colors, it's the earth colors that produce warm tones that are both bright and true to nature. For golden tones and golden browns that don't pop out of the picture, try yellow-brown combinations: experiment with your two basic yellows, cadmium yellow light and yellow ochre, and your two basic browns, burnt umber and burnt sienna. For reddish browns, add alizarin crimson, but stay away from cadmium red light, which can push such mixtures toward a strange, brick red. To darken these brownish mixtures, add a touch of blue. And you can expand your range of golds, red-golds, and luminous browns by bringing in "optional" earth colors like raw sienna or the very powerful Venetian red.

Although treetrunks tend to be in the gray or brown range, these subtle colors are more varied than you might think. For some suggestions about mixing a variety of grays and gray-browns, look back at the preceding chapter.

Above all, remember that no color exists in isolation; every color is profoundly influenced by the colors that surround it. The gold and green of sunstruck foliage looks even brighter against a muted, gray-green background of distant trees. Wildflowers are usually delicate in color, but those yellow daffodils look brilliant because of the green grass and weeds that surround them. A blue or gray sky and some green trees will make the hot colors of autumn foliage seem more vivid. It's not enough to learn how to mix bright colors. They won't work until you learn how to mix the subdued background colors which set the stage.

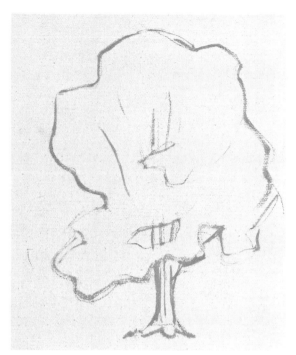

Step 1. The first drawing establishes the leafy mass as one big shape and suggests a couple of large "sky holes." Although these brushlines will soon be gone, the contours are carefully observed.

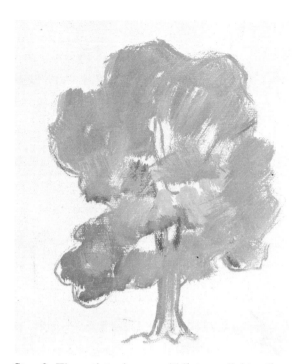

Step 2. The artist mixes a middletone, lighter than the shadows and darker than the lights, which he brushes across the entire tree shape. This middletone defines not only the leafy mass, but also the negative shapes where the sky shines through.

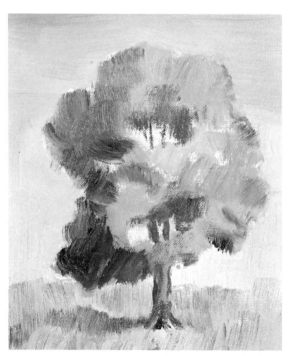

Step 3. Now the painter blocks in the shadows that make the tree three-dimensional. He also brushes in the sky tone (which merges softly with the foliage) and the ground color. Notice the soft transition between the tree and the grass.

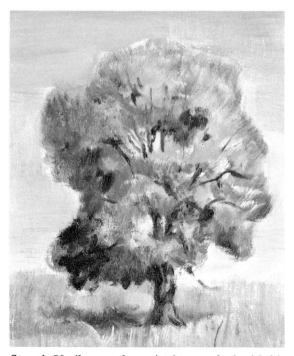

Step 4. Until now, the artist has worked with big brushes. Now smaller brushes pick out the lights, extend the middletones into the darks, suggest the leafy texture, and add details like more branches.

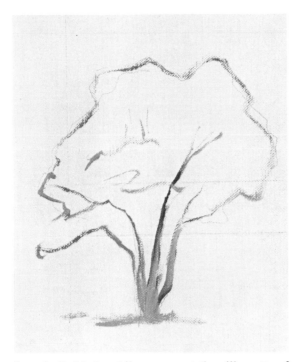

Step 1. Quick brushlines suggest the silhouette of the tree, block in the middletone of the trunk, and suggest a cast shadow that anchors the trunk to the ground.

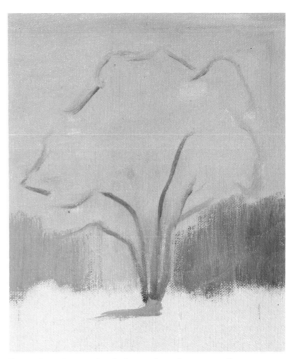

Step 2. The artist brings the sky tone down over the original brushlines and adds some darker tones at the horizon to suggest distant trees. The sky tone partially obliterates the original drawing of the tree, so he quickly redraws some of these guidelines.

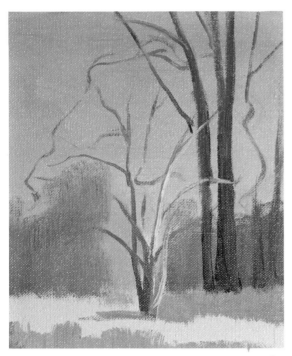

Step 3. Before going any farther with the tree, the artist completes most of the background, adding distant trunks and more ground color. Then he begins again on the trunk of the flowering tree, defining lights and darks more precisely.

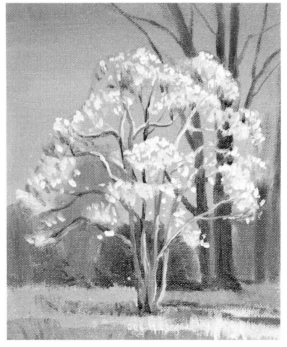

Step 4. Foliage, flowers, and the complete pattern of branches are saved for the final stage. They're painted into the wet background tones, each stroke melting into the color beneath. Thus, the tree becomes part of the total atmosphere.

Step 1. The original charcoal lines are reinforced by brushlines that indicate not only the silhouette of the tree, but the shapes of the "sky holes" and the tierlike internal structure of the foliage.

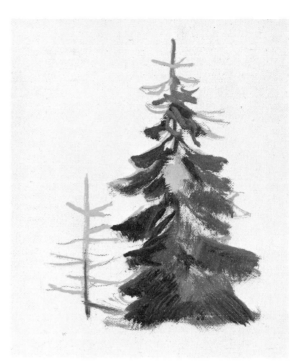

Step 2. With broad strokes, the artist blocks in the darks and middletones of the tree, plus a touch of light on one central branch. He paints these shapes very casually, knowing they'll disappear partially in the next step.

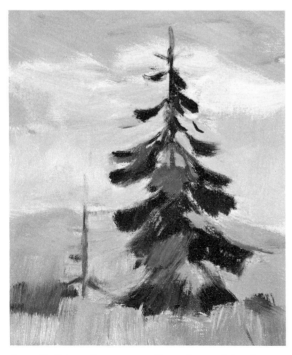

Step 3. Now the surrounding sky and landscape tones are brushed around, into, and partially over the original tree strokes. The silhouettes of both trees are partially obliterated, but the artist retains just enough to recall the big shapes.

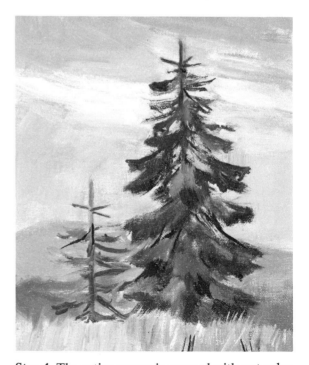

Step 4. The entire canvas is covered with wet color and the artist paints his final tree strokes into this "wet skin." The soft edges of the trees blend into the surrounding sky and landscape. Small strokes add darks, lights, and details.

Step 1. A highly expressive brush drawing, beautiful in itself, captures the shape of the treetrunk and expresses its rugged texture. This brush drawing is so important that it will never completely disappear in the later stages.

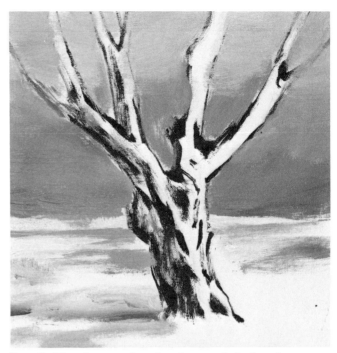

Step 2. The sky tone is painted around the brush drawing, which is obscured but never obliterated. The artist begins to block in darks and suggests texture. The cast shadow gives the trunk greater solidity.

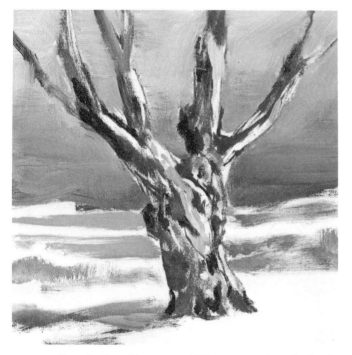

Step 3. He adds more middletones and works back into the darks to further develop the pattern of light and shade. The lights of the branches are bare canvas. The branches are brushed back into the wet sky tone to create soft transitions.

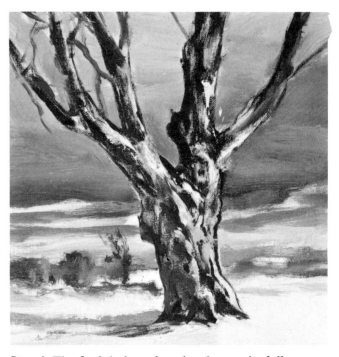

Step 4. The final dark strokes give the tree its full roundness. He covers bare portions of the canvas with heavy color to suggest snow and sunlight. Smaller strokes indicate lesser branches. The upper branches blend softly into the sky.

Step 1. The original charcoal lines—which you can see in the upper part of the picture—are partially covered with brushlines that establish the precise tilt of the trunks and indicate the main branches. A single line creates the horizon.

Step 2. The sky tone virtually obliterates the drawing. The artist paints back into the wet sky to re-establish the trunks and main branches. Notice the soft edges of the trunk and branches; the fresh strokes mix with the sky tone.

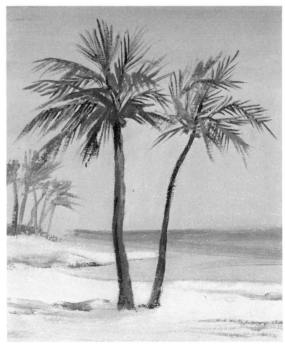

Step 3. The foliage is further developed and distant palms are now indicated with casual strokes that also melt into the background tone. The artist also exploits the texture of the canvas to break up his strokes and suggest the texture of the tree.

Step 4. Darks are added to the trunks to emphasize their cylindrical form. Light and dark strokes complete the foliage, suggesting branches in light and shadow. Some are painted in crisp strokes; others melt into the background.

Step 1. Three different kinds of cactus are carefully drawn with a pointed brush to capture the precise contours that the artist hopes to retain in the final stages of the picture.

Step 2. A broad background tone surrounds the brushlines, overlapping them slightly. Because the shadow pattern on the largest cactus is particularly intricate, the artist blocks in the main shadows beneath the leaves.

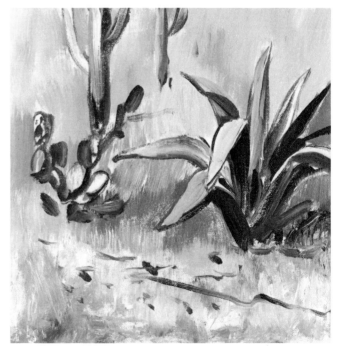

Step 3. Having established the direction of the light—from the upper left—he now adds dark strokes to the shadow sides of the smaller cacti and adds further shadows to the large one. The brush drawing is reinforced, not obliterated.

Step 4. Middletones and touches of light make the upper cacti look cylindrical, model the egg shapes beneath them, and make shapes jut forward or back in the large cactus. Cast shadows connect the cacti with the sand.

Step 1. A rough brush drawing defines the horizon and the shapes of trees and sky. The artist scrubs in a sky tone at the edge of the meadow, then begins to block in a few shadow areas within the meadow itself.

Step 2. With a broad brush that carries just a little dark color, he divides the grasses and weeds into light and shadow areas, also suggesting the direction and texture of the greenery. Large strokes block in the trees.

Step 3. He divides the grasses and weeds into distinct areas of light and shadow. What was once sky is now softened to become a distant, shadowy portion of the meadow. The entire picture is painted in very soft focus.

Step 4. With a slender, pointed brush, the artist works back into the wet color to suggest individual stems and blades. Precise strokes are used sparingly, mostly in the foreground. Details are suggested, never carried too far.

Step 1. The picture begins like the previous demonstration of grasses and weeds. Sky, distant trees, and the large shape of the meadow are established with broad strokes. Light, scrubby strokes suggest shadow areas and the texture of the undergrowth.

Step 2. The entire meadow is now covered with scrubby vertical and diagonal strokes that suggest an intricate pattern of lights and shadows, growing darker in the foreground where a few details begin to emerge.

Step 3. The artist experiments with lights and shadows on the meadow, which he lightens here, darkens there. The undergrowth provides a soft-focus background for the precise strokes of the first flowers.

Step 4. He paints the precise shapes of a few wildflowers in the foreground; the rest are tiny flecks of color in the distance. The foreground is darkened to emphasize the sunlit flowers painted over it. The flowers are painted with quick, dashing strokes.

COLOR
DEMONSTRATIONS

Step 1. Because the desert and the distant mountains will be painted mainly in warm colors, the preliminary brush drawing is executed in an earth brown, modified by a hint of blue. The contours of the mountains are carefully observed and the lines in the foreground define the road and the shape of a large diagonal shadow.

Step 2. The artist blocks in the major dark areas of the painting first, using mixtures of earth colors and blue. A strong blue is needed here, like phthalocyanine or Prussian, combined with red-brown earth colors like burnt sienna or Venetian red, plus an earth tone in the yellow-brown range like yellow ochre or raw sienna. Hotter tones, like those at the foot of the mountains, are mixtures of red-brown and yellow-brown earth colors muted with just a hint of blue. Light red is another red-brown earth which gives results similar to Venetian red.

Step 3. The more brilliantly lit areas of the middleground are brushed in with broad strokes of yellows and oranges. Here again, mixtures of yellow-brown earth tones (like yellow ochre or raw sienna) and red-brown earth colors (like burnt sienna, Venetian red, or light red) can be heightened with touches of cadmium red light and cadmium yellow light for greater intensity. The clouds are a warm blue (ultramarine or cobalt), alizarin crimson, yellow ochre, and white. To develop the various warm and cool tones in the sky, the artist varies the proportions of these three primary colors.

Step 4. The muted yellows of the foreground are predominantly yellow ochre, modified by other earth colors in the brown and red-brown range. Into the wet color of the mountains and the big diagonal shadow, the artist brushes cooler middle-tones: earth colors containing more blue and white. The warm tones of the sky are predominantly a warm blue (like ultramarine or cobalt), alizarin crimson, yellow ochre, and white. The greens of the cacti can be a yellow-blue blend (cadmium yellow light and phthalocyanine or Prussian blue) or even a yellow-green combination (cadmium yellow light and viridian).

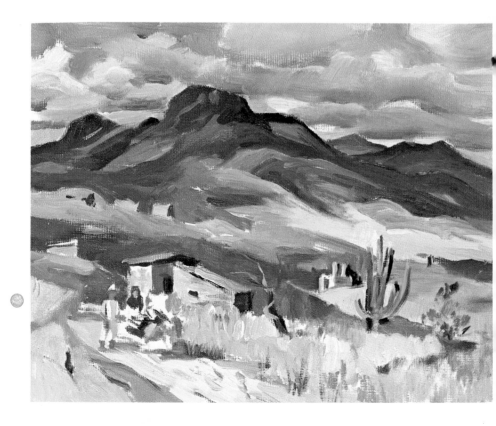

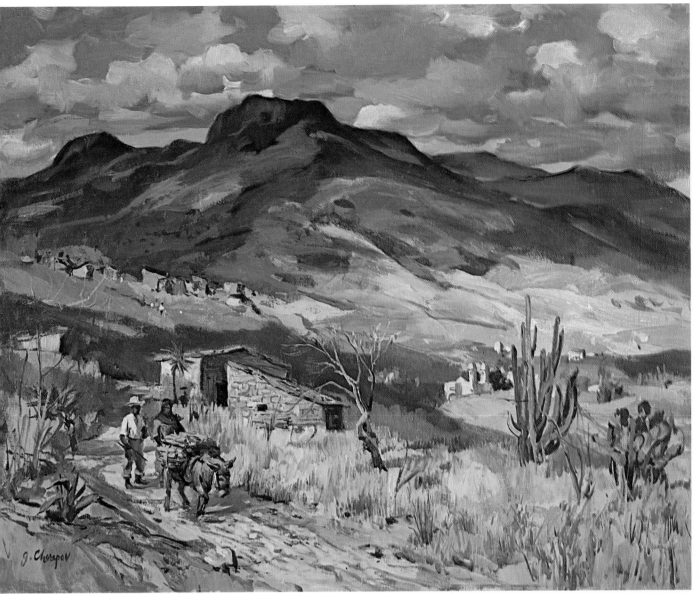

Step 5. In this final stage, the blues of the sky are deepened and more cool notes are introduced into the mountains to make them lie farther back in the picture. Additional yellows are introduced into the landscape at the foot of the mountains. Many more cool notes are introduced into the dusty yellow of the foreground. Notice that the figures and the burro actually cast cool shadows on the warm tone of the road. Now the artist adds small strokes to suggest details like the texture of the stonework in the houses, the texture of the road, the trunk and branches of the tree in the center, and the forms of the cacti, which are rendered in crisp, dark strokes. For this type of desert landscape, the palette would rely primarily on yellow-brown earth colors like yellow ochre or raw sienna; red-brown earth colors like burnt sienna, Venetian red, or light red; a more subdued earth brown like burnt or raw umber; a strong, cool blue like phthalocyanine or Prussian; a warmer, more delicate blue like ultramarine or cobalt; cadmium red light and cadmium yellow light for occasional hot notes; alizarin crimson for the warm tones in the sky; and possibly cerulean blue for the bright blues in the sky.

Step 1. After making a quick brush drawing in cool tones (blue softened with a touch of brown) that reflect the general color of the landscape, the artist blocks in the planes of the mountains in mixtures of a warm, subdued blue (like ultramarine or cobalt), yellow ochre, and alizarin crimson. Notice that each shape gradates from dark at the top to light at the bottom, making the divisions between planes more distinct. The cloud forms are begun with mixtures of these same three primaries softened with more white.

Step 2. The brighter tones of the foreground are now brushed in. These brilliant yellow-greens, with a hint of ruddy warmth, can be yellow-blue mixtures (cadmium yellow light and ultramarine or phthalocyanine for greater intensity) or yellow-green combinations (like cadmium yellow light and viridian or phthalocyanine green for greater intensity), warmed with a hint of cadmium red light or burnt sienna. The darker greens of the trees can be blue-brown combinations (like phthalocyanine or Prussian blue and burnt sienna) or green-brown combinations (like viridian and burnt sienna). The dark shadows beneath the trees are a similar mixture.

Step 3. Brighter greens are now introduced into the trees in the right and left foreground. Like the grass, these greens can be yellow-blue combinations or yellow-green combinations: cadmium yellow light; ultramarine for a more delicate green; phthalocyanine or Prussian for a stronger green; viridian or the more brilliant phthalocyanine green. The warm notes in the trees are a red-brown earth color like burnt sienna or Venetian red, though the latter is so powerful that it must be used sparingly. The sky is warmed with more yellow ochre. The nearest mountain range is darkened with more blue to make a more distinct separation from the distant ranges.

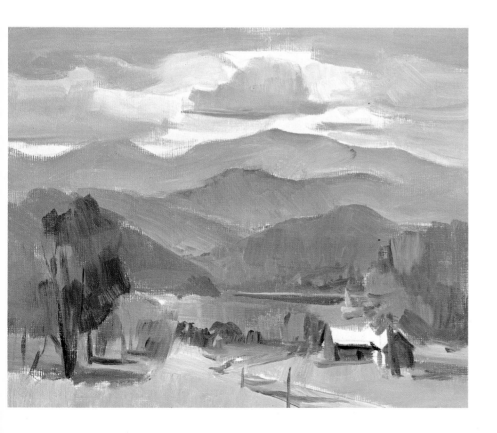

Step 4. The artist warms the grass with more hot color like cadmium red light or burnt sienna and adds a warm reflection (alizarin crimson) in the lake. The shape of the road is sharpened; fenceposts are added for perspective; and he blocks in the house, along with the shadows to the right. The house is a blue-brown mixture and the hot tone in the road contains cadmium red light. Notice that the artist is still experimenting with the shapes of the distant mountains. The lake is painted in the same blue-crimson-yellow-white mixtures used in the clouds.

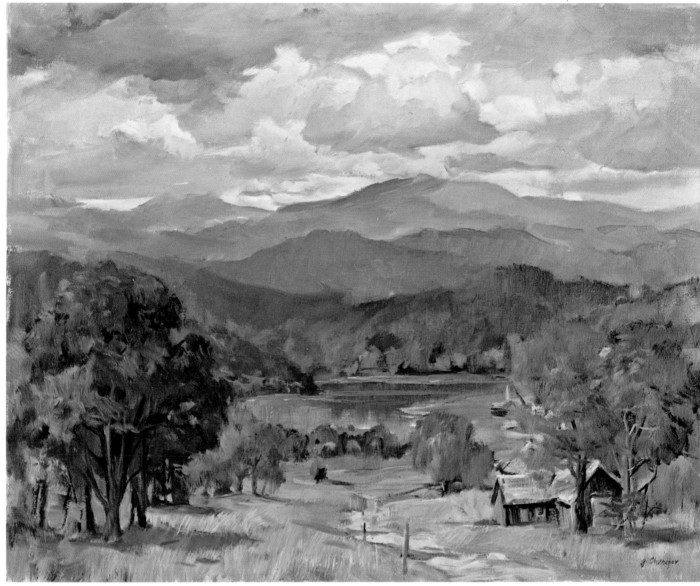

Step 5. The multiple planes of the mountains are now clearly defined as the artist works on final details (sunlit foliage, foreground grass, treetrunks and branches) and begins to subdue his colors. It's always a lot easier to start with strong colors and then subdue them, rather than start with muted colors and then struggle to heighten them later on. The artist now begins to introduce many more cool notes in the sky—more blue, a hint of yellow ochre, and white. The nearest mountains are darkened with more blue and the reflections in the lake are still more clearly defined. The darks of the trees are strengthened by mixtures that can be blue-brown or green-brown combinations (like burnt sienna and ultramarine blue or viridian) with touches of brighter color (cadmium yellow light, cadmium red light, and ultramarine or viridian) to suggest sunlit details of foliage. In choosing a palette for this type of landscape, remember that ultramarine blue will give you more delicate greens, while phthalocyanine or Prussian will give you more vivid greens; viridian will give you bright greens and phthalocyanine green will make them brighter still; cadmium yellow light is essential; cadmium red light, alizarin crimson, burnt sienna or Venetian red are important for the warm tones. In the sky, you may prefer cobalt blue to ultramarine.

Step 1. The grayish brush drawing defines the trees in the foreground and the artist pays particular attention to the gnarled tree to the left, which he draws in much more precise strokes than the rest of the landscape. Except for a few strokes to suggest distant treetrunks, he makes no attempt to draw the intricate foliage. This will be developed later in broad strokes. Grays, like the tones of this brush drawing, should be blue-brown mixtures rather than steely black and white.

Step 2. The most complex single form in the painting is the old tree, which the artist begins to paint in a beautiful range of grays. Such colorful grays are always mixtures of blues (ultramarine, phthalocyanine, or Prussian) and earth browns (burnt umber, raw umber, burnt sienna, or Venetian red) with yellow ochre for a suggestion of golden warmth. The hot notes at the edges, particularly the reflected light in the shadows at the left, can be burnt sienna or Venetian red. This brilliant note of reflected light will be muted later on, but it's always best to start out with strong colors and subdue them in the final stages of the painting.

Step 3. Brilliant green and green-golds like those in the foreground are yellow-blue or yellow-green combinations. Cadmium yellow light and phthalocyanine blue (or Prussian blue) will yield particularly brilliant greens and yellow-greens. So will cadmium yellow light and viridian or phthalocyanine green. These sunlit portions are also warmed with a reddish tone like cadmium red light or burnt sienna. The shadow areas of the road are mixtures similar to the treetrunks, while the lighted portions contain yellow ochre, a touch of cadmium red light, and a fair amount of white.

Step 4. The foreground mixtures—the brilliant greens and yellow-greens—are carried back into the distant trees. The sunny yellow-greens are warmed with cadmium red light. Pale blues (ultramarine or the more delicate cobalt can be most useful here) are introduced into the birches to the right. Touches of the bright road color are dashed in along the edges of the treetrunks on both sides of the road. Cool notes, containing more blue, are brushed into the shadows on the road. For the touches of really deep green, there are various possibilities: phthalocyanine or Prussian blue with burnt sienna; or viridian with burnt sienna.

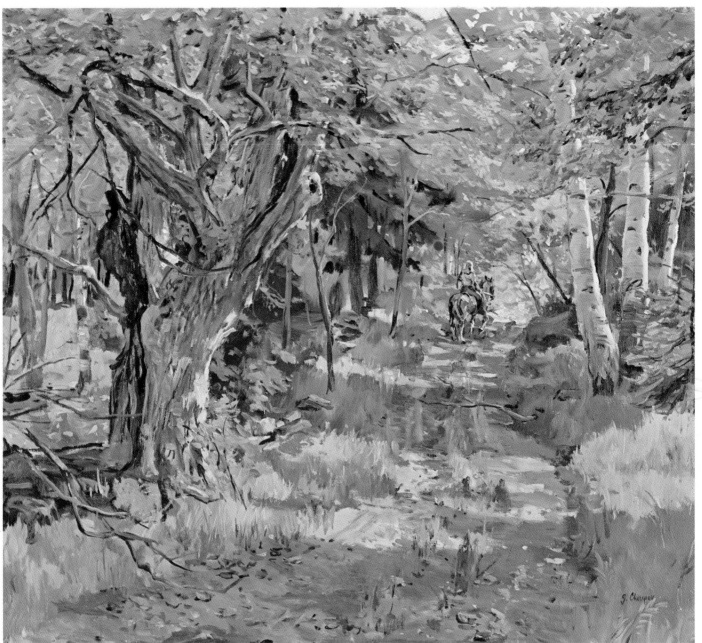

Step 5. Now that the entire canvas is covered with wet color, the artist moves back in with smaller brushes to suggest details. Throughout the foliage he adds touches of yellow-green to suggest leaves caught in the bright sunlight. Pebbles and weeds are painted on the road, which contains cooler notes in the shadows. He also subdues the sunlit patches of the road with yellow ochre and white. Cooler grays, containing more blue, are painted into the gnarled treetrunk, though a hint of the warm shadow remains on the left-hand side. The horse and rider are added, along with more branches, grasses, and weeds. "Sky holes" are added at the top. The patches of light on the tree-trunks are made paler. The palette for such a sunny picture would have to contain the two basic yellows, cadmium yellow light and yellow ochre; phthalocyanine or Prussian blue for the richer green mixtures and the powerful darks; ultramarine blue (or perhaps cobalt) for the more delicate greens, and warm and cool grays; cadmium red light, burnt sienna, or Venetian red for the warm notes; and viridian or phthalocyanine green as an alternative to blue in some of the green mixtures.

Step 1. The artist draws the treetrunks in warm tones that suggest the generally warm tonality of the colors to come. Then he begins to block in the sky with delicate mixtures of the three primaries. For a particularly airy sky tone, he prefers cobalt blue to the slightly heavier ultramarine, plus alizarin crimson, yellow ochre, and white.

Step 2. He begins to brush in the darks of the nearby treetrunks and suggests the dark shape of a fallen log in the foreground, working with burnt umber, a heavier, more subdued brown than most other earth colors. The sky colors are carried down to the horizon with deeper mixtures of cobalt blue, alizarin crimson, yellow ochre, and white.

Step 3. The artist now brushes warm colors across the foreground, keeping these more subdued than the hotter tones of the trees. For such foreground tones, the yellow-brown and red-brown earth colors—yellow ochre, raw sienna, burnt sienna—are particularly effective, heightened with cadmium yellow light or cadmium red light. The large areas of the foliage are brushed in with brighter mixtures of cadmium yellow light, cadmium red light, and alizarin crimson, softened with white, earth browns, and an occasional hint of a warm, subdued blue like ultramarine or cobalt. Notice how the sky colors are carried in among the trees.

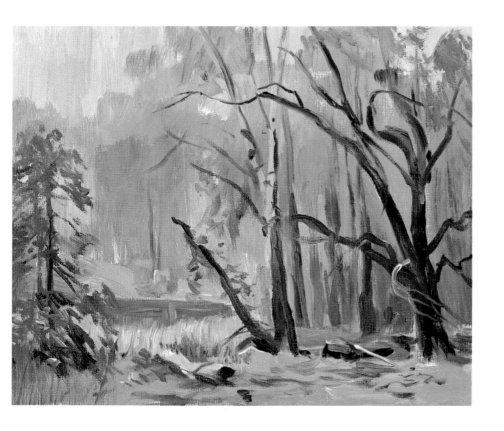

Step 4. Now that the entire canvas is covered with wet color, the artist begins to define the shapes of the treetrunks, the edges of the foliage, and the trees at the left. The darks of the treetrunks are mainly burnt umber, modified with white, blue, and an occasional trace of alizarin crimson. The tree to the extreme left is mainly alizarin crimson and ultramarine blue. Notice how pale blue "sky holes" begin to appear among the trees.

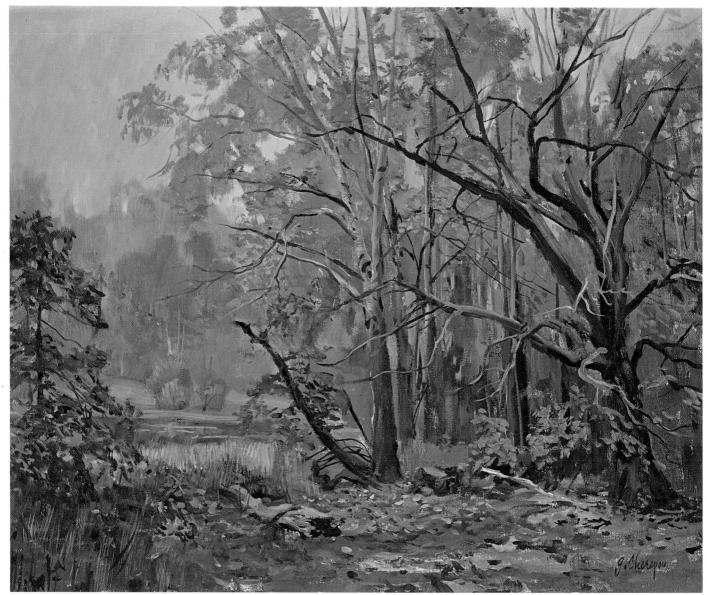

Step 5. With all the broad shapes blocked in, the artist can now concentrate on details. Bright touches of yellow, yellow-orange, and orange are added selectively to the foliage. Blue "sky holes" break through the warm tones of the foliage. With a slender, pointed brush, he traces the lines of branches and twigs, grasses and weeds along the ground, and fallen leaves. The hot touches of cadmium yellow light and cadmium red light are slightly muted with earth colors to prevent them from popping out. Notice the hints of blue that have been introduced among the treetrunks to make the darks cooler. The most important colors on the palette for this type of picture would be cadmium yellow light and cadmium red light, of course; a subdued blue light like cobalt or ultramarine, perhaps with some help from phthalocyanine or Prussian in the darks; alizarin crimson, used sparingly; and a range of earth colors that would include yellow ochre or raw sienna, burnt sienna or Venetian red, and burnt umber for the heaviest browns—provided that this somber color isn't allowed to invade the brighter colors on the canvas.

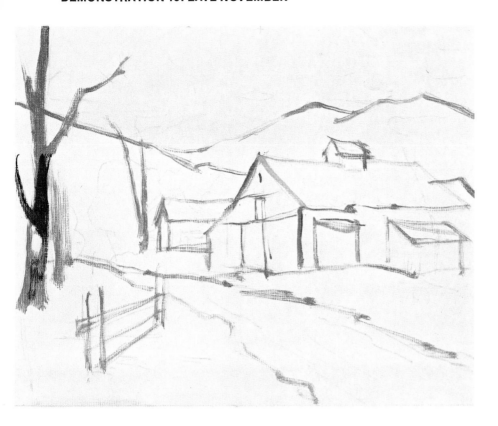

Step 1. The main lines of the buildings, roads, fence, trees, and distant mountains are drawn in a subdued mixture of brown and blue. The artist begins to block in the dark trunk of the tree to the left in a darker version of the same mixture. The perspective lines in the buildings are carefully observed, despite the casual quality of the drawing. And even the irregular edges of the road are in correct linear perspective.

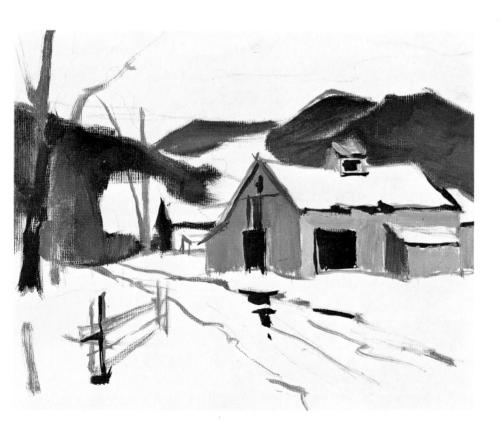

Step 2. The deep blues of the hills are blocked in with a strong, cool blue (either phthalocyanine or Prussian would do here), slightly modified by a red-brown earth color (Venetian red or burnt sienna would be best). The colors of the barn—both on the lighted side and on the shadow side—are a similar earth brown-blue mixture. The strongest darks on the barn contain burnt umber. At the extreme left, the artist begins to introduce a red-brown earth tone for one of the autumn trees.

Step 3. The blue-brown mixture of the hills is extended into the sky, warmed with yellow ochre and lightened with white. More red-brown earth colors are introduced for the distant trees; the one golden red tree—at the center of the picture, just beyond the barn—becomes more brilliant as the artist brushes in some cadmium yellow light. Notice how the sky tones are carried down into the wet color of the hills, creating soft transitions. The foreground is still bare canvas, though this will be covered completely in the next step.

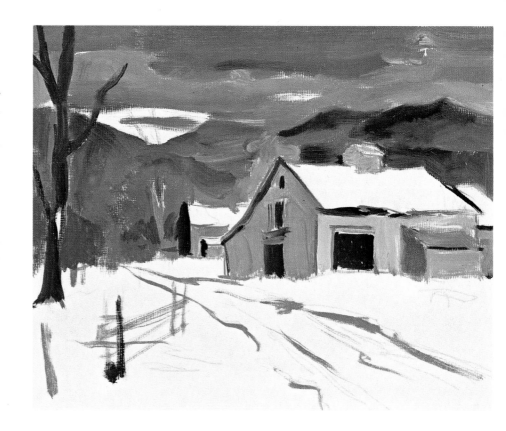

Step 4. The subdued autumn color mixture of the grasses and weeds in the foreground begins with cadmium yellow light, but can then be modified with either a subdued blue like ultramarine or even viridian, and further toned down with an earth color like burnt sienna. The muddy road is a blue-brown mixture. The "broken color" in the foreground is particularly interesting because you can see that the colors were just partially mixed on the palette and never completely blended on the canvas.

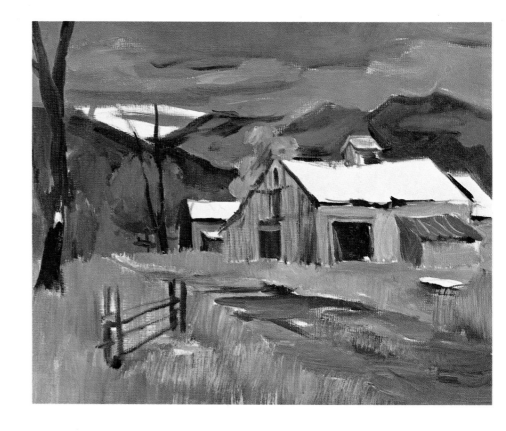

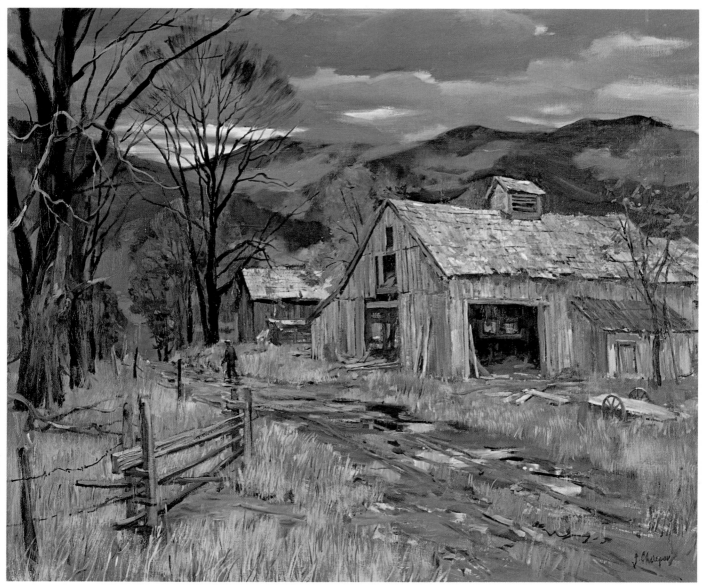

Step 5. To cool the sky, lighten the mountains, and tie them together, the artist works back into the wet color with more blue and white, slightly warmed with yellow ochre. The barn is textured with strokes of cooler color (mixtures of blue, brown, and white) which also appear in the rooftop, warmed with touches of yellow ochre and burnt sienna. The sky mixtures are reflected in the pools in the road. The growth in the foreground is both warmed and lightened by strokes that combine yellow ochre, burnt sienna, white, and a hint of blue, in varying proportions. The artist works on details like the darks of the fence, trees, and architecture with blue-brown mixtures. The bright spots in the sky are completed with white that's toned with the slightest amount of blue and yellow ochre. For a moody painting like this one, with its many tones of blue and blue-gray, you could really get along entirely with phthalocyanine or Prussian blue, although ultramarine blue would be helpful in some of the grays. The two red-brown earth colors, Venetian red and burnt sienna, are both important, as is the old standby, yellow ochre. For the red and gold notes, cadmium red light and cadmium yellow light would be helpful. Burnt umber is a good color for "accents" like the darks of the treetrunks and the interior of the barn.

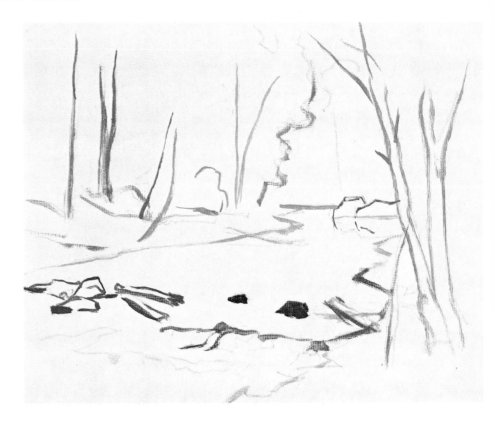

Step 1. The preliminary brush drawing focuses on the shape of the stream—the shorelines are carefully drawn—and indicates a few other details like floating logs, rocks, and the more important treetrunks on either side of the water. The leafy edge of the central tree upstream is drawn, since this tree will account for the strongest reflection in the water, which will become apparent in Step 2.

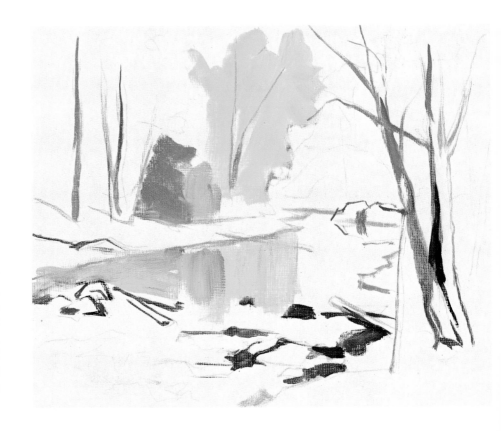

Step 2. The brightest reflection in the water will be the brilliant tree in the center, so the artist blocks in both the tree and its reflection in cadmium yellow light, with just a hint of cadmium red light. The orange reflection and the small tree above it are also a blend of cadmium red light and cadmium yellow light, with a greater proportion of red. The note of green—cadmium yellow light and ultramarine blue or viridian—will be an important note of relief among all this hot color. At this stage, it's obvious that most ot the "water colors" will actually be the hot colors of the landscape that surrounds the stream; very little of the water will be cool.

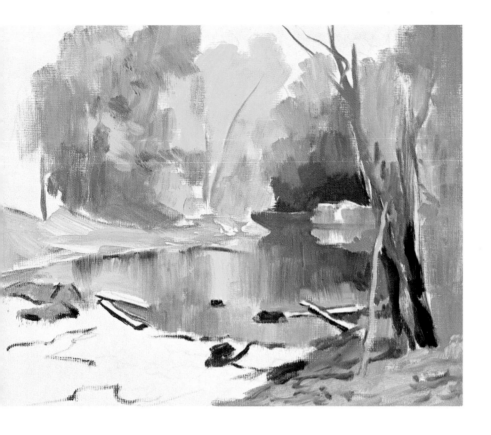

Step 3. Because the water takes its color from its surroundings, the woodland colors and their reflections are painted at the same time. Mixtures of cadmium yellow light and cadmium red light are modified by burnt sienna and a touch of ultramarine blue for the darker notes. The strong violet note is ultramarine blue and alizarin crimson. The grays of the rock and treetrunks are blue-brown mixtures, which could be ultramarine blue and burnt sienna or burnt umber. The blue sky and the blue rapids in the foreground are still unpainted, so they remain bare canvas here. They'll be painted at the same time in Step 4.

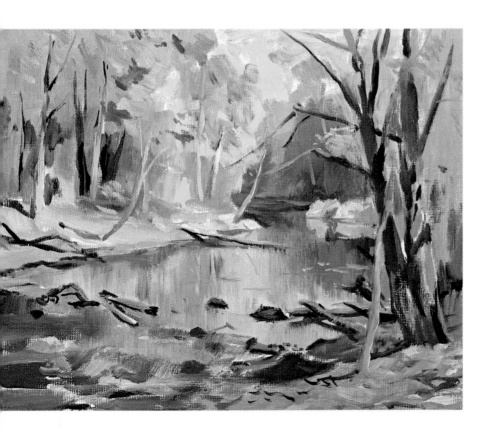

Step 4. Now the artist concentrates on the blue note of the sky, which is reflected in the rapids in the foreground. The sky is the artist's favorite combination of cobalt blue, alizarin crimson, yellow ochre, and white. In the rapids, the same combination is intertwined with the hot reflections of the forest; the darks are a blue-brown combination like ultramarine or phthalocyanine and burnt sienna or Venetian red. Dark strokes of this same type of mixture begin to define treetrunks, fallen logs, and rocks. The trees in the upper left are carried out to the edge of the canvas. The artist begins to suggest foliage and fallen leaves with smaller strokes.

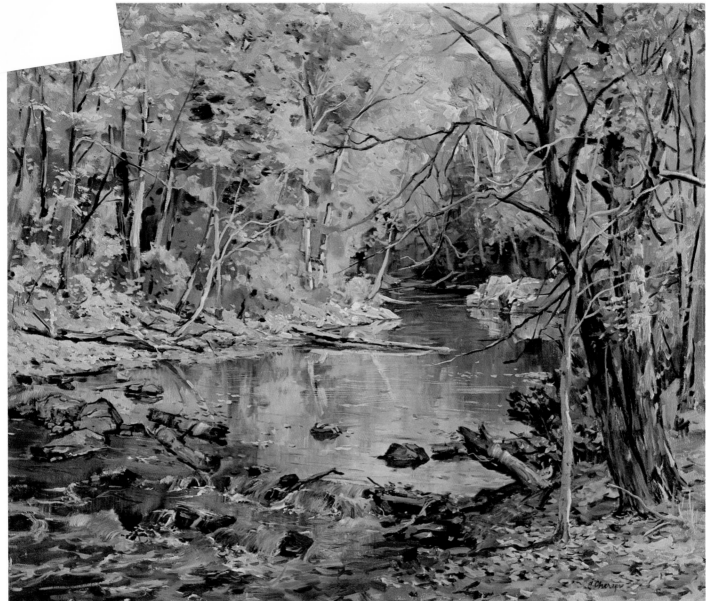

Step 5. The entire canvas is now covered with wet color and the artist can concentrate on refinements and details. To strengthen the contrast between the rapids in the foreground and the tranquil reflections beyond, he introduces more cool color—blue and white mixtures—in the lower left. He also adds "sky holes" of cool color at the top of the canvas. More delicate yellows and yellow-oranges are introduced among the trees, and the single patch of green is subdued to a mere hint of cool color, which is still reflected in the water. The hot tone at the far end of the stream is made lighter and more atmospheric. The nearby tree-trunks on the right contain many more notes of

gray, which are blue-brown combinations. Finally, slender brushstrokes pick out details of sunlit leaves, trunks, branches, floating leaves in the water, and fallen leaves in the foreground. Notice how many cool notes now appear among the warm passages. For this type of landscape, the most important colors on the palette would be cadmium yellow light and cadmium red light; a subdued blue like cobalt or ultramarine, with some help from a stronger, cooler blue like phthalocyanine or Prussian in the water mixtures; alizarin crimson, burnt sienna, and perhaps Venetian red for some of the hotter passages; with some help from yellow ochre and burnt umber in the quieter passages.

Step 1. The preliminary brush drawing is in both warm and cool colors, reflecting the subtle tones that will appear in the snow scene. With deceptively casual strokes—actually just three irregular strokes—the artist carefully defines the shadow shape that moves in from the right foreground to the center of the picture. He also defines the dark mass of trees along the horizon with a single wavy stroke along the top. Then he begins to brush in the colors of the treetrunks, which will be the strongest darks in the picture. Like most interesting warm and cool grays, these are brown-blue combinations.

Step 2. The broad, dark shape of the trees along the horizon is blocked in with a subdued blue like ultramarine or cobalt, alizarin crimson, yellow ochre, and white, just partially mixed on the palette so that the various colors will still be apparent in the painting. The shadow of the snowbank in the right foreground is the same color combination, with more blue to pick up the cool reflection of the light from the sky. (When you paint snow, you'll find that cobalt blue gives you an airier tone than ultramarine blue.) The sunlit portions of the snow are still bare canvas and so is the sky.

Step 3. The sky is a blend of warm tones (yellow ochre and white) and cool tones (cobalt blue, some yellow ochre, and white) which also begin to appear in the sun-lit areas of the snow. On a sunny day in winter, the lighted portions of the snow are often warm, while the shadowy portions are cool, as you see here. Now the artist strengthens the darks of the trees with earth browns, modified by blues. He also begins to introduce a greater variety of warm and cool tones in the shadow of the snowbank at the lower right.

Step 4. The cool shadows on the snow are now blocked in throughout the picture, combining cobalt blue and white, modified by touches of warm color like alizarin crimson and yellow ochre. The warm tone of the snow is a lot of white, plus yellow ochre and a tiny amount of cadmium red light, which will become more subdued in the final stage of the picture. The entire canvas is now covered with color which is generally warmer than the painting will be in its final stage. Once again, the artist is working from warm to cool, from bright to subdued.

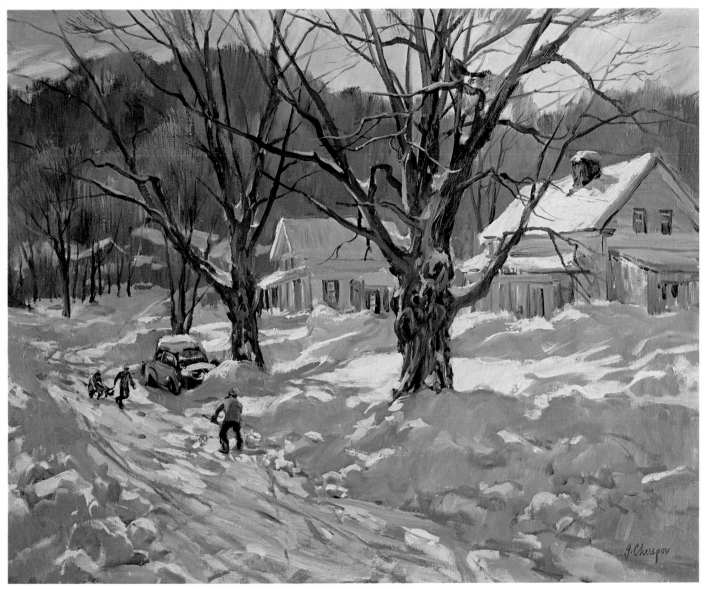

Step 5. The artist begins to tie all the colors together with more subdued strokes. A delicate blend of white and yellow ochre is brushed into the lighted parts of the snow, while more delicate blue and white mixtures are brushed into the shadow areas. More blue is introduced into the sky, which now contains the blues and yellows that are reflected in the snow beneath. Deeper mixtures of blue and earth brown are brushed into the distant trees, which are also softened with more white at certain points. The detailed structure of the trees is drawn with a dark mixture of blue and earth brown. Touches of white, modified by yellow ochre, pick out the sunlit edges of the snowbanks. In a snowy landscape like this one, the artist stays with the more subdued blues like cobalt or ultramarine; relies heavily on earth colors like yellow ochre, burnt sienna, and burnt umber; makes sparing use of more brilliant colors like alizarin crimson, cadmium red light, and cadmium yellow light (in the houses); and uses lots of white, though almost always tinted with some other color. Although it's true that snow contains lots of white, it's never a dead white, used straight from the tube. The white is always colorful.

Step 1. The forms of the rocks are carefully drawn with rather straight brushlines that capture their blocky shapes. The cloud shapes are drawn with blue brushlines and are left as bare canvas, while the artist covers the sky *between* the clouds with small strokes of cobalt blue mixed with white. For a bright blue sky, cobalt is especially suitable, since it's more delicate than either ultramarine or phthalocyanine — although you may wish to experiment with these blues as well. (Another possibility might be cerulean.) The brushstrokes grow smaller, paler, and less dense toward the horizon.

Step 2. Because the sky grows both warmer and paler toward the horizon, the artist intersperses strokes of yellow ochre (with a fair amount of white) among the blue strokes of Step 1. The yellow strokes become denser at the horizon. The artist also begins to block in the shadow planes of the rocks in blue-brown mixtures.

Step 3. Strokes of pink (alizarin crimson and lots of white) are interspersed with the blue and yellow strokes in the sky. Now the sky is almost completely covered with wet color, except for the clouds, which remain bare canvas. In a coastal landscape, the color of the water always relates to the sky, so now the artist blocks in the tones of the sea with deeper blues—cobalt could be replaced by ultramarine, which often looks like a darker version of the same color—and hints of the same pink and yellow mixtures that appear in the sky above. Notice how the color of the sea grows warmer in the foreground, where we begin to see the sandy bottom.

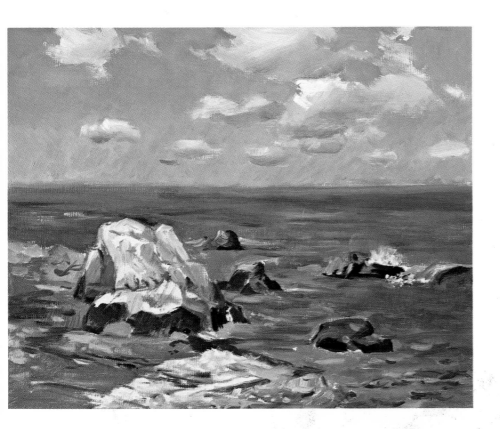

Step 4. With short strokes, the separate color notes in the sky are fused—but not blended absolutely smooth. Thus the artist avoids turning his blue-pink-yellow mixture into a kind of brownish mud. He also retains a feeling of vibrating light. The clouds are now painted with mixtures of the same colors that appear in the sky, plus more white in the lighted areas. The rocks are further developed with rough, irregular strokes of blue-brown mixtures—ultramarine or cobalt blue, burnt sienna or perhaps burnt umber, yellow ochre—that create browns, tans, and a fascinating variety of warm and cool grays.

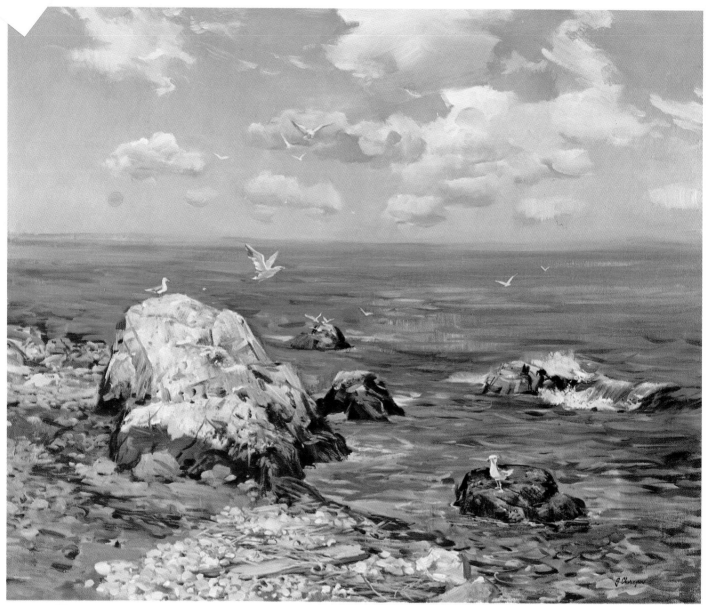

Step 5. Working with blue-white mixtures, plus a hint of yellow ochre, the artist cools the sky to relate more precisely to the color of the water, though you can still see a good deal of warm color in the lower half of the sky and in the clouds. Long, horizontal strokes (darker versions of the sky mixtures) are drawn into the water to suggest distant waves and reflected light. The water in the foreground is animated with small strokes of warm color (burnt sienna, yellow ochre, and white are important here) to suggest ripples catching warm sunlight. The artist also tones down the warmth of the rocks with mixtures of blue, yellow ochre, white, and burnt sienna. Mixtures of the sky colors, though in different proportions, appear in the shadowy section of the beach. The most important colors on the palette are cobalt (and possibly ultramarine) blue, yellow ochre, burnt sienna, and alizarin crimson, with occasional help from cadmium yellow light and cadmium red light in the sunlit foreground.

8

WATER, SNOW, AND ICE

Water takes many forms in the landscape: not just lakes and streams, but snow, ice, rain, and mist. And all these forms of water are in a state of perpetual change. Still water is ruffled by the wind. Sunlit water darkens as a cloud passes before the sun. Snow and ice melt. Thus, painting water is a constant challenge to your powers of observation and your decisiveness in handling the brush.

COLORS IN WATER

In rendering the color of water, bear two facts in mind: that it's a reflecting surface and that it's transparent. Let's see what this means.

A motionless body of pure water—unruffled by wind and uncontaminated by mud or man-made pollutants—is like a colorless mirror. Having no color of its own, this pure, motionless water takes its color from its surroundings. Looking at the surface of this ideal pond, you'll see the colors of the sky above; the colors of the surrounding foliage, rocks, or beach; and possibly the colors that shine through from the bottom of the pond, if you're standing where you can look down at the bottom. If there's a bright blue sky overhead, a mass of green trees along the shore, and yellow-brown sand at the bottom of the pond, these are apt to be the colors you'll see in the pond. At sunset, when the sky reddens and the trees blacken, these will be the colors of the pond. Pure water is the color of its surroundings.

Once that water begins to move, other color changes begin to take place. The wind moves across the surface, rippling the water and creating dark patches. Within these dark patches, ripples may catch glints of light from the sky, creating a broken pattern of light and dark. The dark reflections of clouds and trees may also be broken and distorted by these glints of light. A moving stream develops its own unique pattern of light and dark areas as the water roughens at one point and grows smooth somewhere else. The moving water also blurs and shatters the reflected colors of the sky and the surrounding terrain. And a fast-moving stream often picks up yellow or brown silt from its own bottom, clouding or even obliterating the reflected colors.

Above all, don't make up your mind about water having some standard, predictable color. A body of water, whether still or moving, can

take on any color that might appear above, around, or beneath it. Deep in shadowy woods, a pond or a stream can be as dark as the black-green forms of the trees. At sunrise or sunset, water can be delicate pink, violet, or blazing red. Any sudden change of light or weather can instantly give water some totally unexpected hue.

So forget that water is *supposed* to be blue or green. Look carefully and paint what you see.

DESIGN IN WATER

Because so many different things are happening above, around, and beneath it, water is almost never one consistent color. Depending upon where you set up your easel, you'll probably see patches of many different colors. From one vantage point, you may see sky and cloud colors and color from the surrounding terrain, but practically no color from beneath the water. Then when you walk to some other spot, the water may seem to consist entirely of patches of color from the surrounding trees, with just a few touches of sky color reflected in the ripples.

Thus, a body of water is often a fascinating patchwork of colored shapes. You've got to observe these shapes as carefully as you study the shapes of trees, rocks, or clouds. And you're free to reorganize or redesign them to make a more effective composition. If that pond, deep in the woods, looks too dark and gloomy, you can decide that it needs more ripples and glints of sky color. Paint the touches of sky color that you do see and then add some more. You can exaggerate or minimize any of these colored shapes and you can alter their contours—but don't forget that these shapes are all reflections of something elsewhere in the picture. If you alter a dark green shape to a yellow-green, also be sure to alter the color of the tree that created the reflection in the first place.

Water, too, has its contour lines. If you look closely at any body of water, you often see strips of light or dark that move across the surface, sometimes straight as an arrow, sometimes curving or zigzagging. Many things create these lines: puffs of wind; irregularities along the bottom; rocks or branches that break the surface; changes in the speed or direction of the water. These lines can become important design elements for you. You can use them to break the water up into interesting shapes or to establish

a path for the viewer's eye. And when lots of jagged, free-form reflected shapes make the water look like a mountain range rather than a lake or a stream, you can add a few of these lines to make the water look flat once again.

REFLECTIONS

As you can see, practically everything that happens in water is really a reflection of something that's happening somewhere else. Here are some specific tips about painting reflections:

1. Make sure that a reflected shape is roughly the same size, shape, and color as the object that creates the reflection. If a lake is surrounded by pines, be sure that the reflections are evergreen colors, not the paler, brighter tones of deciduous trees. And don't get so carried away with the reflections that they become a lot bigger than the trees themselves. The reflected shapes can be just a trifle bigger or smaller, but they ought to be roughly in scale with the trees.

2. On the other hand, don't copy reflections too carefully either. Even the smoothest water is a lot rougher than a glass mirror, so reflections are usually a lot blurrier than the object reflected. Paint reflections broadly, with soft edges and very little detail. Make them out of focus, the way you'd see things through someone else's glasses.

3. Just as rocks, trees, and clouds have light and shadow sides, reflections should contain lights and shadows. Let's say there's a big rock formation with lots of shadow planes on one side and some lighted planes on the other; you'll probably see a dark blur and a light blur side by side in the water. In the rock itself there may be a sharp transition between the light and shadow planes, but keep that transition vague and blurry when you paint the reflection.

4. It's also a good idea to play down contrasts when you paint reflections. Looking at that rock formation once again, the sunlit planes may be brilliant and luminous, while the shadow planes may look dark as night. But when these patches of light and shade reappear in the water, make sure that the lights are a bit darker and the shadows are a bit lighter. If you don't minimize these contrasts, the colored shapes will leap out at you and the water will no longer look like water.

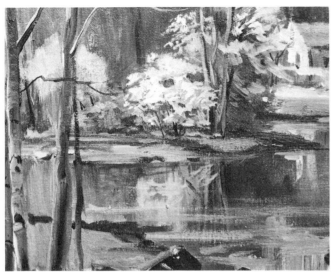

Reflected shapes don't have to be precise copies of the objects reflected. Provided that it bears some resemblance to the object, the reflection can be adjusted to suit the overall design of the picture. In this closeup, the central tree becomes just a bit smaller in the reflection, slightly darker, and is cut short by the horizontal strokes in the foreground. The dark reflection to the right is actually bigger and darker than the shadowy patch of landscape above.

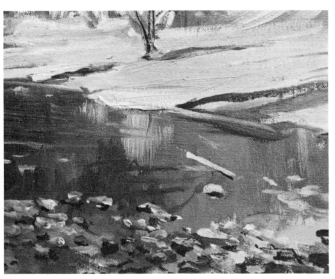

Don't assume that water is always pale and delicate in tone. On a snowy winter day, the water can actually be darker than the surrounding landscape, particularly if the sky is a deep blue or gray. Notice how the shape of the small, snow-covered tree becomes nothing more than a pale blur in the water beneath—not a precise, upside-down copy of the original tree. The water, like the landscape, is visualized in three values: a middletone at the right, a dark at the left, and a few light notes.

5. Although you know the colored shapes in the water are reflections, try to paint them as shapes that are interesting in themselves. When you're painting a blurred green shape in the water, and you know that there's a tree above it, don't try too hard to convert that green shape into an accurate rendering of an upside-down tree. Paint the shape so it's an interesting patch of color, then make sure it contains a hint of the original tree. The viewer should enjoy the colored shapes in the water and *then* notice, perhaps, that they're reflections.

6. After you've painted the shapes of sky color, terrain color, and other reflected hues that become the color of water, find some ways to remind the reader that he's looking at water. Break up the reflected colors with ripples in the foreground—not too many—or add some of those dark and light contour lines that cut across the surface. If you can see lily pads or other floating vegetation, place them here and there to remind the viewer that the water has a flat surface. Rocks, branches, or reeds poking up through the surface will serve this purpose too. In a few spots, sharpen up the banks of the lake or stream to clarify the distinction between land and water.

There's one last bit of advice that famed landscape painter John Pellew always gives his students: don't paint that classic, cornball picture of reflections, where the riverbank cuts a line straight across the middle, the real trees stick up from the center line, and identical reflected trees hang upside down from that same center line. Although it may amuse your friends to discover that the picture looks the same upside down, the idea is so dull and hackneyed that no one will look at it twice.

SIMPLIFYING WATER

So many things are happening in a body of water that you certainly can't paint them all. You've got to be selective.

Although you may see lots of small, fragmentary color areas reflecting patches of clear sky, sunlit clouds, dark clouds, trees, rocks, or whatever, try to merge all these small shapes into a few big ones. Blur the small shapes together with bold, free brushwork. Water is almost always moving and tends to blur these shapes anyhow, so nature is on your side.

Inland water may not have huge waves and crashing foam like the ocean, but you'll see lots of ripples, small waves, white water, and other complicated effects of rapids and water-falls. There's probably more detail than you can put in. Even though the water may be cov-ered.with ripples or small, choppy waves, just indicate them in the foreground—where the viewer would be most likely to see them if he were standing there—and merely suggest them at certain significant points in the distance to which you want to draw the viewer's attention. If the water contains more dark and light con-tour lines than you need, leave most of them out and just place a few where you want them for compositional reasons.

If you find that you have too many colors in the water, try to merge related colors into a kind of compromise tone. Several patches of blue and gray, picked up from the sky, might be reinterpreted as a mass of blue-gray.

Be selective about details like reeds or lily pads. Paint a group of lily pads as one colored mass, then paint just a few of the shapes in de-tail. Interpret most of the reeds as a blur of color, then pick out a few with crisp, slender strokes.

BRUSHWORK FOR WATER

When you're painting water, it's especially tricky to match the subject to your brushwork and paint quality. Since water consists mainly of soft, blurred color areas, it's important to paint these shapes with big strokes of fairly thin color. The paint should look soft and fluid like the water. Although you may build up your paint thickly for the solid shapes on the shore, avoid distracting paint textures on most of the water. And be sure to scrub the edges of the colored shapes so there will be soft transitions from one area to another.

Many landscape painters paint these colored shapes entirely in vertical and horizontal strokes —avoiding diagonal and curving strokes as much as possible—to make the water look really flat. The viewer ought to be much less conscious of your brushwork in the water than on the land. You may even want to scrape the water lightly with your palette knife to make the paint look flatter still and to minimize the brushstrokes.

Having established the main colored shapes

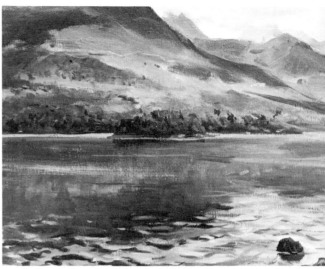

The dark reflection of the mountainside is inter-rupted by horizontal streaks of light that make the water look flat and suggest gentle movement. We know that the water is slightly choppy because of the small waves—painted in short, curving strokes —in the foreground. In fact, all detail of waves and ripples is concentrated in the foreground and we simply imagine that this detail continues beyond.

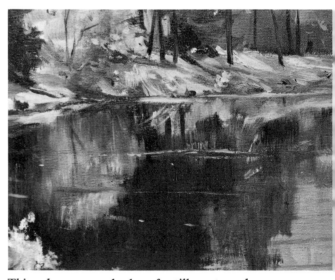

This closeup—a body of still water along a wooded shoreline—shows the rough, simple brushwork that's best for painting the colored shapes in water. The strokes are generally vertical and the edges of the shapes are soft, one shape blurring into another. The marks of the brush are distinct and the artist makes no attempt to smooth them out. Despite the overall softness, each col-ored shape is carefully designed and the overall pattern of shapes is consciously organized. A few casual, horizontal strokes emphasize the flatness of the water.

with broad, flat strokes of fluid paint, you can then go back in with smaller brushes, heavier paint, and more precise strokes. This is where you can have fun with calligraphic brushwork: arcs, chops, and zigzags for ripples and waves; dashing, explosive brushwork for rapids and white water; dabs, blobs, and flicks of the brush for floating vegetation and reeds. When you paint these fascinating details, it's not a bad idea to let the paint stick up from the canvas a bit. Lots of painters enjoy piling on thick strokes for glints of light or masses of foam. But don't let the thickly textured paint dominate. Those thick touches will have maximum impact if they're applied sparingly against a background of smooth, fluid paint.

PAINTING SNOW AND ICE

Although snow and ice are water in solid form, they still behave like liquid water in many ways. Like any lake or stream, snow and ice take their colors mainly from their surroundings.

Although we may think of snow and ice as white, they're almost never pure white. They're influenced most of all by sunlight and the color of the sky. We've all seen snow and ice turn to a delicate golden tone in bright sunlight. They can be pink or violet at sunrise or sunset. On an overcast day, snow and ice are predominantly gray, although they may look white because they're a much paler gray than the sky. And a bright blue sky may appear in the dazzling blue shadows of sunlit snow.

So you can't simply make up your mind that snow and ice are white, squeeze out a big gob of white on your palette, and start piling it on. Observe snow and ice carefully, paint the colors you really see, and reserve those touches of white for highlights, like those glints of pure light that you see now and then among the colors of a lake.

But unlike water in liquid form, snow can become as three-dimensional as any rock formation. Because the contours of a snowdrift or a snowbank are generally softer than any rock formation, you have to look carefully to see that snow does contain distinct planes of light and shadow. The lighted planes blur softly into the shadow planes, but those planes are really there and you've got to paint them faithfully. Nor are the shadow planes simply masses of dark; snow is highly reflective and a lot of surprising reflected colors may appear in the shadow planes if you look closely. In fact, snow has extraordinarily luminous shadows because the lighted plane of one snowdrift will bounce light into the shadow plane of the next snowdrift. So keep these shadows airy and delicate, never murky. And keep them colorful.

Although ice sometimes does appear in three-dimensional form, it's most commonly seen in pools and sheets on the ground or on the surface of a lake. So painting ice is something like painting any flat body of water. The ice will seem to consist mainly of shapes and colors reflected from its surroundings. A light area may reflect a patch of sky and a dark area may reflect a nearby treetrunk. Paint these patches of reflected color first, then superimpose the details of the ice itself: cracks, broken lumps, soil and debris that may be imbedded in the frozen surface. And save those sparse touches of pure white—those flashes of light on the ice —for last.

Just as you paint water, start out by painting snow and ice with broad strokes of thin color, softly applied. Keep shadows thin, luminous, and transparent. Then, when you come to the brightly lit areas, you can pile on thicker color. Remember the guidelines in Chapter 5, *Painting Techniques:* paint from thin to thick; from soft focus to sharp focus; from broad to precise. Keep snow and ice soft and fluid like water, saving a few sharp, precise strokes for the very end.

Step 1. The preliminary brush drawing outlines the major shapes of the landscape and sky, tracing the precise shape of the lake. At this stage, it's important to pay careful attention to the design of the lake as a flat shape, which must be interesting in itself, even before you begin to paint the tone and detail of the water. The contours of the shoreline are carefully observed.

Step 2. Because the still lake reflects the gradated tone of the sunny sky, both water and sky are painted at the same time. The sky moves from dark at the zenith to light at the horizon; the water, reflecting the sky, does exactly the opposite, moving from light to dark. A few dark strokes reemphasize the contour of the shoreline and the artist begins to block in the tones of the landscape.

Step 3. To emphasize the bright sunlight, the artist lightens the lower sky even more. He then concentrates the light at the center of the water, which gradually darkens as it moves toward the edges of the picture. This contrast makes the water seem even more luminous. The surrounding landscape is darkened to emphasize the brightness of the water and sky. Across the vertical strokes of the water the artist draws a few horizontal contour lines.

DEMONSTRATION 24: POND

Step 1. The shapes of the trees are brushed in rather casually, but the shape of the pond is drawn with precision. The brush follows the contours of the shoreline and these contours will be retained faithfully, even though the shapes of the trees may change. Within the shape of the pond, reflected areas are also drawn with the brush.

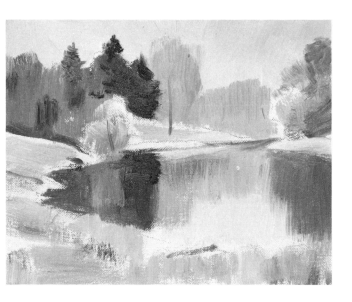

Step 2. Working with broad, scrubby brushstrokes, the artist blocks in the darks, lights, and middle-tones that appear in the landscape and reappear in the pond. Notice how each tonal area in the landscape reappears (in simplified form) in the water below. The brightest patch in the pond reflects a patch of sunny sky. The water is painted almost entirely in vertical strokes that leave soft edges.

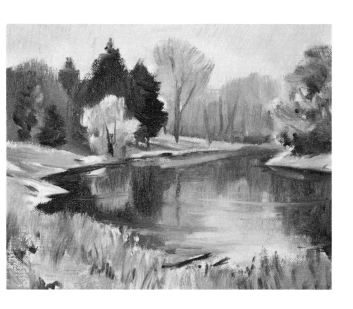

Step 3. As the shapes and tones of the landscape are refined, the colored shapes within the pond are carried to completion. Study how each shape within the pond is an out-of-focus version of a shape above. The only precise detail in the pond is the reflection of a single treetrunk. The edges of the shoreline, which were softened in the previous step, are now sharply redefined. The shadowy parts of the pond are painted thinly, but heavy color is piled on for the luminous patch of sky reflected in the foreground.

Step 1. Over light charcoal lines, which you can still see, the artist uses a brush to draw the contours of the stream, the shapes of the surrounding landscape, and the reflections of these shapes in the water. Notice how the receding shape of the stream conforms to the principles of linear perspective.

Step 2. The entire canvas is covered with color. Everything is painted roughly and kept in soft focus, except for the edges of the stream, which are clearly defined to maintain the interesting shape that was so carefully drawn in the previous step. The artist concentrates on the internal design of the stream, brushing in the darks and middletones that reflect the surrounding shore, saving his one patch of strong light for a sky reflection. The snow in the foreground—another form of water, after all—also reflects the brightness of the sky, but isn't painted a dead white. The snow is a delicate gray, unevenly brushed to suggest its irregular texture.

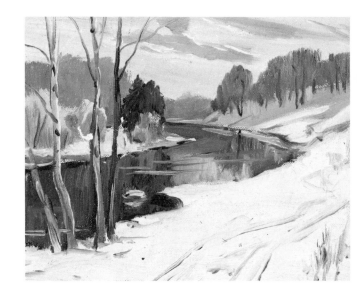

Step 3. To dramatize the curving shape of the stream, the artist darkens the reflections in the near part of the stream and along the distant shore. A single luminous patch of water reflects the bright patch of sky above it. Pale contour lines also pick up the brightness of the sky. Crisp strokes of shadow are added to sharpen the edge of the shorelines to your left. All the reflections are in soft focus, except for a single treetrunk at the curve of the stream. The nearby snow is darkened slightly and the marks of a trail or a partially concealed road are brushed into the snow to suggest the contour of the landscape.

DEMONSTRATION 26: ROUGH STREAM

Step 1. The brush follows the margin of the shore, picking out a fallen log, rocks, and treetrunks. But the artist concentrates on the foreground, where most of the action will take place. He makes no attempt to define the complex forms and movement of the rapids, but simply draws a few swirls and suggests an important shadow area in the lower right. The preliminary drawing is not a rendering but simply a collection of notations to tell the artist how the picture will be organized.

Step 2. The broad tones of the water are blocked in. The artist defines the shoreline and suggests some dark reflections in the center and upstream. But he concentrates on the foreground action, indicating the intricate pattern of darks and lights with decisive brushstrokes. He makes no attempt to paint the intricate details of the rapids just yet, but if you half close your eyes as you look at the picture, you'll see that his lively brushwork already communicates the feeling of the fast-moving water simply because the lights and darks are in the right places.

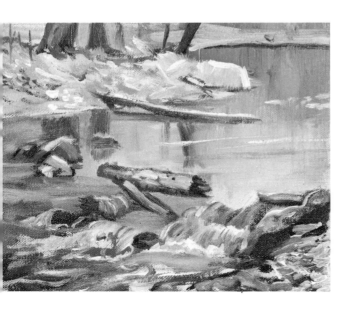

Step 3. With the broad pattern of lights and darks blocked in, he now switches to a smaller brush to paint the curving strokes of the rapids, the darks within the foam, and a few horizontal contour lines on the water in the distance. In the foreground, notice how the direction of the stroke matches the direction of the water, so that the action of the brush can suggest detail without actually rendering every fleck of foam. Nor is the entire picture a bubbling mass of rapids; the foreground action looks so lively because the rest of the stream is smooth, tranquil, and painted with the greatest possible simplicity.

Step 1. The artist chooses a gray-toned canvas which will suggest a shadowy undertone and accentuate the bright strokes of the snow. The preliminary brush drawing concentrates on the road and the shadows that move across the snow, since lines can't define the snow itself. The artist blocks in the distant mountain, a dark area that will provide an important contrast to the snow.

Step 2. He paints the gradation of the sky from dark to light, since this light will be reflected in the snow. He then defines the big dark to the right and begins to paint the shadows which will contrast with the whiteness of the snow. He's obviously saving the lights for the final stages.

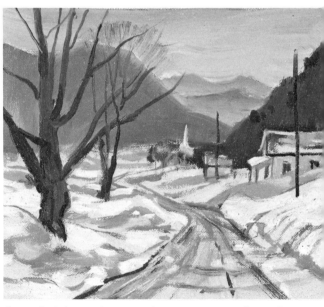

Step 3. The artist now works on the intricate pattern of shadows in the foreground, since the shadows will surround and define the lighter areas. The dark tree is blocked in to provide contrast with the lights. And the first few lights are suggested on either side of the road.

Step 4. The artist now interweaves strokes of shadow, thinly painted, with thick, decisive strokes of light. But the essence of this snow picture is in the shadows, which define the contours of the landscape and enclose the patches of light. The light patches are simply the final accents.

Step 1. The rough brush drawing defines the shape of the sky—which provides the light reflected in the icy road—and the shape of the road itself. The artist begins to block in the shadowy houses, which will provide the dark note to accentuate the brilliance of the ice.

Step 2. The artist concentrates on the surroundings of the icy road, not on the ice itself. He blocks in the pale sky, the dark houses and trees, and a few darks in the foreground, leaving the road bare canvas except for a dark reflection in the center.

Step 3. He continues to work on the darks and middletones, gradually covering every portion of the canvas, except for the reflected lights on the icy street. Now he concentrates on the darks reflected in the ice, but saves the light touches for the final stage—just as he does in the snowy landscape in the preceding demonstration.

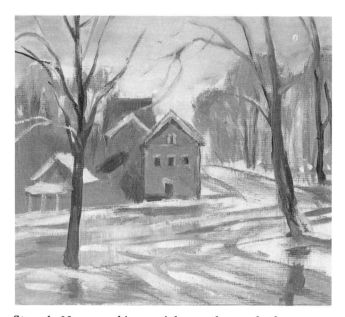

Step 4. Now, working mainly on the road, the artist develops the complex pattern of darks and middletones in thin color, then strikes back into these tones with a few thickly painted lights. In painting ice, like snow, the essence of the picture is the pattern of darks and middletones; the lights are final accents to be used sparingly.

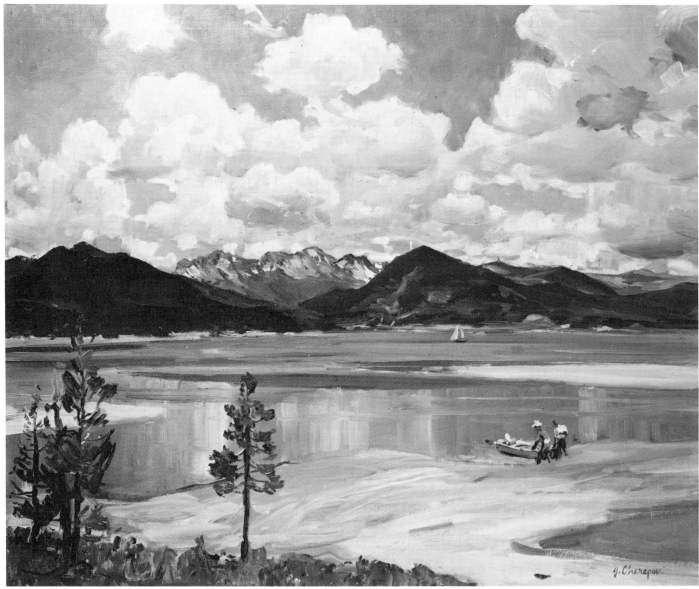

Grand Lake, Colorado by George Cherepov, oil on canvas, 24″x30″. Clouds aren't evanescent puffs of smoke, but three-dimensional objects that can look almost as solid as the mountains below them. Like the cumulus clouds in this painting, the forms of clouds are modeled by sunlight, which gives them distinct planes of light and shadow. On this sunny day, the light source is above the clouds, throwing their tops into brilliant sunlight and their undersides into shadow. Geometry can also help in painting clouds. Cumulus clouds like these tend to look like clusters of spheres or ellipses, distorted by wind. The edges of clouds are almost always soft, blending into the surrounding atmosphere, but the edges are still there and it's important to paint these contours carefully. Keep your brushwork broad, rough, and casual. Notice that the sky isn't smoothly blended, but is painted just as freely as the clouds. The sky strokes crisscross one another and the strokes have different tones, lending an effect of vibrating light. The sky and the shadow planes of the clouds are painted thinly; the artist saves his thick strokes for the lighted edges. Clouds are always moving and the brushstrokes catch this sense of movement.

9
SKIES

The sky, like water, is in a state of constant change. Throughout the day, the sun moves across the sky, altering the direction and color of the light that falls on the landscape below. At night, the moon moves across the sky, making far more subtle changes in the light direction and color, though these changes are just as real. The wind pushes clouds across the sky and these cloud shapes keep changing as the wind reshapes them. The light and shadow pattern on the clouds changes too. So painting clouds, like painting water, demands intense observation and a well-developed pictorial memory.

STUDYING SKIES

The best way to learn about skies is to set yourself the assignment of making lots of small, rapid studies of skies and clouds in color. You've got to work out in the open—or perhaps through the window of your car in bad weather—and you've got to work fast to catch the fleeting effect before it's gone. Rapid work on the spot has two important benefits: you learn to paint skies quickly and decisively; and you build a mental archive of "sky facts" that will stay with you for life. And if you make dozens and dozens of these color sketches, the archive won't just be in your head, but you'll have pictorial reference material that you can use in landscape paintings for many years to come.

If you want to make your sky studies in oil, try working on paper as Constable did. Buy (or cut) some small sheets of sturdy, white drawing paper or smooth watercolor paper, no more than 8" x 10". Some small sheets of white illustration board will do the job too. To prevent the oil paint from soaking into (and slowly rotting) the paper or board, coat the painting surface with thin acrylic gesso (diluted with water to the consistency of milk) or shellac, thinned with denatured alcohol to the consistency of water, so the shellac soaks in and doesn't leave a shine on the paper. Get yourself a 12" x 16" sheet of hardboard that will fit into your paintbox. When you paint your sky studies, you can tape or tack the paper to the board and hold it in your lap like a sketchpad.

The whole idea is to paint as many sky studies as you possibly can at each session. See if you can do each one in no more than fifteen or

twenty minutes, so you come home with half-a-dozen or even a dozen.

Of course, the big headache is getting all those wet oil sketches home without smudging them. If you're traveling by car, I suppose you can spread the sketches out on the back seat to avoid piling one on top of the other. An even better idea is to substitute a fast-drying "underpainting white" or Magna white for the slow-drying white oil paint on your palette. Magna is a turpentine-soluble acrylic that blends perfectly with oil paint. Although most manufacturers are evasive about the contents of their "underpainting white," these often look like some kind of acrylic formulation too. If you add Magna white or "underpainting white" to all your colors, your sky studies should be fairly dry to the touch by the time you head home.

Pastel is a particularly convenient medium for quick sky studies. You can buy an assortment of two or three dozen chalks to get all the basic colors, then supplement these by buying separate sticks of additional blues, warm and cool grays, and white. Pastel and charcoal papers come in 19″ x 24″ sheets which you can cut into quarters and thumbtack to a small drawing board. Or you can buy 9″ x 12″ pads of pastel or charcoal paper. In addition to white paper, you might want to try some soft grays and tans. But avoid blue paper; painting the sky's your job, not the paper manufacturer's. Don't spray your pastel studies with fixative, which alters the colors, but stack finished studies with sheets of plastic (cut from plastic bags) between them.

Watercolor is the most difficult medium of all, but it's ideal for sky studies. You can buy 22″ x 30″ sheets of watercolor paper and cut them into eight equal parts, each 7½″ x 11″. Or you can buy a small watercolor block, which is like a pad of paper bound on all four sides, so the sheets won't flap in the wind. When you're painting on this small scale, stick with fairly smooth paper. If you already know something about handling watercolor, try some cloud studies on wet paper, allowing the color to flow and blend freely then picking out the lights with a sponge or a cleansing tissue.

If you do a dozen sky studies every weekend for a couple of months, you'll have nearly 100! And you'll have an education that will last a lifetime.

PAINTING CLOUDS

Clouds are the real challenge in painting skies. Although airplanes can fly right through them and clouds usually have fuzzy edges like puffs of smoke, it's important to paint clouds as if they were solid objects. They're just as three-dimensional as any rock formation.

Just as you do when you're painting trees or rocks, you've got to begin by analyzing the distinctive shapes of the cloud mass. Can you visualize the shapes in geometric terms? Those great, rounded cumulous clouds often look like clusters of spheres, ellipses, or hemispheres—round on top and sometimes flatter at the bottom. If the clouds don't seem to take anything approaching a geometric shape, try to understand their structure. For example, some clouds, composed of ice crystals, are stacked in layers like so many logs or pancakes.

Movement often explains the shapes of clouds. The wind may shatter clouds and drive them across the sky like slender arrows or wedge-shaped arrowheads. Sometimes the wind whips the clouds upward, turning their edges like fishhooks. Or the wind may whip the top off a cloud, creating a shape like a tabletop or an anvil.

Once you understand the shape, look for the planes of light and shadow that make the cloud three-dimensional. Where's the light coming from? Is the sun directly above the clouds, lighting their tops and throwing their undersides into shadow? At sunrise or sunset, just the opposite may happen: the sun may be at the horizon, beneath the clouds, lighting their undersides and throwing their tops into shadow. If the sun (or the moon) is directly behind the clouds, the entire shape may be in darkness, perhaps with a bit of light along the edges.

Having fixed these facts firmly in your mind, model the light and shadow planes as carefully as you'd model the planes of a rock formation. Of course, the transitions between the planes are a lot softer in a cloud, forming a blurred edge where the two planes come together. But observe this edge carefully and follow its contour methodically.

Work with your biggest brushes and keep your strokes loose and casual. Don't pile on the paint, but work with thin color so the clouds look airy. If your brushstrokes look rough, don't smooth them out too much; better too rough

Integrate your cloud forms so that they flow together and form larger masses, as the artist has merged the light and shadow planes of these cumulus clouds. Notice how he gives the sky a sense of depth by introducing two small, dark clouds which are obviously much closer to the viewer. Even though it's a sunny day, the sky isn't a uniform color: some patches are lighter or darker than others, though the sky is lightest at the horizon.

In contrast to the puffy cumulus clouds, these clouds are in streaky layers. The sun isn't above them, but rather behind them, so the clouds are in shadow and streaks of light break through. The sun is also low in the sky, so the strips of cloud at the top of the picture are lit from below. The darks of the sky are painted so thinly that you can see the texture of the canvas. The paint is piled on thickly in the lights.

than too smooth. Try to follow the gesture of the cloud with your brush: if the wind seems to whip the clouds upward, sweep your brush upward too. Keep the shadow sides of the clouds thin and transparent—don't worry if some of the canvas shines through—and reserve your thick color for brightly lit edges in full sun.

It's particularly important to paint skies wet-in-wet, so the whole texture of the sky is soft and fluid. If you want to repaint a sky after it's dried, scrape it down with your palette knife so the texture of the canvas comes through, then rub the entire sky with medium before you start painting. Or brush a thin, almost invisible haze of pale blue, gray, or even yellow-white over the entire sky, then go back in with fresh paint.

PAINTING SEQUENCE

Because skies change so rapidly, it's important to establish a quick and reliable sequence of operations for painting these effects.

Basically, you're dealing with three kinds of shapes in the sky: the shapes of the sky itself, between the clouds; the lighted areas of the clouds; and the shadow areas of the clouds. If you're working on white canvas, the quickest way to establish these shapes is to mix a gray that approximates the shadow planes of the clouds and a blue (or whatever sky color you actually see) that approximates the patches of sky between the clouds. These colors needn't be absolutely accurate; just keep them thin enough so you can adjust them later on. With your biggest brushes, scrub in the patches of sky and the patches of shadow, leaving bare canvas for the lighted areas of the clouds. Now, even if the wind whisks the clouds away, you've recorded the basic pattern of shapes.

At this point, you can go on to refine the shapes and colors you've brushed in so quickly. If those initial scrubs of color aren't too dark, you can paint back into them with blues, grays, and other mixtures that are more accurate than your first strokes. The patches of sky probably won't be a uniform blue—they'll become lighter toward the horizon—so you can brush in some paler color. Nor will the shadow sides of the clouds be a uniform gray; they'll be darker in some areas, lighter in others, and they'll probably be warmer or cooler than your original gray mixture.

When the sky and shadow areas are ap-

proaching the right tones, you can begin to cover the patches of bare canvas that you've left for the lights. The lighted planes of clouds are almost never dead white, so look at these areas carefully and decide whether to mix a yellow-white, a blue-white, a gray-white, or even a pinkish or violet-white. As I've said, it's best to paint skies thinly, with broad, scrubby strokes that leave soft edges; so scrape the sky lightly with your palette knife if the paint begins to get too thick. However, you can try somewhat thicker paint and crisper strokes in the lighted areas of the clouds, as long as the edges remain reasonably soft and the paint doesn't pile up so thick that it casts a shadow, like icing on a cake. If the whites become too thick, you can smooth them out with the knife and still not scrape down to bare canvas. For some reason, smooth, thick paint looks especially luminous.

COMPOSING SKIES

Because the wind can push clouds in almost any direction and distort them into an amazing variety of shapes, you can custom-make your skies to enhance your entire pictorial design. If you've done your homework—that is, if you've gone out and painted all those sky studies as I recommended earlier in this chapter—you'll be able to paint any sky so convincingly that you can redesign skies at will.

Do you want to dramatize the dark, jagged silhouette of the mountains at the horizon? Then place that silhouette against a bank of pale, low-lying clouds. Alternatively, you might move the clouds up and away from the horizon, then gradually lighten the tone of the sky as it moves toward the horizon so the rocky shapes are silhouetted against a pale glow. But what if those peaks are covered with snow and you want to emphasize their whiteness? The snow will look particularly brilliant against a mass of dark storm clouds. And what if those rock formations are the pink or rusty tone that you often see in the desert? Then the right background to emphasize those hot colors might be a brilliant blue sky or the cool gray underside of a cloud mass.

The shape and movement of clouds can also do a great deal to enhance your composition. Low-lying, horizontal layers of slender clouds will enhance the feeling of tranquility and repose. The vertical shapes of cacti or trees will

look even more powerful against these horizontal shapes. Windblown strips of clouds sweeping diagonally across your canvas can lead the viewer's eye wherever you want it to go.

While you're designing the right sky to enhance the rest of your picture, don't forget that the sky itself has to be a satisfying design. In the process of getting the cloud shapes right, don't neglect the sky shapes between the clouds; these negative spaces should be just as interesting as the clouds themselves. Make sure that the sky areas are different sizes and shapes to keep the viewer interested. And make sure that the cloud shapes are different too. Even if the entire sky is filled with one particular kind of cloud form—cumulus clouds, for example, often sail by in clusters—you can still make some large and some small; make some darker or lighter than others; make some rounder and others flatter; and space them out to make interesting negative shapes in between. Don't distribute clouds evenly, like so many huge polkadots; cluster them here, scatter them there, and allow irregular patches of sky to shine through.

And if you find that you've just got too many clouds, leave some out and merge the others into a few big shapes.

SKY COLORS

There's no such thing as "sky blue"; there's an infinite range of blues at different times of day and in different kinds of weather. Although you probably know that blue is a primary color—which means that you can't create a blue by mixing two other colors—you're not limited to squeezing blue out of a tube, adding some white, brushing it onto the canvas, and hoping that it comes reasonably close to the hue of the sky.

Either of the basic blues on your palette —phthalocyanine or ultramarine—becomes cooler and seems brighter when you add a touch of green like viridian or phthalocyanine green. Blended with plenty of white, these mixtures make particularly clear, airy sky tones. So does cobalt blue.

For a warmer blue, add a touch of yellow ochre, which is a yellow so mild that a small amount won't turn either of the blues to green. Yellow ochre (with white, of course) added to both blues makes a softer and more atmospheric color which is fine for remote sky tones that

This section of a mountainous landscape shows how the wispy lines of windblown clouds can be used to lead the viewer's eye. The brushstrokes tilt down and swirl around the topmost rock, which forms the vortex of all those fast-moving brushstrokes. The sky is darkest at the upper left and palest behind the peak of the rock formation, thus calling attention to the powerful, dark shape.

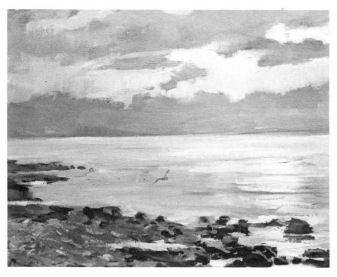

The sky and water are designed in alternating bands of dark and light, forming a lively pattern of shapes. The pattern of the sky might look accidental, but it's not. The artist has carefully designed the shapes so that no two are exactly alike and the spaces between the clouds are as interesting as the clouds themselves.

aren't as electric as the blue-green mixture I mentioned above.

A touch of brown—burnt umber or burnt sienna, plus white—will warm the blues and add a hint of gray. If you add even more brown, you get lovely shadow tones for the undersides of clouds. For a more detailed discussion of grays, you can turn back to Chapter 6, *Forms of the Land,* if you wish. All these grays are important not only for the shadow areas of clouds, but for painting overcast skies, fog, storm clouds, and rough weather in general.

For the lighted areas of clouds, practice mixing colorful whites. Add a bit of yellow ochre or just a speck of cadmium yellow to get a golden white. For a cool, pinkish white, add the tiniest possible amount of alizarin crimson—too much will turn the mixture to a cornball pink—with a hint of yellow ochre to warm the mixture or a speck of blue to create a violet-white.

As you mix sky colors and brush them onto the canvas, be particularly conscious of the gradations in the sky. Even an absolutely cloudless blue sky is unlikely to be a uniform blue. It may be paler and warmer toward the horizon. If the sun is off to one side, it may be paler and warmer over there. A haze or a hint of overcast weather may begin to appear at the horizon, which could actually be darker than the sky above. When patches of clear blue break between your various cloud forms, note that some patches can be darker or lighter, brighter or more subdued, warmer or cooler than others. Nor are the shadow sides of clouds a uniform gray; the nearest clouds may be darker and warmer, needing a gray mixture that contains an extra touch of brown or yellow, while distant shadows may need more blue.

The most difficult sky colors, of course, are the complex hues of sunrise and sunset. The secret of painting a successful sunrise or sunset —contrary to what most beginning painters think—is to keep most of your colors subdued. As I point out in my earlier book, *Creative Color,* "If you spend enough time looking at sunsets, you'll see that their secret is not the intensity of the hot colors, but the contrast between warm and cool, between light and dark. Actually, those reds and pinks and purples aren't as bright as you might think. Nor are they as hot as you might think. They look so vivid because they intertwine with much cooler tones. Interwoven with the hot colors are pale blues, blue-greens, blue-violets, and even yellow-greens. And far above the flaming horizon, there's still a blue or blue-gray sky. The warm colors are also enhanced by the cooler, darker tones of the landscape. At sunrise and sunset, trees and hills and distant mountains have a blue-gray or blue-black tone that provides the perfect 'frame' for the hot colors along the horizon.

"The experienced artist uses his hot colors sparingly and surrounds them with a cool sky and a shadowy landscape. I might add that the most beautiful sunrises and sunsets are often just a few streaks of red, pink, or gold breaking through the gray of an overcast or stormy sky."

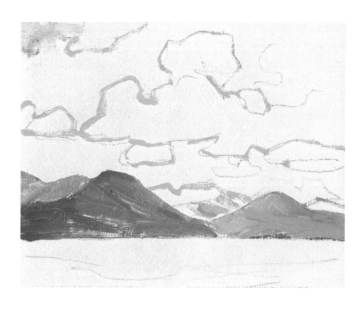

Step 1. Although the brushstrokes are rough, the shapes of the clouds are clearly defined. Equally important, the negative spaces between the clouds are also carefully observed, since these spaces must be just as interesting as the clouds themselves. The darkest notes of the landscape are blocked in; as he paints the sky, the artist must relate the sky colors to these darks.

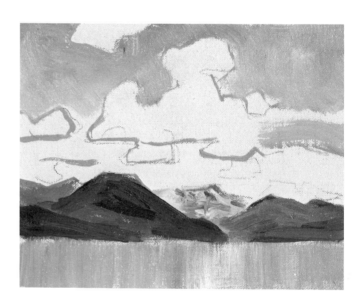

Step 2. The artist blocks in the tones of the sky before he begins work on the clouds. The original brushlines now begin to disappear and the sky emerges as a design of flat dark and light shapes. At this stage, the artist isn't rendering clouds, but simply defining the *design* of the sky, which is just as critical as painting the clouds convincingly. The tone of the water is blocked in because there's always a reciprocal effect between sky and water that must relate in color and value.

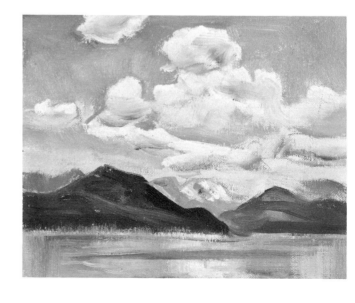

Step 3. The shadowy undersides and lighted tops of the clouds are painted in with bold strokes. The lights and shadows aren't carefully blended—not ironed out to look like puffs of cotton—but the strokes are allowed to remain separate and blend in the viewer's eye. The tones of the water reflect the tones of the sky and clouds.

DEMONSTRATION 30: STREAKY CLOUDS

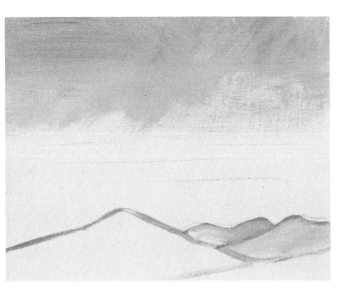

Step 1. Since streaky clouds don't have any definable shape, a preliminary brush drawing would be pointless, so the artist begins by scrubbing in the dark tone for the upper sky, draws a few lines to remind himself about where the streaks will go, and indicates the forms of the landscape. The general tone of the sky could also be painted in the technique described earlier for the clear sky.

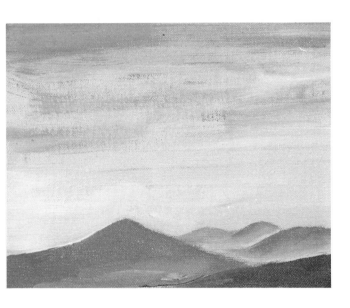

Step 2. Because he knows that he must relate the sky tone to the underlying landscape, the artist blocks in the tones of the mountains. Then he begins to brush in the general texture and movement of the sky with ragged, horizontal strokes. The general tone of the sky now begins to emerge, though there's still no detail. At the end of this stage, the entire canvas should be covered with wet color into which the final details will be painted.

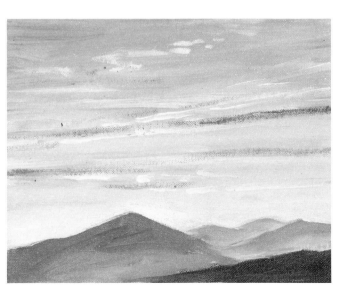

Step 3. Into the wet sky tone the artist now paints horizontal strokes and small dabs, some light and some dark, which partially mix with the underlying color. Because they're painted wet-in-wet, the streaks become part of the sky tone, rather than seeming to lie on top of it. The dark streaks are thin and fluid. The lighter touches are somewhat thicker. He accentuates the luminosity of the sky by lightening the tone along the horizon.

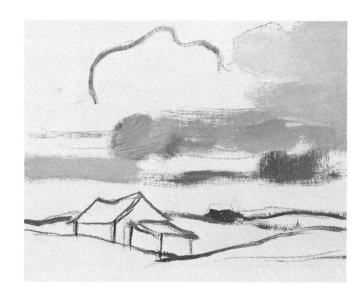

Step 1. After a quick brush drawing of the major cloud masses, the artist begins to block in the soft gray shapes that will fill the sky, leaving a strip of light at the horizon. In an overcast sky, the cloud masses often merge into irregular patches of gray —with an occasional break where the sunlight shines through—and a preliminary brush drawing is often unnecessary. It may be best to abandon the brush drawing altogether and start blocking in values.

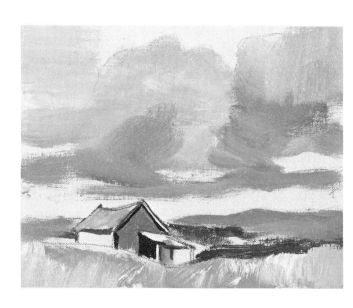

Step 2. The major cloud masses are now covered with color, leaving a few breaks in the sky where the canvas is still bare. The artist blocks in the broad tones of the landscape to establish the overall value scheme of the painting. Once again he's chosen a grayish canvas (or put a gray tone over the white canvas), which adds to the overall grayness. And the final light touches will look even more luminous against this gray background.

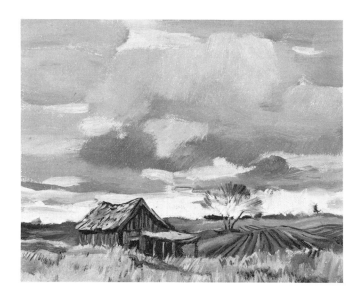

Step 3. He completes the sky by merging the cloud masses and minimizing their edges. Patches of light between the clouds are painted in thick color, as is the strip of light at the horizon. The cloud shapes delineated in Steps 1 and 2 have all but disappeared; what we have, instead, is simply a patchwork of light, halftone, and shadow. Not every overcast sky has a sunlit break at the bottom, but it's a powerful compositional device for dramatizing the darkness of the sky and drawing the viewer's attention to the horizon.

DEMONSTRATION 32: STORM CLOUDS

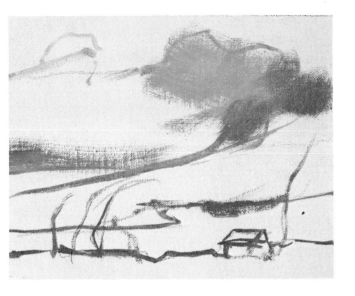

Step 1. Like an overcast sky, a stormy sky is often a mass of darks with no clearly defined edges to the clouds. Here, the preliminary brush drawing simply divides the sky into areas that will roughly correspond to the tones, but the brush makes no attempt to record precise cloud shapes. And once these few brushlines are drawn, the artist begins to block in the tones which will obliterate the lines. Yet the lines are important: if you look at Steps 2 and 3, you'll see that the sky is divided roughly into areas that correspond to these lines.

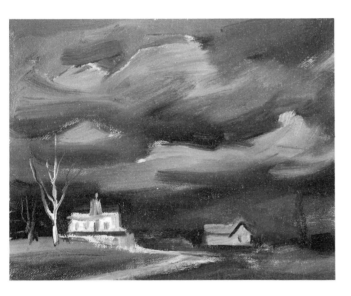

Step 2. Working with large, sweeping strokes, the artist quickly covers the entire sky with wet color. He makes no attempt to blend his tones evenly, but allows the action of the brush to fuse the colors almost by accident. The sweeps of the brush not only capture the tones, but reflect the violent movement of the clouds as they're pushed by the wind. Since the light and shade of the sky are inseparable from the landscape beneath, he brushes in the values of the landscape. Although there's very little light in the sky, the blurred cloud masses are lightest at the top and darkest along the bottom, suggesting an unseen light source which also illuminates the houses, trees, and road below.

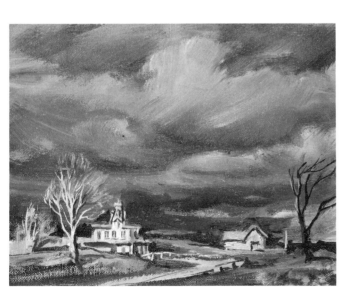

Step 3. Working mainly with diagonal and horizontal strokes that follow the movement of the clouds, the artist refines the shapes in the sky, defining the light and dark shapes more precisely and suggesting that a few of the clouds do actually have edges. The brushstrokes are still apparent; he doesn't smooth them out, but retains their lively texture. He concentrates darks at the horizon to dramatize the eerie lighting on the landscape. Compare Step 3 with Step 2: you'll see that the lights have been darkened and the artist has introduced many more middletones so that the entire sky is now in a low key.

Step 1. To create the glowing sky typical of a sunrise, the artist returns to the technique he used to paint the clear sky, brushing in separate touches of blue which become paler as the eye travels down to the horizon. At sunrise, the sun is either at the horizon or actually below the horizon line, which is why the sky is most brilliant at the bottom. See pages 110-112 for a color demonstration of this method of painting a clear sky.

Step 2. Still following the method used to paint the clear sky, the artist adds touches of yellow and pink, which intertwine with the blue touches. Because the sun is actually behind the horizon in this picture—which means below the horizon line—the entire landscape is in shadow, so it's painted in dark silhouette. This darkness also accentuates the luminous lower sky.

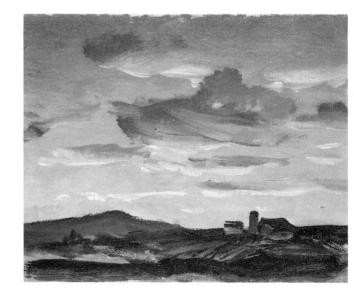

Step 3. After merging the blue, yellow, and pink strokes as he did in the clear sky, the artist paints the clouds into the wet color. Because the light source is below, the undersides of the clouds are brilliantly lit and the upper parts of the clouds are in shadow. For the same reason, the brightest clouds are low in the sky and the clouds darken as they approach the top of the picture. As the landscape is completed, even stronger darks are introduced to heighten the brilliance of the sky. Notice how the brushstrokes in the sky convey the sense of movement in the clouds.

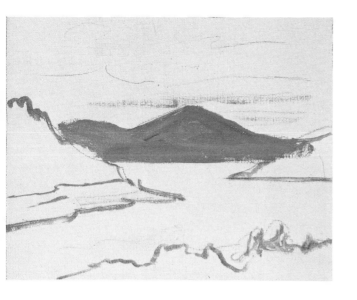

Step 1. Except for a few quick lines that suggest the more brilliantly lit strips of sky just above the distant peaks, the artist makes no attempt to draw the turbulent shapes of the clouds. Brushlines define the main shapes of the landscape below and the artist pays particular attention to the shape of the water, which will reflect the colors of the sky. He then begins by blocking in the peak at the horizon, since this is the value that will contrast most strongly with the color of the sky above and the reflections in the water below.

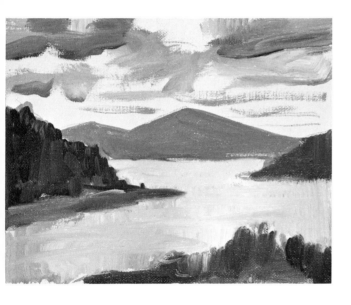

Step 2. In front of the middletone of the distant peaks, the artist brushes in the darks of the shoreline and the pale tone of the water, making the value scheme complete. He can now concentrate on the sky, where he brushes in darks and middletones, leaving bare canvas for the lights. As in the sunrise, the light source is below the horizon and therefore the most brilliantly lit area of the sky will be just above the peaks. Observe the suggestion of perspective in the sky: the nearest clouds are large shapes, while the more distant clouds are slender strokes.

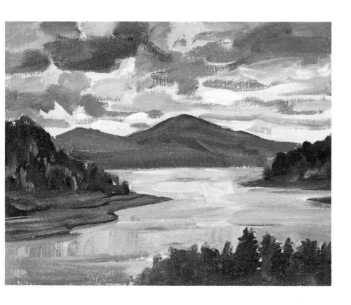

Step 3. Many more middletones are introduced into the sky, tying together the tones painted in Step 2. More darks are introduced along the horizon and thick touches of light are interspersed to suggest the brilliantly lit undersides of the clouds. Then, to accentuate the contrast between the sky and the horizon, the distant peaks are darkened and their shapes are more precisely drawn. To reflect the dark-to-light gradation in the sky, the water is gradated from dark in the foreground to light at the horizon.

Step 1. A few lines describe the shapes of light and shadow in the sky, which you'll see more clearly in Step 2. Then the artist begins by painting the darkest note in the picture, which is the shadowy strip of trees at the horizon. This will provide a strong division between the tone of the sky and the lighter tone of the landscape.

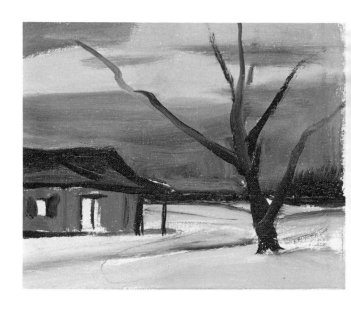

Step 2. The sky is now begun as two broad, simple tones, one for the layers of cloud and the other for the clear sky where the moonlight breaks through. The moonlight falls on the landscape below and the snow acts as a reflecting surface, which is painted as light as the patches of clear sky. The darks of the house and tree are brushed in to accentuate the light on the snow. Remember that snow is just another form of water, so the light of the sky reappears on the landscape.

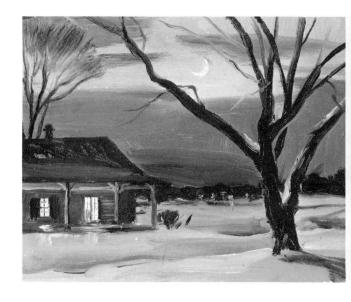

Step 3. The area of open sky is lightened and a crescent moon is introduced to provide a light source. To accentuate the light in the sky, the artist darkens the surrounding clouds. But then he darkens the tree and house even more, so the clouds look remote and luminous. The lights and darks on the snow are also exaggerated to reflect the increased contrast in the sky. The cast shadow of the tree (in the lower right) and the light on the trunk are carefully related to the light source. In general, twilight gives us more tonal contrast than we might expect.

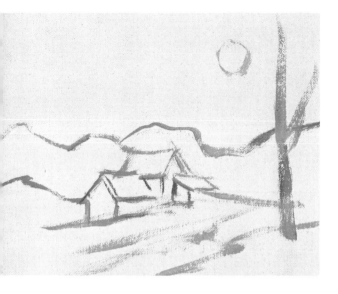

Step 1. When the sky is cloudless and there's a full moon, a surprising amount of detail appears in the landscape. Thus, the preliminary brush drawing divides the landscape into the same kind of planes that might appear by day: foreground with buildings; distant trees; and sky.

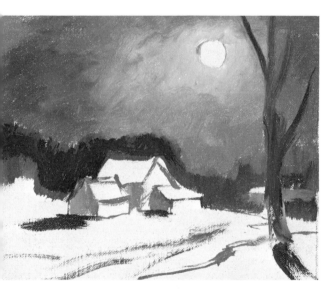

Step 2. Saving the moonlit foreground for the final stage, the artist concentrates on the sky as the source of light. The sky is lightest around the full moon and gradually grows darker as the eye moves away from the moon. The distant trees are painted much darker than the sky; in a moonlit landscape, the sky is much lighter than we might expect. With the direction of the light established, the artist then brushes in the shadow sides of the buildings, plus the shadows cast by the buildings and the nearby tree.

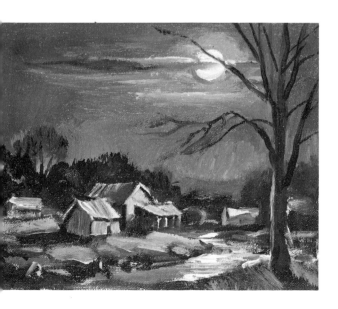

Step 3. The details of the landscape are now painted with every element modeled by the moon, just as it might be by the sun. Each form has its lighted side, its shadow side, middletones in "half light," and cast shadows on the side away from the moon. On the landscape directly beneath the moon, the artist brushes in some glints of bright light. And he adds details to the sky, like the horizontal clouds that cross the moon, picking up glints of light along their edges.

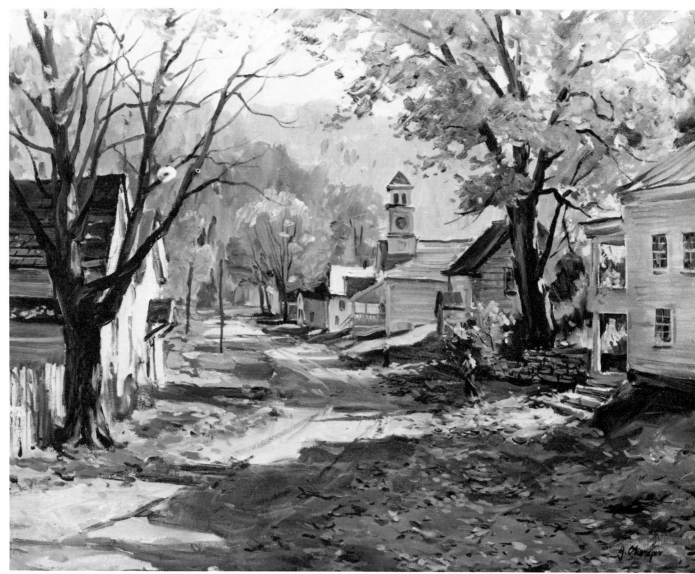

Jacksonville, Vermont by George Cherepov, oil on canvas, 24″ x 30″. Manmade structures like houses, barns, fences, and roads—and the figure of man himself—must be painted so they integrate with the landscape, not clash with it. One important secret is to paint these structures as freely as you paint the trees and other natural surroundings. Notice the casual brushwork on the buildings in this glimpse of a country town. The lines of the walls, rooftops, windows, and distant steeple aren't geometrically perfect, but rough and irregular, painted as freely as the trees. The buildings are also painted very simply: the artist renders them with broad strokes and then adds just a few touches of detail, but never gets carried away with rendering the details of boards, shingles, or win-dows. The nearby windows on the right are simply blocks of tone, crossed with a few strokes to suggest mullions. The steps leading up to the porch are nothing more than parallel strokes of light and shadow. And notice how the wooden fence to the left is painted: vertical strokes of pale color for the boards in sunlight; vertical strokes of darker color for the boards in shadow. The simplified buildings integrate with the landscape because they never call attention to themselves with excess detail. The road, too, is manmade, but its geometric form is interrupted by shadows, obscured by fallen leaves, and indicated by nothing more than a few tire tracks. The human figures by the side of the road are simply dabs of color without any details.

10

MANMADE STRUCTURES AND FIGURES

Some painters prefer landscapes in which no sign of human life appears; other painters like to include a house or a barn, walls, fences, roads, and other manmade items to suggest that man has been there. The great landscape painters of ancient China nearly always included a human figure, which seems to be a way of putting the viewer into the picture: you look at that tiny figure and feel that you're the one who's really there among those gnarled trees and misty peaks.

COMPOSING WITH MANMADE STRUCTURES

If you decide to include a manmade structure, such as a barn or a bridge, be prepared for the fact that the viewer's eye will go straight to that pictorial element, no matter how small it may be. We're always drawn to any sign of life in a landscape. And this means that manmade structures ought to be used sparingly and generally be reserved for the focal point of the picture.

Let's say you're painting a panoramic landscape of rolling green hills and groves of trees. The panorama is so vast—with so many different shapes and colors—that it's hard to establish a focal point. A tried-and-true solution is to nestle a tiny farmhouse, barn, and silo in some spot where you'd like the eye to rest. You can use the same device in a densely detailed forest interior, where you're surrounded by treetrunks, leaves, shrubs, and fallen logs, with no clearly defined center of interest: a corner of a deserted shack appearing between the trees will give your picture an effective focal point.

However, you have to decide just how much attention you want such manmade objects to command. If your purpose is simply to steer the viewer's eye to the most significant area of the painting, keep that bit of architecture small and simple. Leave out as much detail as you possibly can. Don't paint every window, every brick, or every board: just indicate a couple of window panes or a few lines for bricks and boards, and paint the other forms in patches of flat color. Keep your brushwork rough and make sure that the edges of the shapes are a bit soft and scrubby. Too much detail and too many sharp edges will magnetize the viewer and make him think that this touch of architectural detail is actually the subject of the picture.

PAINTING MANMADE STRUCTURES

Naturally, manmade structures *can* become the dominant subjects of a landscape. If so, you can certainly lavish a lot more attention on painting the details of stonework, wood, and geometric form.

Begin by checking your perspective carefully and making sure that parallel lines lead to the appropriate vanishing point. If you must line everything up with a ruler, plan with pencil and ruler on a separate piece of paper, not on the surface of the painting. Although it's possible to guide your brushwork with a ruler, such straight, mechanical brushstrokes always look cold and lifeless in a picture which is otherwise freely painted. It's better to get your perspective right in a pencil drawing, then try to paint the same shapes more roughly with a brush on the canvas. It doesn't matter if the brushstrokes aren't absolutely neat and the edges are ragged here and there; they look more natural and spontaneous that way.

When you're painting manmade structures, it's easy to visualize them as geometric forms. Houses and barns tend to be collections of cubes and pyramids. A silo is almost always a cylinder with a cone on top. Stone walls tend to be collections of blocky shapes. But don't render these geometric forms too precisely. They shouldn't look like architectural drawings. Paint them boldly, with rough strokes and ragged edges. They often look better if the forms are just a bit cockeyed. Nature's almost always rough and irregular, so architectural shapes will harmonize with the rest of your painting if they're rough and irregular too.

Use your biggest brushes to block in the large color areas. Swing the brush freely and don't be too neat. After you've established the major planes of light and shadow on that stone bridge, for instance, then pick up your smaller brushes and dash in just enough strokes to suggest the light and shadow planes of some of the stones—not all of them. Finally, with your smallest brush, indicate cracks between some of the stones, but stop before you get carried away with too much detail. Follow the same guidelines when you're painting something like an old barn: rough in the big shapes with large brushes; suggest some weathered wood textures with smaller brushes here and there; and finish up with a few calligraphic lines for some cracks

When you place manmade structures —like these two shacks in the forest—among natural forms like trees, grasses, and weeds, try to make them blend into their surroundings. Let them seem to "grow" out of the landscape. Notice how the near shack is half concealed by undergrowth, which covers its foundation and most of the side wall. The right-hand side of the shack literally seems to melt into the shadowy trees.

This closeup of a farmhouse—a small section of a much bigger painting—shows how casually the artist handles architectural geometry. The planes of light and shadow are blocked in with rough, irregular strokes, and the artist makes no attempt to retain crisp edges. The brushstrokes are applied quickly and he never smoothes them out. There's a soft, irregular transition between the foundation of the house and the ground. The figure of the farmer is painted in the fewest possible strokes: quick, vertical touches of the brush for his torso and legs, an arc for his arm, and a few dabs for his head and hat.

between the boards. But stop before the job looks "finished."

Do your best to match the brushwork and paint quality to the subject. Try your shortest bristle brushes for rough stonework, painting in dabs of thick color that stand out slightly from the canvas. For the weathered boards of that old barn, you might do just the opposite: pick up a long-bristled brush with not too much paint on it and paint in long, straight scrubs. For the cracks between the stones or boards, a slender, pointed brush, loaded with fluid color, will permit you to paint those crisp lines with a flick of the wrist.

PAINTING FIGURES

Although figures are never the "subject" of a landscape painting—or it would really be a figure painting—they have enormous psychological impact. More than anything else you can include in a landscape painting, a figure lends a sense of scale. Because the viewer knows that most adults are a certain size, he immediately relates a figure to its surroundings and instinctively calculates the size of everything in relation to that figure. If he sees a tiny figure at the base of the tree, he immediately concludes that the tree is huge. But if he sees a big figure, the tree automatically shrinks.

So a human figure—or several figures—will not only draw the viewer's eye to the focal point of the landscape, but will tell the viewer how big everything is. Tiny figures will make trees and mountains look that much loftier. Larger figures will make the landscape look smaller and more intimate.

Unless what you really want to paint is a figure with a landscape background, keep your figures simple and unobtrusive. Paint the body and limbs with a few flat strokes, then add a dab for the head. Leave out eyes, noses, mouths, and fingers. If you need a small note of color to lead the viewer's eye, you can give the farmer a red kerchief or his wife a yellow blouse, but keep it small and paint it flat.

Avoid corn. Don't place your figures in storytelling situations: show the farmhands working, but not having an argument. Resist the temptation to paint a pink nude bathing in that distant stream. If you want to paint a nude, fine, but save her for another picture and put her in the foreground where you can paint her with the care that she deserves. In a landscape, figures are accessories, not stars.

NATURAL AND MANMADE COLOR

When manmade structures are built from natural materials like wood or stone and they're allowed to retain their natural color, they harmonize with the landscape automatically. They're usually quiet grays and browns that blend easily into the background of woods and fields.

But when the builder buys a bucket of paint and produces a red barn, a white house, or a yellow silo, then you've got a design problem. How do you paint these "unnatural" colors so they don't stick out of your canvas like a beacon? It helps to keep these items small, so they don't occupy too much space in the landscape and command more attention than they deserve.

But you've also got to find a way to mute those noisy colors. One good trick is to turn that barn or farmhouse so the shadow side faces the viewer, who sees only a bit of the lighted side. A particularly good way to harmonize bright colors with the surrounding landscape is to work some of the landscape colors into the architecture. If that red barn is surrounded by green trees or fields, scrub a bit of green into the red here and there; the red won't turn green, but it will turn cooler and more shadowy. Don't paint that white farmhouse a dead white; make it a grayish white and scrub a few random strokes of green into the shadow side.

That yellow silo is the toughest problem of all. You can't add some green from the surrounding fields and trees; this would simply create a yellow-green which is almost as bright. Make the silo show its age: paint it a kind of dirty yellow-gray and add a few strokes of brighter yellow to suggest its original color. If that doesn't work out, there's no law that says you're stuck with that bright yellow. How about a gray silo?

Step 1. The edges of the road are drawn with broad brushstrokes that will eventually function as shadows in the final stage of the picture. The zigzagging shape of the road conforms to linear perspective, but the perspective lines aren't so precisely drawn that they seem artificial. The distant houses and trees are also drawn with a minimum number of lines, just enough to define their light and shadow planes. The artist works on a gray-toned canvas that will make the snow look more luminous.

Step 2. He blocks in his darkest notes for the shadowy edges of the road, a few ruts, and the shadow sides of the buildings. Then he begins to add middletones to darken the road and the distant hills. As the road darkens, he adds a few touches of snow around it to make the dark shape more distinct.

Step 3. More darks and middletones are added to define the texture of the road, the ruts, its edges, and the generally dark tone that contrasts with the surrounding snow. The snow itself is painted in tones of gray, with just a few touches of white in the foreground. A single line carries the road off into the distance. The snow-clad rooftops in the distance are painted in pale tones, while the walls that face us are painted in middletones. The distant hills and sky are completed last. To the left of the road, posts are added; they grow smaller as they recede, aiding the illusion of perspective.

Step 1. The roof, walls, window, and doors of the old barn are quickly sketched in with brushlines. There's no indication of the texture of the weathered boards just yet. The barn is drawn in accurate perspective, but it's interesting to note that the lines aren't actually straight, but slightly curved. The artist consciously avoids geometrically straight lines so that the architecture will look more "natural" in the landscape setting.

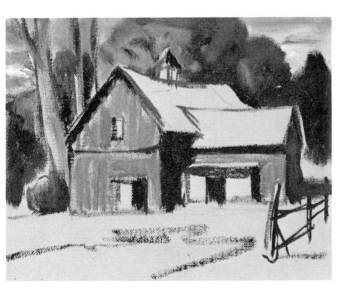

Step 2. He blocks in the dark shadows on the walls to the right and the strips of shadow under the eaves. He also indicates the dark shadows in the window and doorways. On the walls that face us, he blocks in middletones with straight strokes that allow some of the gray canvas to shine through, thus suggesting the texture of the boards. The sunlit rooftops are still bare canvas. The darks of the distant landscape are blocked in to dramatize the sunlit planes. The shadow sides of the fenceposts are also indicated with dark strokes.

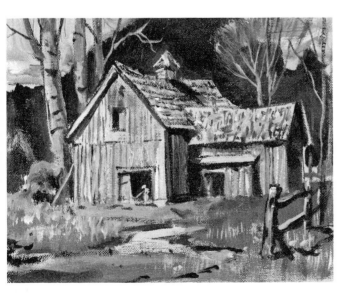

Step 3. The walls are now covered with wet color, and the artist strikes back in with lighter and darker strokes to suggest the texture of the weathered wood. In particular, notice how the dark shadow planes on the right have been lightened to suggest reflected light. The battered shingles on the rooftop are now suggested with short dabs of lights, darks, and middletones. The shadows in the window, doors, and under the eaves have been strengthened with strong touches of dark. The light and shadow planes on the wooden fence to the right are now clearly defined. Notice the soft edge where the foundation of the barn merges with the ground.

DEMONSTRATION 39: WOODEN FENCE

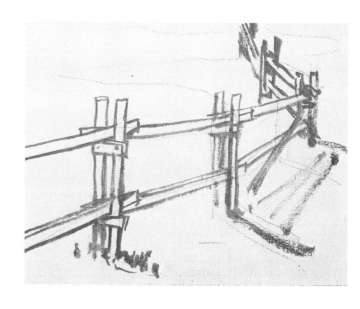

Step 1. Dipping a slender brush into liquid color—diluted with a lot of turpentine to flow smoothly—the artist draws the boards and their shadows with considerable care. The fence is shown in perspective, but he avoids too much precision and draws lines which are a bit ragged and unpredictable, like the fence itself.

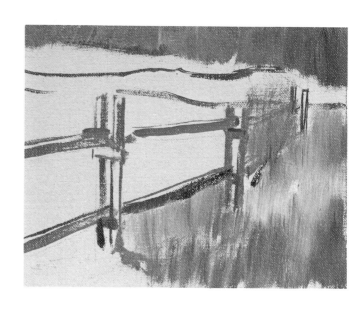

Step 2. The artist blocks in the shadow sides of the boards and then begins to paint the surrounding grasses and weeds. He knows that the painting would look tight and finicky if he tried to paint the undergrowth *around* the fence, so he allows his rough, scrubby strokes to overlap and partially obscure the original drawing. Soon the entire canvas will be covered with this casual brushwork, leaving just enough of the fence to guide him when he repaints it in Step 3.

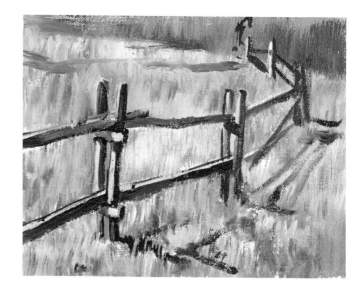

Step 3. Now the fence is repainted into the wet underbrush. The strokes of the fence merge slightly with the surrounding grasses and weeds, so that the manmade structure integrates with the natural landscape. The artist adds some crisp lights and darks to the nearest portions of the fence so they'll be more sharply defined. But the more distant parts of the fence are more simply painted, with less detail, conforming to aerial perspective as well as linear perspective. Notice the soft, irregular shadows of the fence, which melt into the grass.

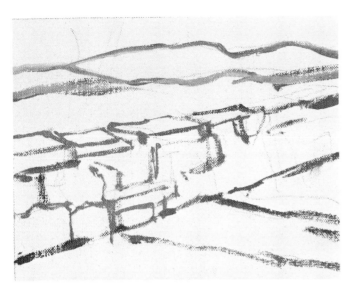

Step 1. Thick, irregular brushstrokes define the top planes of the stones, the bottom edge of the wall, and just some of the blocks within the wall itself. It's significant that the artist doesn't draw every single block. He also draws a few lines in the foreground to suggest the shadows that will move across the grass and up over the wall.

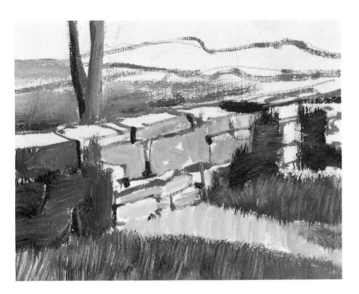

Step 2. The central portion of the wall is in sunlight, but two other sections of the wall are obscured by dark shadows cast by unseen trees to the right. The cast shadows are blocked in with dark strokes that obscure the detail of the wall. The artist brushes in the lighted plane of the wall with a pale middletone that runs into the sunlit grass. This middletone leaves gaps where the canvas and the original brushstrokes come through, suggesting the stony texture. The top planes of the wall are still bare canvas.

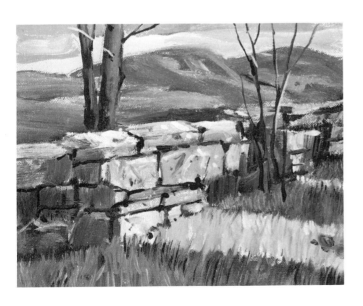

Step 3. Working back into the dark, wet paint of the cast shadows, the artist now adds middletones and a few dark strokes to recapture some—but not all—of the lost detail. On the sunlit portion of the wall, he adds lighter strokes and a few random dabs to suggest texture; then he adds a few dark touches to emphasize the shadowy spaces between the stones. The tops of the blocks are also painted in middletones, with flecks of lighter color. The seams between the rocks are suggested, but not precisely defined. There's more detail and texture in the sunlight than in the shadows.

SUGGESTED READING

Ballinger, Harry R. *Painting Landscapes*, 2nd ed., New York: Watson-Guptill, and London: Pitman, 1973.

Blake, Wendon. *Creative Color: A Practical Guide for Oil Painters*. New York: Watson-Guptill, and London: Pitman, 1972.

Carlson, John F. *Carlson's Guide to Landscape Painting*. New York: Dover, and London: Constable, 1958.

Cherepov, George. *Discovering Oil Painting*. New York: Watson-Guptill, and London: Pitman, 1971.

Cole, Rex Vicat. *The Artistic Anatomy of Trees*. New York: Dover, and London: Constable, 1965.

Cooke, Hereward Lester. *Painting Techniques of the Masters*. New York: Watson-Guptill, and London: Pitman, 1972.

De Reyna, Rudy. *Creative Painting from Photographs*. New York: Watson-Guptill, and London: Pitman, 1975.

————. *How to Draw What You See*. New York: Watson-Guptill, and London: Pitman, 1972.

————. *Magic Realist Landscape Painting*. New York: Watson-Guptill, and London: Pitman, 1976.

Dunstan, Bernard. *Composing Your Paintings*. New York: Watson-Guptill, and London: Studio Vista, 1971.

————. *Learning to Paint*. New York: Watson-Guptill, and London: Pitman, 1970.

Guptill, Arthur L. *Oil Painting Step-by-Step*. New York: Watson-Guptill, and London: Pitman, 1965.

Mayer, Ralph. *The Artist's Handbook of Materials and Techniques*. New York: Viking, and London: Nelson, 1970.

Pellew, John C. *Oil Painting Outdoors*. New York: Watson-Guptill, 1971.

————. *Painting Maritime Landscapes*. New York: Watson-Guptill, and London: Pitman, 1973.

Pitz, Henry C. *How to Draw Trees*. New York: Watson-Guptill, and London: Pitman, 1972.

Savage, Ernest. *Painting Landscapes in Pastel*. New York: Watson-Guptill, and London: Pitman, 1971.

Schmid, Richard. *Richard Schmid Paints Landscapes*. New York: Watson-Guptill, and London: Pitman, 1975.

Taubes, Frederic. *Oil Painting for the Beginner*. New York: Watson-Guptill, and London: Pitman, 1965.

————. *The Painter's Dictionary of Materials and Methods*. New York: Watson-Guptill, and Newton Abbot, England: David & Charles, 1971.

Waugh, Coulton. *How to Paint with a Knife*. New York: Watson-Guptill, 1971.

————. *Landscape Painting with a Knife*. New York: Watson-Guptill, and London: Pitman, 1974.

INDEX

Edited by Margit Malmstrom
Designed by James Craig
Set in 11 point Times Roman